"In a world where Scriptu[...] [...]ng the church are often drawn fr[...] [...]awing on his deep, loving engage[...] [...] in churches on the margins, Mark Glan[...] [...]arating invitation to become congregations that help our [...] encounter the joy of Jesus and his way in the world. Like the jazz that serves as its primary metaphor, *Improvising Church* brought me to tears and made my heart sing. It is a gift to anyone seeking to help God's people become who we're called to be in our post-Christian, Western world."

Michael J. Rhodes, lecturer in Old Testament at Carey Baptist College and author of *Just Discipleship: Biblical Justice in an Unjust World*

"Imagine an interpreter of Scripture with trustworthy credentials. Now imagine a musician who enchants with creativity. Next imagine a pastor who can mobilize a community to bless a neighborhood. In Mark Glanville, all three of these are one person. Read, listen, and imagine what more may be possible."

Jason Byassee, senior pastor of Timothy Eaton Memorial Church in Toronto, Ontario

"There is a good case to be made that the missing component in our contemporary apologetic is *beauty*. In this book, Mark Glanville draws on his pastoral and musical experience to invite and instruct the church to move in ways—like good jazz—that show the beauty of God to a world that desperately needs good news."

Tim Morey, Life Covenant Church

"*Improvising Church* is a harmony of scriptural insight and pastoral wisdom, soulfully explored. Drawing from the metaphors of jazz, Glanville calls Western churches in post-Christian contexts to embrace an improvisational journey shaped by the biblical narrative and the perception of artists within incarnational community that loves their place and its people. Like a musician in sync with our contextual rhythm, Glanville urges us to embrace our interconnectedness with creation, tying that to the need to confront the legacies of colonialism with courageous solidarity. This book resonates deeply, hits all the right notes, and will inspire you to embrace a new, transformative song to improvise with for our twenty-first-century witness."

Drew G. I. Hart, associate professor at Messiah University and author of *Who Will Be a Witness? Igniting Activism for God's Justice, Love, and Deliverance*

"Mark Glanville writes with a kind of humility, curiosity, creativity, and compassion that are not merely desired but required when learning from traditions that you've been graciously grafted into—be it from Moses or Miles Davis, Elijah or Ella Fitzgerald, Nathanael or Nina Simone, John Coltrane or Jesus, the Christ. Mark has experienced a 'love supreme' and is inviting us to take giant steps of communal improvisation and imagine somethin' else, an alternative to Christendom and its colonial legacy, something that looks like Jesus, something that is the shape of things to come."

Jarrod McKenna, founding director of CommonGrace.org.au and formation catalyst at Steeple Church in Melbourne, Australia

Improvising

Church

Scripture as
the Source of
Harmony,
Rhythm,
and Soul

Mark R.
Glanville

IVP
Academic

An imprint of InterVarsity Press
Downers Grove, Illinois

InterVarsity Press
P.O. Box 1400 | Downers Grove, IL 60515-1426
ivpress.com | email@ivpress.com

InterVarsity Press® is the publishing division of InterVarsity Christian Fellowship/USA®. For more information, visit intervarsity.org.

Scripture quotations, unless otherwise noted, are from the New Revised Standard Version Bible, copyright © 1989 National Council of the Churches of Christ in the United States of America. Used by permission. All rights reserved worldwide.

While any stories in this book are true, some names and identifying information may have been changed to protect the privacy of individuals.

The publisher cannot verify the accuracy or functionality of website URLs used in this book beyond the date of publication.

Cover design: David Fassett
Interior design: Jeanna Wiggins
Cover images: Getty Images: © Tetiana Garkusha, © ngupakarti, Tyas drawing

ISBN 978-1-5140-0745-7 (print) | ISBN 978-1-5140-0746-4 (digital)

Printed in the United States of America ∞

Library of Congress Cataloging-in-Publication Data
Names: Glanville, Mark R., author.
Title: Improvising church : scripture as the source of harmony, rhythm, and
 soul / Mark Glanville.
Description: Downers Grove, IL : IVP Academic, [2024] | Includes
 bibliographical references and index.
Identifiers: LCCN 2023035566 (print) | LCCN 2023035567 (ebook) | ISBN
 9781514007457 (print) | ISBN 9781514007464 (digital)
Subjects: LCSH: Mission of the church–21st century. | Ministers of music.
 | Church music.
Classification: LCC BV601.8 .G535 2024 (print) | LCC BV601.8 (ebook) |
 DDC 262/.70905–dc23/eng/20230914
LC record available at https://lccn.loc.gov/2023035566
LC ebook record available at https://lccn.loc.gov/2023035567

31 30 29 28 27 26 25 24 | 13 12 11 10 9 8 7 6 5 4 3 2 1

To Simeon Pang,

one of the kindest people

I have had the privilege of calling friend;

the kind of bighearted leader who is

the heart and hearth of a community.

Contents

Acknowledgments

CREATIVE CHURCH COMMUNITIES are made of many gifted leaders. Such churches tend to be "leader-full," as we shall see in chapter two. So, in these pages you will meet many leaders I have had the privilege of partnering with through the years. I write this book with deep gratitude to these partners in the gospel, both named and unnamed, for all that they have taught me.

There is one friend I will mention by name. My journey of learning and dreaming for the church is inextricably intertwined with my wife Erin's journey. This is so much so that when I share a new insight, Erin often responds: "I came up with that!" And when Erin shares a new idea, I often exclaim: "That's what I said!" The regularity of these exchanges shows us how intertwined our journeys are: we intuitively find a path for reimagining church together (with the Bible in our hands) in ways that are both similar and dissimilar, yet seemingly always addressing the same questions, and with the same soft heart. I am incredibly grateful for our creative, spiritual partnership.

This book has been greatly improved through ongoing feedback from trusted friends. An initial draft of *Improvising Church* was discussed at a day-long book workshop at Brooksdale Farm, A Rocha. Thanks to the participants who labored through a very rough version of the book and who then fired volleys of critical feedback for six hours straight, namely Erin Glanville, Kim Boldt, Vania Levans, Regula Winzeler, Dawn Humphreys, Sarah Jeong, Jeff Schuliger, and Jamie Hellewell. They gifted their vast experience in leadership, justice seeking, and creative ministry to this book.

Thanks especially to Jeff Schuliger who provided a thorough, professional edit of the book prior to submission, improving the book's coherence and

clarity. Michael Rhodes, Noah Collins, and David Groen also provided helpful feedback on the book as a whole. Other friends provided invaluable feedback as I wrote, chapter by chapter, including Steven Gomez, Toni Kim, and Earl Phillips. Others kindly offered their thoughts on select chapters, including Conor Wilkerson, Rhonda McEwen, Joshua Liem, Monica Hoff, Chris Wright, Keith Walker, and Joshua Koh. I am grateful for the generosity and insights of these friends.

Thanks to Rachel Hastings for her exceptional editorial support, in particular her keen cultural intuition and heart for the church. And thanks to Alexandra Horn and the supportive, passionate, and talented team at Inter-Varsity Press. I am truly grateful for my creative partnership with IVP Academic.

This book is written for Mahla, Lewin, and other sojourners of their generation. May reading it nurture your faith and imagination. Finally, a shoutout to my Aussie family: to Sa, Daddy-o, Lukey, Pokey, Joey, and the crew.

Introduction

Twelve Notes for Improvising Church

I GREW UP IN THE BLUE MOUNTAINS NATIONAL PARK, near Sydney, Australia. My parents bequeathed their evangelical heritage to me and my siblings, an evangelicalism shaped especially by British evangelicals such as John Wenham and John Stott. My mother also bequeathed her love of music, ensuring that I studied classical piano from a young age. Both stuck. I spent most of my twenties working as a full-time jazz musician. In the most intense periods I would practice eight hours a day, often alongside my brother Luke, who is a jazz drummer and scholar. (Luke and I later cowrote the book *Refuge Reimagined: Biblical Kinship in Global Politics*.) These years were full of art and soul.

Next came seminary studies. In seminary, I assumed I was headed for academia, with no thoughts of pastoral work. But God had other plans. While working on my MDiv, I interned with an older Presbyterian pastor who was in his final two years of pastoral ministry, Robert Benn. The first time I ever met Rob, it was his prayer that captured me. Rob was also deeply pastoral. Every member of the congregation felt Rob's love for them as he pointed them toward Christ. After a month or so interning with Rob, I thought to myself: "I can give my life to this. Nourishing faith in a local congregation—that's worthy of a life." So I put the PhD on hold.

After seminary I was called to a church in a large government housing area in Western Sydney. The area was high in unemployment and crime (my

next-door neighbor appeared in court on murder charges), and yet it was also high in community and full of heart. As I look back, living and pastoring in this place was one of the most blessed and transformative experiences of my life.

For many years I had been passionate about evangelism. Yet living in this neighborhood, Jesus' concern for every dimension of human life—financial, emotional, employment, housing, and so on—sunk in. In the coming chapters I will share stories of how our church slowly turned to face our neighborhood, of how bighearted leaders in our church dreamed up fresh ways of loving our neighbors and displaying Christ. We praise God that a number of people came to know Jesus.

As a young pastor in those days, I began reading in missiology, soaking up the work of Lesslie Newbigin, Christopher Wright, and others. Living in our neighborhood, I began to appreciate the various insights of missiology, such as that the church is called to witness in life, word, and deed (Rom 15:18). As I began to read South American theologians such as Gustavo Gutiérrez, I sensed that these so-called liberation theologians occupied a similar social location as the biblical authors.[1] Ministering in the shadow of powerful institutions, they had a unique sensitivity to vulnerability, responsibility, and the heart of God.

Halfway through my time in Western Sydney, I met Erin, a Canadian who was vacationing in Australia. Within one week we had pretty much decided to get married! After some years our new family moved to Canada, and I began PhD studies.

In our third year in Canada, Erin and I accepted a call to a church that was already busy loving its neighborhood in East Vancouver (East Van, as we call it). Our new church had birthed several "social enterprises," including Kinbrace, an organization that offers housing, support, and advocacy for refugees.[2] So we moved into East Van, where for the first time Erin and I shared a pastoral role.

All told, I have pastored in creative, prayerful, biblical, justice-seeking communities for fourteen years, making plenty of mistakes along the way.

[1]Gustavo Gutiérrez, *A Theology of Liberation: History, Politics, and Salvation*, trans. Caridad Inda and John Eagleson (Maryknoll, NY: Orbis, 1973).

[2]We tell the story of Kinbrace in Mark R. Glanville and Luke Glanville, *Refuge Reimagined: Biblical Kinship in Global Politics* (Downers Grove, IL: IVP Academic, 2021), 14-15.

During this time, living and leading in solidarity with people on the margins has been deeply transformative for our family, shaping both how we read Scripture and how we live.

In July 2020 I transitioned vocationally from pastoring to training pastoral leaders at Regent College. With a satisfying coherence, my role at Regent combines my pastoral journey with my writing and teaching as a biblical scholar. The transition has given me a chance to look back and to reflect on the journey so far. I sometimes pause in gratitude to God that the Spirit has guided me down this rich path of incarnational community.

I think of my story (as I have told it here) as a triad, a simple chord consisting of three tones; a triad also illustrates the approach of this book. When a triad is played, the three tones blend and resonate in our ears, producing something new and beautiful. The first note in the triad is the missional church conversation, especially as it has been articulated by Lesslie Newbigin and Michael W. Goheen.[3] The second note in the triad is my work as an Old Testament scholar. I have done this scholarly work within the warmth, the hearth, the adventure, and the pain of incarnational communities, which is the third note in the triad.[4] These three tones, missiology, biblical studies, and pastoral leadership, are played together throughout this book. Yet the book is also practical. As we explore twelve "notes" for improvising church, we will engage in biblical exegesis alongside imagination, strategy, skills, and lived stories with the goal that you can nurture these notes in your communities.

> *As we explore twelve "notes" for improvising church, we will engage in biblical exegesis alongside imagination, strategy, skills, and lived stories with the goal that you can nurture these notes in your communities.*

[3]See, for example, Michael W. Goheen, *A Light to the Nations: The Missional Church and the Biblical Story* (Grand Rapids, MI: Baker, 2011) and Lesslie Newbigin, *The Gospel in a Pluralist Society* (Grand Rapids, MI: Eerdmans, 1989).

[4]A gaping hole in scholarly discussions of mission and "missional" exists around fresh theological and practical imagination for witnessing communities themselves. However, see Stefan Paas, *Pilgrims and Priests: Christian Mission in a Post-Christian Society* (London: SCM Press, 2019).

Improvising Church

Both the church and the jazz club are rooted in rich tradition, and both can also be profoundly creative. Jazz musicians immerse themselves in the jazz tradition, listening to the music for thousands of hours, tapping its rhythms, and humming its melodies. The jazz tradition, which runs deep within every good jazz performance, works similarly to the biblical tradition, which runs deep within every Christian community and gives it its identity.

Both of these traditions inspire creativity. The creativity of each new jazz performance is improvised on the jazz tradition. Jazz requires a step into the unknown, an interdependence with other musicians, in order to create something beautiful. Similarly, the biblical tradition should inspire fresh improvisations, daring creativity, interdependence, careful listening, and pursuit of beauty. The creativity demonstrated in the Scriptures themselves demands that we not merely re-perform Christian community (as in reading notes off a page) but improvise church, riffing on the biblical story within our neighborhoods.

To be clear, this book is about the church, not jazz! And you don't have to like jazz to play along. Yet jazz by its nature—as a traditioned, improvised, nuanced, conversational art form—is a helpful analogy for the church in post-Christian societies. So, twelve notes for incarnational communities form the creative imagination in this book, as in the twelve notes that make an octave on a piano. These notes, each represented by a chapter, are: 1. The Text *Grants*, 2. Leader-Full, 3. Local, 4. Beauty, 5. Worship in Polyrhythms, 6. Shared Life, 7. Healing, Kinship, and Maternal Nurture, 8. Creation, 9. Voice, 10. Conversations, 11. Sins of Our Kin, and 12. Prayer. These twelve characteristics of incarnational communities are offered as practical and biblical themes for your own improvisation. Take these notes and play them! Riff on them, create a beautiful groove on the street corner! This creative, prayerful task is yours. Every church needs to improvise a fresh melody on the biblical tradition, enlivened by the creative energy of the Holy Spirit.

This book unfolds a biblical, creative, and practical vision for churches that seek to receive and extend the healing of Christ within their local neighborhoods. And it offers some pathways for how to do it. I have written this book for people who are seeking a fresh vision for the church and who are curious to see if Scripture can resource their imagination. I have written for

pastors and student-pastors, with whom I share a common journey. And yet this book also shows that flourishing incarnational communities need to be what I call *leader-full*. So I have written for passionate lay leaders too. Fresh imagination often arises from lay leaders, whose role in the church will be increasingly crucial in the coming decades. Whether laity or vocational pastors, readers of this book likely will share an aching for something more for the church, a readiness to lead creatively, and a compassionate heart.

The book contains personal stories of mistakes and delights, experiments and discoveries, all on the ground in neighborhoods, all embedded within biblical theology and scholarly reflection. It is full of practical suggestions—a kind of guidebook for both pastors and lay leaders.

My choice to include these twelve notes did not arise from an academic or hypothetical effort at describing what a community could potentially be. Rather, they are my effort to discern and describe what God is already birthing in real, lived, incarnational communities. While these notes emerge from the lived experience of real communities, I have tried to unpack them in a way that is open and nonprescriptive. Scripture has inspired the imagination of the communities of which I have been a part, and I want Scripture itself to inspire your imagination. In essence, these twelve notes represent a call to the Christian life, to Christian living, contextualized to Western neighborhoods today.

Let me make an important acknowledgment before we begin. As a White Australian Canadian, I am an outsider to the Black American story that gave birth to jazz music. Jazz music tells the story of the Black American people. This is a story of creative community, of suffering and enslavement, of segregation, resilience, outrage, and celebration. Through the years, musicians belonging to diverse cultures have been woven into the story of jazz. These contributions range from sophisticated Latin rhythms to the thriving jazz scene in Japan. I am among the thousands of non-Black musicians who have drawn close to listen in, who have come to love the imagination and soul of the music. I have spent countless hours absorbing the harmony of the music, feeling its time deep in my gut—so much that jazz is a part of me. Yet to play (or write about) the music responsibly as a White musician, I sense that I must listen to the stories of Black America, the stories and histories that have shaped the music, and be shaped by them myself in turn. And I need to roll

up my sleeves and do the work of discerning my own racism and of living well in my own neighborhood.[5] I hope and pray this book honors the history of the music and its people, and I welcome dialogue from readers about how to do this better.

"What Is the Church Supposed to Be?"

Many passionate lay Christians are aching for more from the church. They know intuitively that the compassion and solidarity they see in the life of Jesus should be seen in the life of the church, but they don't find it there. Many have an instinct to leave the church, an instinct that involves both the personal and the ethical. To illustrate, a popular social media communicator posted these words:

> Why do people leave a community? Many reasons, but one that I've recently gained insight into is that people leave when they no longer see a vision for or room for their future self—who they want to be and are already becoming. True for me w cities, jobs, & recently a church.[6]

This discerning tweet seems to join personal experience and ethics. People have a vision for their life, a vision for beauty, justice, and community; yet they feel a disjunction between their vision and their church, or even their faith.

If many young Christians have one foot out the church door, many secularists have one foot in. Young people today are not secular in the sense of lacking spiritual beliefs. One study found that 71 percent of Americans between the ages of 13 and 25 consider themselves at least "slightly religious."[7] This same study uses the term "unbundled" for the Gen-Z generation (those born in the mid-1990s to early 2010s), referring to a bundling together of "their own sense of beliefs, identity, practices, and community—from a variety of religious and non-religious sources," in a way that is often disconnected from a single religious tradition.[8]

[5]I have explored this further in Mark R. Glanville, "The Birth of the Blues and the Birth of Biblical Law in Parallel: A Dialogue with James Cone's Theology of the Cross," *Review and Expositor* (2020): 114-27.

[6]Twitter post by Matthew Terrill, used with permission.

[7]Kevin Singer and Josh Packard, "Uncertain and Unbundled: Are You Ready for Gen Z?" *In Trust* (Autumn 2021), 6. See online version at, https://intrust.org/Magazine/Issues/Autumn-2021 /Uncertain-and-Unbundled.

[8]Singer and Packard, "Uncertain and Unbundled."

Yet if many Christian young adults are seeking a church that reflects "who they want to be," many Christian leaders sense the need for something fresh too. My predecessor at Regent College, Darrell Johnson, mentors no less than seventy vocational pastors. Darrell tells me that many if not most of these pastors are asking two searching questions: "What is the church supposed to be?" and "What is the church supposed to do?" These are good questions; in fact, they are the very questions this book sets out to address.

There is a corresponding crisis of confidence in the pastoral vocation. Young leaders often associate vocational pastoral ministry with burnout, scandals, financial instability, and limited chance of success.[9] So today, far fewer Christian leaders in their late twenties and early thirties are considering vocational pastoral ministry than in my generation, Gen-X (those born in the mid-1960s to late 1970s).

These questions—"What is the church supposed to be and do?" and "Why on earth would I want to be a pastor?"—expand in the vacuum created by the cultural movement toward post-Christian cultural identities. It is quite incredible that in my lifetime (and in yours, if you are my age) many Western cities have shifted from being more or less "Christian" to thoroughly post-Christian.[10] This is certainly true of the cities in which I have lived, Sydney and Vancouver. Of course, there are states in the United States where most people identify as Christian. However, the direction of Western culture is clear: Christianity has become (or is becoming) more of a sideshow than the main performance.[11]

This momentous cultural shift demands that we read the Bible to imagine a fresh witness of the church. There is no shortcutting this hard creative work, for there is no going back to what was.

[9] My pastoral students share with me that within non-White cultures, parents may be reluctant to support their children entering pastoral ministry.

[10] Christendom assumes a special relationship between the church and the state. Nonetheless, representatives of other religious groups, such as Sikh, Jewish, etc., may resist the term "post-Christian." As Pastor Matthew McCoy (Spring Church, Bellingham) commented to me: "America hasn't yet had a president who wears a turban."

[11] According to The Association of Religious Data Archives, 28.5 percent of the American population in 2021 were religiously unaffiliated. Yet among eighteen- to twenty-nine-year-olds, 46.3 percent identify as "nones." See M Davern, R. Bautista, J. Freese, S. L. Morgan, and T. W. Smith (March 2022), General Social Survey, 2021: www.thearda.com/us-religion/statistics/beliefs?sid=14&qsid=200.

The shift to post-Christian societies is here to stay. And the disjunction people feel between the church and their vision for justice, beauty, and community won't go away. For this reason, this book doesn't offer a list of things to do to get your church "back on track"—because there is no track to get back on. The same downpour that washed away Christendom has also turned the old track for how to do church into a mud puddle. We need a new track, we need Scripture itself: fresh imagination with the Bible in our hand, for a new cultural moment.

As we seek this fresh imagination, we cannot simply assume that everything we do as a church is demanded by Scripture, for much of what we do is, in fact, cultural. Reading Scripture afresh includes comprehending the redemptive arc of the biblical story and learning to play our role in the story. And as we read Scripture afresh, we also see that Scripture is shaping communities of justice and tenderness, churches that receive and extend the healing of Christ within their neighborhoods.

If the post-Christian cultural turn is creating the conditions for a crisis of confidence in the church and in pastoral ministry, then at the same time this new cultural reality makes the present moment a uniquely exciting time to be a Christian leader! For it is this generation of leaders who have the responsibility to lead the church into what is literally a new era. We must forge new patterns for church, a task requiring creativity, empathy, and courage—and "a tolerance for pain" (echoing the musical *Hamilton*).[12]

Yet what are these new patterns? The most hopeful sign of the kingdom of God in the West today, in my experience, is Christ's work birthing and renewing worshiping communities that are striving to be a foretaste of the kingdom of God by their shared life of worship and kinship. They are busy loving their neighborhoods, living as a sign to Christ's restoring reign in a particular place. These communities are not seeking political power, wealth, or numbers—they are often smaller in size and less sensational on the surface. But they are seeking to live faithfully for the sake of the world, embracing the humble way of Christ. They support one another in the challenge of living out of the biblical story amid opposing cultural stories. We might call these "incarnational communities." By their slow work of

[12]Lin-Manuel Miranda, *Hamilton: An American Musical* (2015).

faithfulness, hospitality, and prayer they display the beauty of Christ, up close and personal. These churches often don't have slick marketing campaigns, so it's hard to know they exist unless you're within proximity of the community itself!

Sadly, many churches are headed in the opposite direction. I was dialoguing with a friend of mine, using the metaphor of jazz to illustrate Christian community. She reflected that churches are often playing in the wrong time signature. It is all too easy for us to be enthralled by success and polished marketing strategies. We may be tempted to try to recover a glorious "Christian" past. And yet this is like trying to improvise a beautiful solo with a time signature of 26/59—it's set up to fail! So long as we are pursuing these goals our rhythm will be frenetic, and we will be unable to respond to or even hear God's invitation in Scripture toward compassion and kinship.

Kinship—a biblical ethic of kinship—is key for faithful Christian community; we might say it is the musical key in which we improvise church. Kinship concerns who we belong to and who we take responsibility for. There is a movement in Scripture of bringing the weakest among us into the center of the community. However, we will come to this theme in more detail in chapter one.

> *Kinship—a biblical ethic of kinship—is key for faithful Christian community; we might say it is the musical key in which we improvise church.*

Harmony, Rhythm, and Soul

This book unfolds a biblical and practical vision for churches in post-Christian societies that seek to embody the tenderness of Christ in their neighborhood. It offers twelve notes for improvising church, which represent twelve characteristics of incarnational communities, devoting a chapter to each. These notes are divided into three sections: Part I: Harmony; Part II: Rhythm; Part III: Soul.

Part I: Harmony, explores the personality of incarnational communities. In music, harmony (along with melody) provides the color or personality of the music. Harmonies can be voiced differently, producing a variety of textures and tones. The four notes that offer harmony are:

1. The Text *Grants*

2. Leader-Full

3. Local

4. Beauty

Part II: Rhythm, explores four notes that, if played thoughtfully, can bring deep energy into the community, shifting our sense of reality. The element of rhythm in music concerns how a performance relates to the passing of time. A musician can push the time or pull back on the time, changing our sense of space. And for each performance, we decide on what we call a groove or "time feel." These kinds of nuanced rhythmic decisions represent our interpretation of the music. An outstanding musician is set apart by their interpretation of the time—by their rhythm. The four notes in Part II can each be interpreted creatively, shifting our sense of reality and what is possible:

5. Worship in Polyrhythms

6. Shared Life

7. Healing, Kinship, and Maternal Nurture

8. Creation

Part III: Soul, explores the heart of incarnational communities. Emotion, or expression, is a third crucial aspect of music. Expression is not the same as sentimentality, as in the gushiness of the theme to the movie *Titanic* ("Near, far, wherever you are . . ."). I use the term *expression* to describe that deep and discerning feeling that listeners may experience as *light* or *heart*. It is that deep emotion that connects with the stories of people and land, through the unique perception of art. In jazz we call this "soul." This section shines out the light and heart of a community:

9. Voice

10. Conversations

11. Sins of Our Kin

12. Prayer

Of course, these three categories—Harmony, Rhythm, and Soul—are fluid rather than rigid, and evocative rather than descriptive. So, for example, the chapter on worship could just as well belong in Part III: Soul. And yet by

locating worship in Part II: Rhythm, we can get curious about the way worship shifts our reality and sense of what is possible.

On Words

Before we launch in, two key concepts need to be defined. Both defy categorization by a single word or phrase, so we must pause to consider them. The first is what is traditionally referred to as "mission" and the second is a word for the kinds of Christian communities I am describing in this book.

First, *mission*. How do we refer to God's redeeming movement toward humanity and the world, and God's invitation to the church to embody and to share God's love? For centuries the word "mission" has done a lot of this heavy lifting. *Mission* is derivative of the Latin word, *mittere* ("to send") and it captures corresponding actions of the Father toward the Son and the Son to his church: "As the Father has sent me, so I send you" (Jn 20:21).

Some leaders and scholars who are deeply committed to the missional identity of the church nonetheless have argued that we should find alternative phrases and concepts for "mission," given the legacy of colonialism.[13] New Testament scholar Lisa Marie Bowens, for example, has cited Howard Thurman's observation that sharing the good news about Jesus has often been done with a sense of superiority, to the extent of dehumanizing the objects of mission: "For decades we have studied the various peoples of the world and those who live as our neighbors as objects of missionary endeavor and enterprise without being at all willing to treat them either as brothers or as human beings."[14] Today the word "mission" carries the stain of this historical dehumanization. Bowens states: "Thurman's observations back in 1949 are just as important today because he lifts up the fact that for many the notion or idea of mission is antithetical to what it means to be human, for historically mission in many instances tells those to whom it is directed, you are not human (American slave trade)."[15]

[13]For further discussion, see Michael Stroope, *Transcending Mission: The Eclipse of a Modern Tradition* (Downers Grove: IL: IVP Academic, 2017).

[14]Howard Thurman, *Jesus and the Disinherited* (Boston: Beacon, 1976), 13.

[15]Lisa Marie Bowens, "The Paradox of the Missional Theology/Hermeneutic Conversation: Unsalvageable vs. Salvageable—Two Levels," paper delivered at Society of Biblical Literature, Annual Meeting, 2020, The Forum on Missional Hermeneutics. Bowens isn't heckling from the sidelines; rather, she is a key contributor to the discussion around the witness of the church.

I feel the need to respond to this challenge by finding different ways of speaking of the concept referred to as "mission." And I need to be curious about the ways in which this concept has been distorted by colonialism. Yet I don't want to lose sight of the theological discourse around mission in the mid-to-late twentieth century, which is a deep ocean of theological reflection. Indeed, this book wouldn't be possible without the discipline of missiology, which at its best has been at the forefront of intercultural and contextual reflection.[16] So in finding fresh vocabulary, we can no more bypass reflection on missiology than we can extricate ourselves from the colonial story.

It is difficult to find a single word or phrase that does the same work as *mission*. Among the best suggestions I have heard are *liberation, reconciliation, jubilee, healing, walking in a good way* (a First Nations' phrase). While each of these phrases has strengths, it seems impossible to land on a fresh word that will stand the test of time and resonate with all people in all places. In this book I have chosen to use the word *witness* to describe the posture of sharing and embodying God's love. A person who is a witness first experiences something and then communicates what they have seen.

Second, there is the difficult question of how to refer to the kind of Christian community Scripture is calling us to—communities that receive and extend the healing of Christ in a local neighborhood. Various authors have called these churches "intentional communities," "new parishes," "neighborhood churches," "communities of healing," or something else again. In this book I will most often use the phrase *incarnational communities*, because this phrase highlights the embodied dimension of witness to Christ.

> *In this book I have chosen to use the word* witness *to describe the posture of sharing and embodying God's love. A person who is a witness first experiences something and then communicates what they have seen.*

Another acknowledgment is that this book primarily addresses the church in the West. And yet the center of the global church has shifted from the West to the Majority World, to the degree that Western

[16]For example, Lamin Sanneh, *Whose Religion is Christianity? The Gospel Beyond the West* (Grand Rapids, MI: Eerdmans, 2003).

nations only contribute 15 percent of the global church today. The church of the Global South and East supplies most crosscultural missionaries.[17] Indeed, within Western nations themselves, some of the most spiritually vital congregations are immigrant churches and intercultural churches. I welcome ongoing conversation with readers on how the themes in this book are being expressed in non-Western cultures.

Finally, as I narrate my own journey, I want to avoid conflating my narrative with the journeys of the congregations I have served. In this book, the churches in which I have pastored will remain unnamed, to honor these churches' freedom to be whatever God calls them to be in the coming years. Our family no longer worships regularly with the churches you will encounter in this book due to vocational shifts. The practices and ideas laid out here have been developed in partnership with other pastors and lay leaders. In this way, the book belongs to many people, because healthy incarnational churches are *leader-full* (as we shall see in chapter two). I don't write in the posture of an expert but as a fellow sojourner, a traveler who is gathering fellow travelers along the way.

As you dive into this book, you might consider reading alongside another person in your church, or even reading together in a small group. In this way, you will have companionship as you reflect and prayerfully discern God's invitation for your community's improvisational work. And I hope that the biblical exploration in the book will not only "preach" to you but also be "preach-able" for you. Perhaps, if you are a preacher or teacher, some of the exegesis in this book can be used in your own preaching and teaching.

This path of incarnational community is still the road less traveled in the Western church, but it won't stay that way. I am grateful that you are also somewhere on this journey—perhaps some way along, perhaps about to step out. Either way, I pray that this book is a blessing to you as you go.

[17]See Soong-Chan Rah, *The Next Evangelicalism: Freeing the Church from Western Cultural Captivity* (Downers Grove, IL: InterVarsity Press, 2009), 164-70.

Part I

Harmony

MUSICAL MOMENTS SOMETIMES LODGE in our memories, for both listeners and musicians. I will never forget a gig I played in Australia where I was comping (playing behind) a saxophonist. The saxophonist was improvising an abstract melody that didn't fit neatly into any harmonic structure. In the moment, I slammed down a six-note chord using both hands. The chord was constructed of stacked fourths (a fourth interval layered five times over). This chord has an abstract (or ambiguous) harmonic quality that matched the melody of the soloist perfectly. I felt a coherence deep in my gut, as *my* harmony made sense of *his* melody and invited him to say something more. A second after I whacked down the chord, the double bass player, a highly respected musician, yelled, "Yeah!"

Harmony brings out the color and personality of the music; played thoughtfully, it can create tremendous excitement. These first four notes for improvising church have to do with the personality, the characteristic spirit of the community: Scripture, leadership, place, and aesthetic.

The Text *Grants*

THE WORD OF GOD, full of creativity, poetry, and life-as-it-is, shouldn't produce static or predictable churches. Rather, Scripture inspires and even demands improvisation. Of course, there will be a level of predictability in churches. When we worship, the Word and sacraments will take center stage, for example, and we may draw on rich historical traditions. And yet, playing our part in the biblical story is like a jazz performance. Immersed in the biblical tradition, we play fresh improvisations on the tradition that make sense in the context in which God has placed us.

The first, ongoing step is to immerse ourselves in the biblical tradition, getting it into our bones. In this way, Christ-followers are like jazz musicians who immerse themselves in the tradition of jazz. We jazz musicians learn from the masters, those who hold the tradition. We study their playing. When I am listening to jazz, an amazing, improvised line will often catch my ear. I may choose to pause and to learn from this line. I will put the section of music on repeat, studying the line to discover how it works harmonically. Then I practice the line on piano, getting it under my fingers. Next, I practice the line in each of the twelve keys. Finally, I try to improvise in a fresh way, using the rhythmic and melodic "vocabulary" of the line.

Immersion in the biblical tradition takes the same kind of devoted, intelligent, soul work. We get the Bible under our fingers, we become familiar with its characters, structure, intricacies, and paradoxes. We delight, we memorize, we suspend judgment, we rage, maybe we learn the original languages. And we find companions—perhaps new voices or experts who haven't been given their due in the tradition's historical records—to learn

from. When playing jazz, within a few seconds good jazz musicians rec-
ognize whether or not the music is emerging from the tradition. For
example, when a good musician plays with someone who has not spent
time immersed in the jazz tradition, they know almost instantly. It's the
same with Scripture.[1]

The tradition inspires creativity. As we study Scripture, we recognize the
ingenuity of the biblical authors themselves, as they hold out the word of life
within their own diverse contexts (as we will see in this book). The Bible
inspires in us fresh imagination as we re-express the tradition in our par-
ticular place. The rich inventiveness of jazz that requires musicians to step
into the unknown, in trusting interdependence with one another, can in-
spire us to imagine: What fresh and beautiful melodies and rhythms can the
biblical tradition birth in us? How can we rechoreograph the harmony, the
rhythm, and the soul of Scripture in our lives to faithfully display the beauty
and tenderness of Jesus within our neighborhood? Only with this kind of
poetic imagination can we improvise our part in this story as those who are
"sent" for witness (Jn 20:21).

Like jazz musicians, Christ-followers improvise out of the biblical tra-
dition together, in conversation with one another, interdependent with one
another. Maybe one person in your church begins to develop a motif that
seems to be Spirit inspired. This motif may begin to shape the whole per-
formance. In community with one another, we can ensure that we are
always playing out of the tradition, inspiring one another to go deeper into
the tradition.

Consider what the following qualities have in common: nuance, trust,
coherence, conversation, listening, poise, story, subtlety, creativity, gener-
osity, emotion, wariness of sentimentality (but embracing authenticity).
These are all qualities of an excellent jazz performance, and they are also
qualities of a community that is creatively playing its part in the biblical story.
I am convinced that the key to unlocking fresh imagination for the church
is not a new strategy but a rich understanding of the biblical story, alongside
embracing the invitation to improvise on the tradition. I hope that by reading
this book you will discover that there is more than enough imagination,

[1] A part of our work is disentangling cultural traditions from biblical traditions, ensuring that we
are not mistaking one for the other.

creativity, and tenderness in Scripture to last a lifetime. Our first note for improvising church is Scripture, the text that *grants*.

The Text *Grants*

It is helpful to acknowledge that many of us (but not all) have a complex relationship with Scripture. We might wonder, *What shall we do with the apparently violent texts? What about the misogynistic texts in Scripture that rightly trouble so many of us?* Indeed, a troubled relationship with Scripture is one aspect of the pervasive doubt that characterizes the church today. Relationship with Scripture is not the only cause of this pervasive doubt. Religious pluralism, violence within Christian

> *I am convinced that the key to unlocking fresh imagination for the church is not a new strategy but a rich understanding of the biblical story, alongside embracing the invitation to improvise on the tradition.*

history, Christian nationalism, and toxic masculinity all contribute profoundly, among other causes. Yet our relationship with Scripture is almost always a part of the puzzle. How then should we approach the texts in Scripture that may trouble us?

Let me share a story. When I was in my twenties, I was impressed by eighteenth century revivalist preacher Jonathan Edwards's approach to theological perplexities. When Edwards found a biblical or theological issue that had him stumped, he wouldn't rest until he had the issue "solved," and he encouraged others to do the same. This approach suited my young, energetic personality, and I adopted it for some years! And yet the longer I live and the longer I journey with the Bible, the more I realize that I need to sit with difficult texts over time, maybe even a lifetime. As a professional exegete, I have chosen to be patient with texts that sit uneasily with me, to hold them curiously over months and years. Sometimes through unexpected avenues I find fresh insight into a text that has stumped me, maybe while I am studying a different text altogether, or maybe as I am listening to a friend from a culture that is closer to the communal context of Syria-Palestine than my own. In some cases I decide to devote significant time to a particularly difficult text.

The text *grants*: these three words are my adaptation of a beautiful phrase from Rainer Maria Rilke and explain my experience of journeying with a text in trust over time. My experience in these journeys is that, in the end, the text *grants*. By "grants" I mean that texts that seem to be harshly dissonant within the narrative of Scripture may, in time, be seen to make a beautiful and unique contribution to the narrative. Rilke's original phrase reflects on the fecundity of the earth, which gives life and blesses. "The earth grants," Rilke says. "The farmer never reaches down to where the seed turns into summer"—the earth does this work: "The earth grants."[2]

Even as the earth grants, I find that as I persevere with Scripture, *the text grants*. As the Spirit "reaches down to where" we interpret Scripture and Scripture interprets us, the text gives, blesses, invites, amazes, challenges, dignifies, joins, puzzles, shocks, horrifies, resolves, sings, heals, brings life.

The Unity of the Biblical Story

Each chapter in this book will enrich our understanding of the biblical story, and yet it is helpful now to take a deep dive into the biblical story by addressing four key themes. Doing so will give us the big picture as background for studying individual passages in later chapters. This is a bit like practicing scales before learning to solo. My reason for choosing these four particular themes is that, taken together, they help us to read Scripture as a unified story that finds its fulfillment in Jesus. These four themes help us to comprehend the grand narrative of Scripture, the overarching narrative within which each of the parts make sense. Comprehending Scripture's unity won't untangle the knots of every difficult text. But it will assist us, at least, to see their ultimate goal. I find that these four themes emerge as one begins to answer four key questions about Scripture:

1. What is the biblical story? Creation is a unifying element in the biblical story: the world matters to God.

2. What is biblical ethics? A biblical ethic of kinship runs through Scripture.

[2]Rainer Maria Rilke, *Duino Elegies and the Sonnets to Orpheus*, trans. A. Poulin, Jr. (Boston, NY: Houghton Mifflin, 2005), 107.

3. What is the gospel? The gospel announces Jesus' redeeming lordship over all of the creation, as the "mender of all things."

4. What is witness? Witness—in life, word, and deed—isn't merely one task among many, but the very identity of the church.

Christian leaders can spend their whole lives deepening their answers to these four questions. Yet too often in Protestantism, reductionistic answers to the questions have been assumed, and remained uncritiqued. First, the biblical story has been reduced to God saving individuals from hell—and the world is left behind. Second, ethics has lost sight of biblical kinship. Third, the gospel has been limited to penal substitutionary atonement. Fourth, witness has been narrowed exclusively to evangelism and considered as a task rather than as an identity. Little wonder that leaders are left wondering: What is the church *for*? What is the church supposed to *do*? The biblical story has been abstracted and disconnected from the pressing questions of life, community, and culture. I have landed on these four themes, because together they demonstrate the unity of the biblical story, also providing compelling answers as to the identity and purpose of the church.

As we understand the Bible as a unified story, a new and beautiful invitation for Christian life and witness emerges. We unpack these four key themes in turn now.

The World Matters to God

A key and unifying motif in the grand story of Scripture is the creation. This is so often misunderstood that we will give the creation some attention here as a way of enriching our understanding of the biblical story.

In the first two chapters of Scripture, God creates the world with care and delight. You remember from Genesis 1 that seven times God saw that the creation was "good." The seventh time God saw that the creation was *very* good (Gen 1:31)! It's as if Genesis 1–2 stretches an eye-catching banner over the creation that says, "A first class world!" The other side of the banner reads: "This world matters to God!" And God places humanity in the creation as

divine image bearers, as stewards of God's good creation—think of images installed in an ancient temple as representatives of the temple's gods (Gen 2:15).[3]

The first two chapters of the Bible are mirrored by the last two chapters of the Bible, Revelation 21–22. Here the creation is restored, healed. The new Jerusalem, which is a symbol of God's renewing rule, comes to earth, healing the creation (Rev 21:2, 10; 22:2). So the first two chapters of the Bible are about the creation of the world, and the last two chapters of the Bible are about the healing of the world. Creation bookends the Bible! This shows us that the biblical story takes the whole of creation within its gaze. And the gospel of Jesus Christ comes in the *middle* of this story. This hints to us that the gospel must be about nothing less than the healing of the creation itself.

In Genesis 3, as a result of human transgression there is no part of the good creation that is not distorted by the curse of evil. And yet, there is virtually no part of the creation that does not also still display something of creation's original goodness. We might say that as the result of the fall, evil preys parasitically on the good creation, as Al Wolters puts it.[4]

In the middle of the biblical story, Christ's incarnation and resurrection reveal God's commitment to the creation. The point of the resurrection is not that my sins are *definitely* forgiven—I grew up thinking this is what the resurrection meant. And the point of the resurrection is not that you and I will be raised, though that's not wrong. Rather, God raised Jesus from the dead as the first fruit of the whole creation renewed (1 Cor 15:20, 23)![5] With Jesus' resurrection, renewed creation has begun. And *that* should be our call and response on Resurrection Sunday:

Leader: "Christ is risen!"

Congregation: "**Renewed creation has begun!**"

That's why Easter Sunday is the high point of the Christian calendar. In light of the resurrection we look forward to *this* world being renewed: *these* mountains, *these* rivers, *these* cities. We will live in renewed bodies in *this*

[3]See further, Carmen Joy Imes, *Being God's Image: Why Creation Still Matters* (Downers Grove, IL: IVP Academic, 2023), 35.

[4]Albert M. Wolters, *Creation Regained: Biblical Basics for a Reformational Worldview*, 2nd ed. (Grand Rapids, MI: Eerdmans, 2005), 57.

[5]See further, N. T. Wright, *The Resurrection of the Son of God* (Minneapolis: Fortress, 2003), 219.

world, renewed. That is why repeatedly Paul says of Christ's return, "When he comes," "when he comes" (see 2 Thess 1:10; cf. 1 Cor 11:26).[6]

The message that this world matters to God can shape our understanding of discipleship, of worship, of work, of witness and of the gospel itself. I will never forget the day I connected this rich theology of creation with jazz piano. *God listens in when I play piano, and delights in it!* I thought. I realized that God values my music not because I am using it in a homily, and not even because music can be a prayer or a conscious act of praise (though this is wonderful). God values my music simply because God values aesthetics and art making! For God created the world with care and delight, and so we know that the beauty we create brings God joy.

A Biblical Ethic of Kinship Runs Through Scripture

We can't understand the unity of Scripture without discerning the ethical impulse that runs through Scripture, the ethical goal of it all. Yet this is no easy task, for the conception of right and wrong in modern Western culture is vastly different from the communal culture of the ancient Mediterranean world. For example, a modern concept such as human rights, as important as it is, is so embedded in Western individualism that it doesn't get to the heart of the ethics of the Old and New Testaments. Have you ever wondered how the ancients conceived of good and evil, of what we owe to one another? And have you ever wondered what is the unifying ethical impulse that unites the sense of right and wrong in Scripture?

The ancients who wrote the Bible experienced their lives and identities communally, in communal societies. The most pressing questions for the people in the world of the Bible were "To whom do I belong?" and "For whom do I have responsibility?" Practically speaking, a crisis of poverty would have been experienced also as a crisis of kinship. Imagine that you fell into deep poverty in ancient Israel. Certainly, you would have been aware of a scarcity of food and a lack of means to plant the next crop. And yet you would have also been acutely aware that your plight was the result of an absence of strong kin ties. For an impoverished person lacked kinsfolk who could offer subsistence.

[6]On the restoration of this world, see Mt 5:5; Rom 8:22; Rev 21.

Think of the gleaning laws in the book of Deuteronomy, for example. The command to leave the gleanings of the field, vineyard, and olives for vulnerable people (Deut 24:19-22) could, in modern contexts, be interpreted as mere charity. However, in the communal context of the Bible, God's command to leave the gleanings signified that God's people were to treat the stranger and the fatherless as kin. In other words, Israel was to extend to vulnerable people the kind of protection and sustenance that befits kinsfolk.

Such kinship responsibility appears at the very start of the story of the Bible, with the sons of Adam and Eve. After Cain kills Abel, he responds to God by asking whether he is his brother's keeper. This prompts God's rebuke: "Your brother's blood is crying out to me from the ground" (Gen 4:10). Cain has failed in his responsibility toward his kinsfolk, and the very earth cries out in protest. According to Genesis, kinship responsibility isn't limited to brothers from the same immediate family such as Cain and Abel. For Genesis portrays humanity as one giant family, descended from common parents (Gen 10). Humanity's common descent that unifies all people as family is called the "one blood doctrine" in Black theology. The one blood doctrine was a key theological pillar for antislavery activism.[7]

Coming to the New Testament, consider Paul's letter to Philemon, which Paul wrote while in chains in Rome.[8] Onesimus, Philemon's slave, had escaped and fled from Colossae to Rome. In Rome, Paul introduced Onesimus to Christ. And now Paul is sending Onesimus back to Philemon, carrying the letter that we know as Philemon. Paul appeals to Philemon that, far from punishing Onesimus, he should no longer even consider Onesimus a slave, but a brother, "a beloved brother . . . both in the flesh and in the Lord" (Philem 16).

In the punitive and hierarchical culture of the empire, Paul's request to Philemon insists on a totally different category for human relations, that of family. People, even slaves, are no longer to be viewed in terms of what they deserve or their given lot in life but as a beloved sister or brother in Christ. We will see that Scripture is reshaping God's people as family, a family

[7]Lisa M. Bowens, *African American Readings of Paul: Reception, Resistance, and Transformation* (Grand Rapids, MI: Eerdmans, 2020), 28.

[8]See also, Mark R. Glanville, "A Biblical Ethic of Kinship for People On the Move," *International Journal for Religious Freedom* 15 (2022): 9-23, at 21.

characterized by tenderness.[9] Following the example of our God, who has adopted us, we enfold one another as family, offering belonging, solidarity, and protection (Deut 10:15, 18-19). We bring the weakest among us into the center. And biblical kinship extends beyond the church to enfold the most vulnerable in our neighborhoods (Lk 15:1-2).

The Gospel Announces Jesus as Lord, the Mender of All Things

As we come to address the question "What is the gospel?" the word *gospel* itself can be confusing. The word may bring to mind a "gospel presentation," a ready-at-hand explanation designed to lead people to Christ. But it is clarifying to put these presuppositions aside and instead to see how the word *gospel* is used in the New Testament itself.

Our discussion so far has hinted at the nature of the gospel. Because the biblical story starts and ends with the creation, the gospel, which comes in the middle of the story, must concern the creation. This is a good start. Now let's see how the word *gospel* is used in the Gospel accounts. The word *gospel* is used three times in Mark 1:1-2, 14-15 (emphasis mine):

> The beginning of the good news [gospel] of Jesus Christ, the Son of God. As it is written in the prophet Isaiah . . . [Mark then cites a mosaic of Old Testament texts] Now after John was arrested, Jesus came to Galilee, proclaiming the good news [gospel] of God, and saying, "The time is fulfilled, and the kingdom of God has come near; repent and believe in the good news [gospel]."

Here are five things we learn about the gospel from these verses:

1. The gospel concerns the life, death, and resurrection of Jesus (verse 1);
2. The gospel is the fulfillment of world history long anticipated by the prophets. That is to say, the gospel is eschatological (verses 2 and 15);
3. As the long-anticipated fulfillment of the Old Testament story ("the time is fulfilled"), the gospel is redemptive. The gospel redeems

[9]Kinship in the ancient world looked very different from the modern nuclear family, as we shall see in chapters five and six.

everything that the Old Testament concerns itself with, including human community, justice, politics, God's presence with humanity, and so much more (verses 2 and 15);[10]

4. In Christ, God's restoring reign is at last present in power (the "kingdom of God," verse 15);

5. The gospel calls for a response, and a faithful remnant is gathered (verse 15).

We might summarize the gospel in this way: now at last, in Christ's life, death, and resurrection, God is establishing God's healing reign, for the sake of the whole world and for humanity within it.[11]

A further lens for understanding what the first Christians meant by the word *gospel* is the imperial context. In 9 BCE the Provincial Assembly of Asia proclaimed Augustus's birth as the beginning of the "gospel" or "good news" and reset the calendar accordingly (cf. Mk 1:1).[12] With the battle of Actium in 31 BCE, Caesar Augustus had ended a decade-long civil war. New Testament scholar Richard Horsley writes: "Starting almost immediately, and continuing into subsequent generations, there was an outpouring of gratitude and goodwill toward Augustus himself as well as Rome for bringing the peace for which people had yearned so long."[13] Augustus was repeatedly heralded as the "Savior of the whole human race."[14]

> *We might summarize the gospel in this way: now at last, in Christ's life, death, and resurrection, God is establishing God's healing reign, for the sake of the whole world and for humanity within it.*

Luke's narrative of the shepherds who visit the newborn Jesus picks up this imperial vocabulary and transforms it (Lk 2:1-21). Luke presents

[10]Consider the range of concerns that the Old Testament addresses, ranging from constraining royal power to welcoming refugees (e.g., Deut 15:14-20; 10:18-19).

[11]The apostle Paul has the same narrative dynamic in mind when he uses the word *gospel* (Rom 1:1; 1 Cor 15:1-5; 2 Tim 2:8).

[12]"The birthday of the god [Augustus] has been for the whole world the beginning of good news [gospel, *euangelion*] concerning him." *Orientis Graeci Inscriptiones Selectae* 2, no. 458 (1905), cited in Richard A. Horsley, *The Liberation of Christmas* (New York: Continuum, 1993), 27.

[13]Horsley, *Liberation of Christmas*, 26.

[14]Horsley, *Liberation of Christmas*, 27.

Jesus as the "Savior" who brings "peace," placing him in direct opposition to Caesar's rule.[15] Yet Luke does not present Jesus merely as a spiritual ruler who replaces an earthly ruler (Augustus), as if the world doesn't really matter because we are all going to heaven anyway. Rather, Jesus' reign challenges Augustus's barbaric and idolatrous reign in every dimension (Lk 1:46-55): "He has filled the hungry with good things and sent the rich away empty" (Lk 1:53). For Luke, the gospel is God's establishing a liberating, worldwide kingship in the face of the brutal reign of Caesar.

I sometimes refer to the gospel as an announcement of Jesus as the "mender of all things."[16] Mending clothes is a craft that requires costly attention to detail. Mending speaks of kinship, of loving repair on behalf of those we love. While Jesus' kingship and power are certainly prominent in the Gospels, so is his humility (think of the feeding trough in which he was placed at his birth; see also Mt 11:29) and familial welcome.

Improvising Witness is the Very Identity of the Church

Witness is the fourth theme that discloses the unity of the biblical story. Witness is not just one task among the many tasks of the church; witness is the very identity of the church. And our witness is to be improvised, played with creativity and soul, like jazz music.

Human witness to God's redemption did not begin with the church but with God, who called ancient Israel to be a light to the nations. Israel's life was supposed to be contrastive and compelling so that other nations would notice and be attracted to the wisdom and justice of Israel's God. To this end Moses said to Israel:

> You must observe [these statutes] diligently, for this will show your wisdom and discernment to the peoples, who, when they hear all these statutes, will say, "Surely this great nation is a wise and discerning people!" For what other great nation has a god so near to it as the LORD our God is whenever we call to him? And what other great nation has statutes and

[15]Horsley, *Liberation of Christmas*, 33.

[16]Tom Wuest, *Mender of All Things*, copyright 2016; used with permission. I have borrowed the phrase "mender of all things" from my favorite bard, Tom Wuest.

ordinances as just as this entire law that I am setting before you today?
(Deut 4:6-8)

By their beautiful life, ancient Israel was supposed to be magnetic, and
the nations would come to Yahweh their God. Yet, tragically, as the Old
Testament unfolds, Israel failed to be the contrasting community that God
had called them to be.

Coming to the New Testament with Christ's resurrection, witness has a
new, Spirit-empowered edge. Acts 1 is a turning point in the history of re-
demption. As we interpret Acts 1, it is helpful to think of the role of cultural
symbols or signs. For example, for Aussies, symbols such as koala bears and
Vegemite (a black, almost inedible substance that we spread on bread) con-
tribute to our shared identity as Australians. Similarly in Acts 1, three
striking Jewish symbols are telling the disciples that this is the moment
when Israel (and all of creation along with it) will be restored. The disciples
are gathered in Jerusalem (sign one), there is a resurrection (sign two), and
Jesus has promised his Spirit (sign three). All three are signs of the great
Day of the Lord the prophets had spoken about. So it makes perfect sense
that the disciples would ask the resurrected Jesus: "Lord, is this the time
when you will restore the kingdom to Israel?" (Acts 1:6). This is not a silly
question; it is exactly what an observant Jew should have thought. Jesus'
answer is a watershed:

> "It is not for you to know the times or periods that the Father has set by his
> own authority. But you will receive power when the Holy Spirit has come
> upon you; and you will be my witnesses in Jerusalem, in all Judea and Samaria,
> and to the ends of the earth." (Acts 1:7-8)

What is the new insight? Jesus is saying that this is, indeed, the great Day
of the Lord predicted by the prophets. And yet, the end has been pushed
back for a particular purpose, for a time of witness. The purpose of this time
in world history is for God's people to witness to Christ as we await his
return. And this witness is for the sake of all peoples to the ends of the earth.

Jesus is not so much giving the church the job of witnessing, as one
task among many that the church has to do. Rather, witness is the very
reason that the end has been pushed back, the reason why the Spirit has
been given. It is our very identity as Christ-followers to be people of

witness.[17] To illustrate, imagine that there is a meeting-room in your church, the place where the leaders of the various ministries in your church meet for important conversations. Each of the ministries in your church is represented by a chair placed around a meeting-room table. There is a chair for children's ministry, a chair for preaching, and so on. The point of Acts 1 is that there isn't a chair for witness. Rather, witness is the table itself. Everything we do and everything we are are meant to serve the purpose of witness.

And what is the nature of witness? The breadth of the gospel, which is as wide as the creation, compels us to witness to Christ in life, word, and deed. We are to *be* the witness, *do* the witness, and *say* the witness, as Darrell Guder put it.[18] The church is a community caught up in God's reconciling purpose for all the creation, a people living by the Spirit as a sign, an instrument, and a foretaste of Christ's restoring reign.[19]

And our witness is improvised, performed with soul like a saxophonist's solo. This is implicit in the way the book of Acts ends. In Acts 28, Paul is under house arrest in Rome, proclaiming the kingdom of God at that time. There is a certain finality to the rejection of the gospel by the Jews in Rome. And so Paul declares: "This salvation of God has been sent to the Gentiles; they will listen" (Acts 28:28). Acts doesn't tie a neat bow on the story, it stirs anticipation! Such an open-ended conclusion begs for another twenty-eight chapters—chapters left unwritten, at least on papyrus. The next chapters of Acts are for the *ekklēsia* (church) to write, both then and today. And lest you be tempted to write a dull and unremarkable sequel to Acts, recall the adventure of Acts 27 and 28, which include Paul's lethal snake bite, a shipwreck, and a magnificent eucharistic gesture embracing all who are on the boat with Paul. Let's just say that Acts 29 through 56 had better be more than coffee and biscuits (cookies) after the morning service.

[17]Michael Goheen makes this point powerfully in *A Light to the Nations: The Missional Church and the Biblical Story* (Grand Rapids, MI: Baker, 2011), 128.

[18]Darrell L. Guder, *Be My Witnesses: The Church's Mission, Message, and Messengers* (Grand Rapids, MI: Eerdmans, 1985), 91.

[19]*Sign, instrument,* and *foretaste* are Lesslie Newbigin's characteristic images of the church, first articulated in Lesslie Newbigin, *The Household of God: Lectures on the Nature of the Church* (London: SCM Press, 1953), 166.

Bringing Acts 28:28 together with Acts 1, we realize that the risk-taking creativity that the book's final scene requires is inspired and energized by the Holy Spirit, who opens the book (Acts 1:7-8). The Holy Spirit, God's personal agency in the world, is an improviser of unparalleled genius. Acts 27–28, and indeed the whole book, displays the creative virtuosity of the Spirit, through Christ's followers. It is as if the whole meaning of this time in history is for our jazz ensemble to follow the Spirit's lead, in a solo of shifting tonalities that is so beautiful that to hear it (let alone to "sit in") will leave you changed forever.

Let's sum up. In a ten second version, we can summarize the biblical story like this: This is my Father's world! Broken and corrupted by evil it may be, but it still belongs to God. In Christ, God is healing humanity and the whole world from sin's curse. And God is nourishing a people to live as a tender sign to God's restoring love.

Immersing in the Tradition

I hope that these four themes into Scripture remind you of the harmonic depth of Scripture. Scripture is more like a six-note chord of layered fourths[20] than the predictable Alberti-bass pattern that accompanied melodies during the classical period.[21] The layered fourths voicing creates a rich and open harmonic texture that can inspire soaring improvised lines. The layered fourths that I whammed down behind the saxophonist open up more imagination and space for his solo, not less. So it is with Scripture.

Certainly, holding out the word of life in post-Christian contexts today poses fresh challenges. As we have said, many of our people (and perhaps we ourselves) have complex relationships with Scripture. We wonder: *How can we display the beauty of Christ and the wisdom of Scripture to our people?* Be encouraged that we can, in time, grow an intuitive awareness of the diversity of relationships that our people have with Scripture. And we can learn to hold out the word of life responsively; we can even learn to display the beauty of Scripture in contexts where this seems

[20]Listen, for example, to pianist McCoy Tyner's chording on John Coltrane's *A Love Supreme* (Impulse! Records, 1965), at 1:00, www.youtube.com/watch?v=ll3CMgiUPuU.

[21]Listen, for example, to the left-hand piano accompaniment in the opening bars of Mozart's piano Sonata K 545, www.youtube.com/watch?v=kUnYGUwatpo.

highly implausible. Perhaps the most alluring aspect of Scripture is its capacity to shape communities of tenderness, especially in its relentless call to biblical kinship, to bringing the weakest among us into the center of the community. This vision is found throughout Scripture and fulfilled in Jesus himself. I hope that the appendix, "Preaching that Nourishes Incarnational Communities," is helpful to those who preach and teach.

The purpose of this chapter has been to discern the deep harmonic structure within Scripture, which we have likened to a thick, six-note chord of layered fourths that opens space for creativity and creates energy. We have focused on the unity of the biblical story, by unpacking themes of creation, an ethic of kinship, the gospel, and witness. We have taken in the big picture to supply context for the investigation of Scripture that lies before us. Our end goal is to compose and perform new melodies on the tradition, as Christian communities, even as we continually return to Scripture for fresh orientation and inspiration.

In the next chapter we are going to dive into practicalities. The personality of a church will be deeply influenced by its approach to leadership and participation; we will explore skills and biblical resources necessary to nourish leader-full communities.

Leader-Full

THREE YEARS INTO MY PASTORAL ROLE in Vancouver, I hit a crisis point. The leadership conducted a three-year review, which involved surveying members of the congregation on how they perceived my ministry. The review was conducted with love and grace, and while the report on my ministry wasn't damning, it wasn't glowing either. As I read the review, I realized that some congregants were ho-hum about my ministry. And the anonymity of the comments made the review feel impersonal and overwhelming. Initially, I was angry: "Why did we leave our previous church and come here?" I said to Erin. The report made it clear that while my warm, high-spirited personality had been an asset in my previous church, it wasn't working the same way in East Van. It was difficult not to take this personally. At the same time, Erin received her results from the review, which *were* glowing.

In the following days I pondered my discouraging review, and Erin helped to untangle the knots. While leadership problems are always multilayered, the nub of the problem was a cultural gap between me and the community. "You are a warm, friendly Aussie," Erin explained to me fondly. "You are six foot three, and if you're not careful, you can take up a lot of space." Erin walked me through the cultural disconnect step by step, explaining that while Australians tend to be outgoing, boisterous, and quick to talk, Canadians value politeness, which looks like waiting for others to talk and asking questions instead of speaking directly. And East Van, with its artistic vibe and justice sensitivities, is particularly wary of tall White men up in front. What's more, I had come from an evangelical culture where strong, exhortatory preaching was not only acceptable, it was desired. My inherited preaching style was grating for some in my congregation.

Through the wrestling I eventually settled on a new image for my ministry. I pictured myself as a monk wearing a hooded habit, sitting quietly on the pew at the back of the sanctuary, ready to pray with people. And for a time, this is exactly what I did: after each service I simply sat on the back pew, ready to pray. And when I came to preach, I sat down on a stool instead of standing, lowered my voice and energy, and limited my gestures. I simply *offered* the sermon, staying close to my written text (rather than eyeballing the congregation or speaking strongly). I made these changes immediately, and people responded warmly. They appreciated my quieter, more sensitive posture. When I preached in this way, people had the space they needed to receive the homily, to reflect on it prayerfully, and to explore the Scriptures for themselves as I preached. I sensed a bond of trust forming between me as a preacher and our congregation of artists and justice-seekers.

This painful period of learning touches on the broader dynamics that are significant for all Christian communities in post-Christendom. These dynamics are far broader than preaching style. Twenty years ago, alpha leaders (especially male alpha leaders) were admired and sought after. Yet today, with the declining authority of the pastor both in church and society, alpha qualities have become less important, and relational skills have become much more important. The high value placed on dialogue and collaboration in society today calls for a relational and communal approach to leadership. Leaders need emotional intelligence and the skills necessary for working through conflict. Communities that gather around an alpha leader rarely harness the creativity, imagination, skills, and spiritual gifts of the whole congregation. In post-Christian societies we need what I have come to call *leader-full* communities, those that bring forth the ingenuity of every person, as together we love our neighborhood to life.

Being leader-full entails high participation in the life and work of the church. It is commonly recognized that in most churches, 20 percent of a congregation does the work, while 80 percent of a congregation warms the pews. By the grace of God and the dedication of many people, our churches in Sydney and Vancouver flipped the 20-80 ratio: 80 percent of the congregation were highly mobilized in the life of the church and the community.

And yet being leader-full means much more than high volunteer engagement. For it is not uncommon for churches to manage volunteers as if they are a hive of worker bees, busily fulfilling tasks given to them by church staff. Being leader-full is different. When 80 percent of the congregation rolls up their sleeves, there can be an expectation that we will make decisions together (at least to some degree) and that there will be space for new ideas and new voices. There can be an expectation that people's opinions will be heard and that relationships will be valued, even in times of conflict. This, in turn, allows for new initiatives, different ways of being in the church, and differing views on secondary issues. This work of dynamic co-creation is no easier to do as a Christian leader than in jazz. This is why this chapter is important: we need a pathway for nourishing leader-full communities.

Incarnational communities are leader-full in the sense that they are full of members who are empowered to use their gifts and creativity within the community and neighborhood. Being leader-full is necessity because spiritual vitality and neighborhood engagement require the ingenuity and energy of many people. In post-Christendom contexts, key leaders need to nurture leader-full communities, placing a high value on relationships and mutuality.

In a flourishing community, the members of Christ's body hold the various aspects of kingdom work for one another. Each person and household may have a natural interest in two or three matters pressing on the community, such as prayer, creation care, studying Scripture, welcoming refugees, or creative housing arrangements. (One person or household can't attend deeply to *every* aspect of discipleship.) When communities are dynamic in this way, pastors quickly recognize that they need not be expert on everything. So pastors become encouragers, learners, coaches, co-creators, and guides.

When a community is leader-full, discipleship takes place naturally as we serve one another and our neighbors. We don't so much program for discipleship as experience discipleship taking place in our shared life, joining in practices of prayer, Scripture reading, making, protesting, living in solidarity with street-adjacent people,[1] and so on.

[1]"Street-adjacent people" refers to those who have spent time living on the street or are at a high risk of doing so.

Jazz performance exemplifies a leader-full community. A jazz performance entails elegant balance between the soloist and the group; leadership is constantly shifting as musicians each take turns to solo. Performers must maintain an open heart to what the other musicians are offering at any moment, and in an ever-evolving performance, agree on the direction of the music together. A jazz masterpiece emerges from mutual submission in the context of dynamic co-creation.

> *When a community is leader-full, discipleship takes place naturally as we serve one another and our neighbors.*

As the pianist in my jazz trio, I naturally take the lead. And yet I need to be extraordinarily sensitive to what the double bass player and drummer are "saying" through their instruments, listening with carefully attuned ears. When the bass player or the drummer take a solo, they lead. As they do, my role as pianist is to responsively create a sparse rhythmic and harmonic landscape over which they can solo. Listening with my whole body, I support the soloist, responding to their new ideas, sensitively offering up a new idea here and there for them to consider.

The Leadership Conversation

The conversation around church leadership has rightly moved from leader-centered approaches toward collaborative leadership, at least in Western contexts. I suggest that the challenge before us is to lean deeply into collaborative approaches, while also taking a step further toward nourishing leader-full communities.

Twenty years ago, when I was at seminary, leader-centered approaches were the norm. These models had the effect of centering the capacity, magnetism, skills, and vision of a key leader. They tended to emphasize vision crafting, goal setting, leader selection, promotions, and budgets, alongside personal qualities such as character and prayer.[2] There is certainly much wisdom to be mined in the leader-centered literature, and yet there are also profound weaknesses to this approach. For one, the success of this model is due to a palpable and enduring cultural desire for strong male leaders. Noted

[2]One such example is Bill Hybels, *Courageous Leadership* (Grand Rapids, MI: Zondervan, 2002), 199.

philosopher Zygmunt Bauman writes of the allure of the "strongman" in America, a leader who will make America safe again.[3]

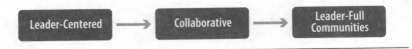

Figure 2. Movements in the leadership conversation

Strongmen also have an allure in the church, having magnetic pull at the point where entrepreneurial energy, patriarchy, and tradition converge. Leader-centered churches may yet become success stories today; however, these churches are unlikely to be the leader-full communities that post-Christendom neighborhoods ache for. And, even more problematic, the idolatry of the big man seems to routinely foster ill health in the big men themselves, who all too often descend into pastoral moral failure.[4]

Juana Bordas is representative of more recent collaborative and communal approaches to leadership. In *Salsa, Soul, and Spirit: Leadership for a Multicultural Age*, Bordas turns to Latino/a, Black American, and First Nations models of leadership. She highlights qualities and practices for leaders based on communal identity, such as equality, justice seeking, neighborhood development, collective identity, honesty about our colonial stories, courtesy, and generosity.

Bordas observes that the "inclusive, relationship-based, and activist leadership of communities of color" suits the preferred leadership style of Millennials.[5] Collectivist cultures (as opposed to individualistic cultures) tend to prefer "community-conferred leadership." Her insights are worth quoting at length:

> In collectivist cultures, where a leader's authority comes from the group, leaders are expected to listen, integrate the collective wisdom, and reflect the

[3]Zygmunt Bauman, *Strangers at Our Door* (Cambridge: Polity, 2016), 27-37.

[4]Of course, there is great variation in these leader-centered approaches. Jim Collins's book, *Good to Great*, was seminal in a wave of publications that emphasized humility and vulnerability in a leader. While these approaches offered key insights, they nonetheless tended to center on the qualities of an individual, outstanding leader (Jim Collins, *Good to Great: Why Some Companies Make the Leap and Others Don't* [New York: Harper Business, 2001]).

[5]Juana Bordas, *Salsa, Soul, and Spirit: Leadership for a Multicultural Age*, 2nd ed. (Oakland: Berrett-Koehler, 2012), X. The term "Millennials" (or Gen-Y) refers to the generation born in the early 1980s through to the mid-1990s.

group's behavior and values. Leaders charge people up, facilitate their working together, and help them solve problems. As they empower others, a community of leaders evolves.[6]

"A community of leaders evolves"—that's just what we are seeking! A community in which each person feels empowered to bring their gifts and insights to the performance.

Bordas's reflection brings us to the focus of this chapter, one that is related to the emerging emphasis on collaborative leadership, but is also slightly different. We are intent on *nourishing leader-full communities* with a high value on relationship. I offer that our goal is Christian communities where just about every person feels empowered to bring their creativity, energy, and heart to serve the community and its vision. So our key question is: What nourishes leader-full communities? The rest of this chapter explores what theology, mindset, posture, and skills are needed to support and grow a community full of leaders.

"End of the Fathers"

In Scripture we see a rejection of authoritarian leadership accompanied by an affirmation of the gifts and responsibilities of every person in the community. Jesus taught that his own example of servant leadership should be exemplified in the community that followed him. This led Jesus to insist on a way of being together that Gerhard Lohfink has referred to as the "end of the fathers."[7] In the highly stratified social hierarchy of the Greco-Roman world, fathers were dominant, with absolute authority over those in their household. Yet when Jesus recognized "those who do the will of God" as his own family, he named brothers, sisters, and mothers, but not fathers (Mk 3:35). Jesus was signaling that the "patriarchal domination" of the surrounding culture was to have no part in his community of followers.[8] Similarly, in his seminal teaching on leadership in Matthew 23:8-11, Jesus commands his followers:

> But you are not to be called rabbi, for you have one teacher, and you are all students. And call no one your father on earth, for you have one

[6]Bordas, *Salsa, Soul, and Spirit*, 85-86.
[7]Gerhard Lohfink, *Jesus and Community: The Social Dimensions of Christian Faith*, trans. John P. Galvin (Philadelphia: Fortress, 1982), 44-50.
[8]Lohfink, *Jesus and Community*, 45.

Father—the one in heaven . . . The greatest among you will be your servant. (Mt 23:8-11)

Noted scholar of the Synoptic Gospels Richard Bauckham writes: "The patriarchal status, with its distinctive authority, is reserved for God. Instead of the fatherhood of God being the paradigm of patriarchal privilege, it excludes it."[9]

The "end of the fathers" isn't so much innovation on the part of Jesus' followers, but of Jesus calling his followers to embody what ancient Israel was always supposed to embody. Deuteronomy's law of the king is perhaps the clearest and most striking example of the Old Testament's relatively egalitarian framework for leadership.[10] Among ancient Israel's neighbors, the king had final authority in every domain of society, for kingship was thought to have been appointed by the gods. Some rulers even deified themselves.[11] Yet according to Deuteronomy, the king was to be merely a "brother" among "brother-sisters," one who does not think of himself more highly than his fellow Israelites (Deut 17:20). The king may not accumulate wealth or amass a powerful army (Deut 17:16-17). Amid the many prohibitions laid on the king, there is one thing that the king must do: he is to write for himself a copy of the Torah and read it daily (Deut 17:18-19). An expert on Deuteronomy, Bernard Levinson, captures the irony entailed in Deuteronomy's description of the so-called king: "There remains for the king but a single positive duty: while sitting demurely on his throne to 'read each day of his life' from the very Torah scroll that delimits his powers."[12]

Yet Deuteronomy's vision for governance extends beyond diminishing the role of king.[13] Ultimately Deuteronomy vests responsibility and dignity not in honored office holders but in the whole people of God. In a dramatic shift from the pattern of ancient Near Eastern texts, the book of Deuteronomy

[9]Richard Bauckham, *Jesus: A Very Short Introduction* (Oxford: Oxford University Press, 2011), 76.

[10]The law of the king is a standard by which the narrative of the books of Samuel and Kings determines the faithfulness of Israel's kings.

[11]See John H. Walton, *Ancient Near Eastern Thought and the Old Testament* (Grand Rapids, MI: Baker Academic, 2006), 278-79.

[12]Bernard M. Levinson, *Deuteronomy and the Hermeneutics of Legal Innovation* (Oxford: Oxford University Press, 1997), 141-42.

[13]Deuteronomy diffuses power across diverse institutions in society—the central sanctuary, judiciary, priests, prophets—ultimately putting every institution under the authority of Torah (see Deut 16:18–18:22).

addresses the whole people of God, using what is known as the "singular address"—"you" (singular)—addressing both the whole people as an entity, and also every individual in the community.[14]

By placing responsibility both with the community in its unity and also with each person (conceived within their respective clan groupings), Deuteronomy projects a vision for a community in which every person and clan has a role to play.[15] Biblical communities were envisioned as leader-full communities.

In sum, Scripture does not present a prescriptive pattern for leadership structures or leadership processes, but it does offer a prescriptive posture. These corresponding movements in the New Testament and Old Testament prompt us to discern leadership practices that value and empower every person in the community in a way that is suitable to our cultural context.

To return to the metaphor of improvisation, the ingenuity of the biblical authors around leadership (and the contextualized nature of these texts) shows us that our task today is not to replicate the leadership strategies of these biblical authors but to improvise fresh melodies on the tradition.

Shifts in Corporate Leadership

If we are discerning a shift in the competencies required of church leadership, the competencies required of leaders in the corporate world are shifting too. Marv Franz, Principal Consultant of New Vantage (a leadership consulting firm), explained to me that during the Covid-19 pandemic there was a subtle but noticeable shift toward recognition of the need to excel at the relational, nuanced side of leadership in the business world.[16] The detached mentality of hustle culture, an individualistic culture where employees work harder to impress their boss, may have been the norm in the past. Now, however, good managers need softer relational skills.

Franz explains that in the corporate world a leader does not necessarily have the power of a reporting relationship, for lines of responsibility and authority are often highly matrixed; that is, leaders often move across a web

[14]J. G. McConville, "Singular Address in Deuteronomic Law and the Politics of Legal Administration," *Journal for the Study of the Old Testament* 97 (2002): 26-29.

[15]In contradistinction, ancient Near Eastern texts generally spoke only of the king and the gods, leaving the general population out of view altogether.

[16]Marv Franz, in a personal communication on April 6, 2023.

of relationships rather than operating within linear lines of authority. Successful leaders learn to bring people together and create settings where people listen well to one another. In these complex relational environments, leadership competencies such as co-creating, bridge building (forming alliances), sponsoring new initiatives, coaching (asking powerful questions), course corrections, and evaluation are vital.[17]

New Vantage lists two leadership outcomes focused on empowering teams and trust, with relevance for church communities. They are:

Shift mindsets away from controlling, top-down decision-making and toward empowered decision-making among autonomous teams so that the best decisions are made for the customer.

Leverage existing trusted relationships and goodwill to expand and broaden trust networks among teams and functions to accelerate collaboration among teams.[18]

These outcomes suggest that the teams who are busy doing the work are the best people to make decisions concerning their work. These teams are close to the action, they know the people they seek to serve, and they feel the nuanced impacts of company decisions on their clientele. Effective leaders learn to trust their people, empowering teams while providing the necessary training and support. Key leaders nurture cultures of trust, continually discerning where trust is diminishing and looking out for opportunities for enhancing relationships and collaboration.

If we seek collaborative, relational competencies as church leaders, we don't do so because we want to be on the leading edge of the corporate leadership discussion—not at all. Rather, if we seek these skills it is because Scripture calls us to a posture that values and empowers every person in the community.

As you can imagine, even corporations that are awakened to the importance of collaborative leadership tend to get stuck in old patterns of doing things. Doesn't this sound a bit like the church? As with the corporate world, oftentimes pastors, lay leaders, and church boards lack skills in collaboration, empowering, dialogue, bridge building, and trust building. Simply

[17]Marv Franz, in a personal communication on April 6, 2023.
[18]These points are from unpublished New Vantage training material; used with permission.

put, church leaders often lack even the desire and will to give up power and release others for ministry. This is a key reason why so many churches feel sluggish and unexciting and why the ingenuity and passion of so many lay Christians remain deeply underutilized. Too many churches never shift out of first gear.

I will never forget the evening I skipped a planning meeting for our combined churches' men's retreat. I had a vision for a men's retreat that empowered men to disciple one another, and a key strategy was to have lay leaders in the up-front roles. I also invited four or five other churches to partner with us, explaining to my pastoral colleagues that we would stay away from the microphone. Yet I must admit that in the planning phase for the retreat, I was still firmly holding the reins.

On the evening of a planning meeting that I had called, I needed to stay home and tend to a family matter. But my absence was explosive in the very best way: the creativity of the leadership team blossomed, and the lay leaders became energized as they made important decisions for the retreat. As my friends reported back to me with excitement, I realized that I needed to step back and loosen the reins. And yet in doing so I wasn't completely released from responsibility. During the retreat itself I was busy behind the scenes, coaching the leaders, praying with them, and ironing out some logistics. Yet skipping that meeting was the best thing I could have done. Since that night, I have deliberately skipped a good hundred meetings—also following up with coaching and accompanying. The result? Energized teams.

Posture

The leader-full posture begins with the conviction that leadership is not a title but a function. A Christian leader is someone who shapes the community in Christ's way just by hanging around. In other words, leadership is more about influence than a formal role. We are the "aroma of Christ" (2 Cor 2:14-16), as the apostle Paul said. You know someone is a leader when you realize that if they weren't here, the community would be impoverished and we would see Christ a little more dimly.

Fundamentally, the primary function of Christian leaders is to nourish faith and create a sanctuary. Whether in corporate worship on the Lord's Day, in a home group, over coffee, or digging in the garden together, we are

creating spaces where people can encounter Christ. By design and by our very presence we invite people to gather in Christ's presence, learning to grieve what Christ grieves, and to celebrate what Christ celebrates.

Moreover, we don't nourish faith in the abstract but from within a deep and tender knowledge of our people. This requires an investment of time. Leader-full communities tend to require a high-touch pastoral presence, where key leaders care for people in their griefs, journey with people in their doubts, and know and value people's gifts.

Yet key leaders don't have to be shy. Using the metaphor of jazz, a leader doesn't have to be coy about playing a solo from time to time. Juana Bordas holds the tension nicely: "In the Black community, although uniqueness and personal style are celebrated, self-expression is a way to enhance collectivism—unlike the usual American individualism that separates one from the group. It's analogous to a jazz group playing different interpretations—each musician has to be in harmony with and contribute to the music of the group."[19]

> *We don't nourish faith in the abstract but from within a deep and tender knowledge of our people.*

At the same time, nuanced leadership that places a high value on relationship requires us to learn from emerging practices for understanding interpersonal relationships and collaboration. These include facilitation skills (discussed further in chapter ten), skills for working with conflict,[20] strategies for building trust, and more.

As we take a leader-full posture, and as people take ownership of the church's vision, we hope and pray that many new ideas will sprout, from the grassroots. Many of the new initiatives that your church adopts should, ideally, come from there. Yet what do we do with these new shoots? Pastors will often ask me: "What do I do when someone comes to me with a new idea?" When eager beavers share their dreams, a key leader has an important role. On the one hand, we learn to say "yes" to the right ideas. We fan into flame the good ideas by offering coaching, providing resources, and shepherding plans through church decision-making processes. On the other

[19]Bordas, *Salsa, Soul, and Spirit*, 90.
[20]See, for example, Betty Pries, *The Space Between Us: Conversations About Transforming Conflict* (Harrisburg, VA: Herald, 2021).

hand, I find that the wrong ideas, the dreams that are not for this time, usually die a natural death. I usually don't have to say "no" to the wrong ideas, because the energy around them tends to dissipate naturally.

As we reflect on a key leader's posture, be assured that there is no *one* personality style or skill set for effective pastoring (whether paid or lay pastoring) in post-Christendom. On the contrary, a variety of pastoral personalities is a blessing to the church. Some examples of pastoral personalities I have noticed are: a) the priestly presence (prayerful contemplative), b) the entrepreneur (offering vision and catalyzing new ventures), c) the theological vision holder (offering a rich missional theology), d) the kin keeper (drawing the community together), e) the organizer (creating structures), f) the creationist (drawing the community to nature), g) the prophetic voice (calling us to the margins), h) the older sibling (offering care and pointing to Jesus), and many more. The strength of some leaders lies in combining a number of these gifts in balance.

The bottom line is that one or two pastors or even a leadership team cannot sustain the kind of energy and nut-and-bolts activity required for keeping an incarnational community healthy, growing in Christ, and engaging a neighborhood. Thus, leaders should lead in such a way as to empower and equip others to lead, step into the gap, and take initiative.

Creative Models for the Pastoral Vocation

The nature of church life in a post-Christian society requires us to think freshly about the pastoral vocation. Among other dynamics, there is a pressing need for resilience and for creative neighborhood engagement among leaders. Consequently, personal health and flexibility should be core values. Though many books and conferences will doubtless in time be devoted to this topic, here I will make three brief observations.

First, while pastors of my generation signed up for a (paid) pastoral role until the day they retire, this model of lifetime pastors has all too often led to unimaginative leadership, depression, and even moral failure. A healthier approach would be to accept the vocation of a *pastoral leader* for life, moving in and out of a paid role as God leads and as personal and family health permits. As a pastoral leader, one can live into the wisdom that leadership is not tied to a formal role, rather it is a matter of character and spiritual

authority. Our goal should be healthy differentiation, so that when we move into a paid pastoral position, we can say with conviction: "I am not a pastor, rather I am called into the role of (paid) pastor at this time in my life." To this end, having another vocation to fall back on gives pastors flexibility in their vocational lives. A benefit of this approach is that a pastor can potentially move out of a paid pastoral role and yet continue to offer a pastoral presence within the same community for the long haul. While it is common for denominations to require pastors to discontinue their church membership upon resigning from a pastoral position, I suggest that we need to find more flexible approaches, whereby a pastor can continue to serve in the community (after an appropriate break) while also stepping back to give new leaders the space to lead.

Second, co-vocational (often referred to as bi-vocational) pastoring, in which a pastor engages both in church work and also paid work outside of the church, likely will be increasingly commonplace. This model gives opportunity for flexible staffing structures, smaller budgets, and increased connections within the neighborhood. The significance of the word *co-vocational* is that the pastor's nonchurch work is not engaged merely to fund their pastoral work, rather it is a meaningful part of their integrated life. Pastor Matt McCoy, who works co-vocationally in Bellingham, Washington, explains: "The pastoral and non-pastoral vocation have to weave together. They are dance partners." As we consider co-vocational strategies, we should be aware that pastors and their families need a suitable income, for financial stress can, itself, be detrimental to the health of pastors.

Third, attractional church planting approaches can be rethought. Cities desperately need fresh, small, creative, and tender communities that are loving their neighborhood to life in Christ's name. Do we not want to see fifty such new communities in every city? In the attractional approach, churches are planted with the hope that increased attendance will quickly provide income to replace denominational funding. This leaves little room for error, little space for true creativity, and little motivation to enfold the poorest in the neighborhood.

Matt McCoy reached a point of frustration as he was seeking to plant a church the traditional way. He was trying to engage a sending church in

connecting with the neighborhood, but he was getting nowhere—people were reluctant to engage. Matt's wife, Denise, intercepted his trajectory with sage advice; she encouraged him to focus his attention on his business and the community, and to "wait for church to bubble up." So they waited. And, slowly, church bubbled up—by the power of the Spirit and through countless friendships and prayers! This story illustrates a powerful combination of strategies: 1) "wait for church to bubble up," alongside 2) co-vocational pastoring. I suggest that this powerful combination has the potential to normalize, demystify, and de-professionalize church planting in the coming years.[21]

Monday–Saturday

A crucial aspect of leader-full community not discussed so far in this chapter is the Monday to Saturday vocations of every person in the congregation. As the "congregation scattered," we display to the world the gracious lordship of Christ in our work, our volunteering, and our caregiving. Monday through Saturday we are all priests; I might even say that we all have leadership responsibility. Lesslie Newbigin writes, "The exercise of [the church's] priesthood is not within the walls of the Church but in the daily business of the world. It is only in this way that the public life of the world, its accepted habits and assumptions, can be challenged by the gospel and brought under the searching light of the truth as it has been revealed in Jesus."[22]

In offices, parents' groups, cafés, trucks, homes, factories, hospitals, and advocacy groups the church bears witness to the restoring reign of Christ. We bear witness to Christ by loving what Christ loves and challenging what Christ challenges in these places. And we bear witness to Christ simply by doing skillful work in God's world, serving others through our labor.

Work and corporate worship are intimately linked. We *gather* on the Lord's Day to be nourished as the people of God. Then, at the conclusion of corporate worship, we are blessed and sent to our places of caregiving, work, and volunteering, to bless in Christ's name—we *scatter*. After six days we *gather* again for renewal.

[21]Matt McCoy, personal communication on April 2, 2023.
[22]Lesslie Newbigin, *The Gospel in a Pluralist Society* (Grand Rapids, MI: Eerdmans, 1989), 230.

In order to nourish a sense of discipleship and purposefulness to Monday through Saturday, our church has engaged in "kingdom consultations" with one another. When we share in kingdom consultations, we restructure our Sunday services completely, sometimes relocating the service to the church eating hall. We invite parishioners to sit with people who share a similar vocation to facilitate conversations about bearing witness as an engineer, a grandparent, or a nurse, for example, and to encourage one another to honor Christ in our daily work. During our kingdom consultations, we offer brief biblical reflections, we dialogue, and we pray for one another.[23]

A church that is leader-full has the grassroots capacity and flexibility to engage its neighborhood. For this reason, leader-full communities have a unique opportunity to be genuinely local. The next chapter discusses "local" as a third note for improvising community.

[23]For further reflection on discipleship in the workplace, see R. Paul Stevens, *Work Matters: Lessons from Scripture* (Grand Rapids, MI: Eerdmans, 2012); Amy L. Sherman, *Kingdom Calling: Vocational Stewardship for the Common Good* (Downers Grove, IL: InterVarsity Press, 2011).

Local

LOCAL IS THE THIRD NOTE for improvising community. Lesslie New-
bigin reflects: "It is of the very essence of the church that it is *for* that place,
for that section of the world for which it has been made responsible."[1]

Being *for* a place means more than running evangelistic programs; it is
an orientation toward a local community from within that community, dis-
played in a deep investment of time and love in its individuals, families, and
structures. From this position of investment, we share the life-giving truth
about Jesus in a posture of dialogue.

As I finished up in my first pastoral role in Western Sydney, I wrote the
following as a way of processing the journey we had been on as a community
and also as a way to invite other leaders to consider God's invitation to rei-
magine witness as loving a place.

> Reframe for a moment the witness of your church in this way: witness as
> *loving a place*. Imagine a witness that begins with affection for the people and
> streets of your local area. Imagine a congregation of Christians that delights
> in the shapes and personalities of its suburb and desires to bless it, care for it,
> and speak into it. This congregation shares a conviction that they have been
> *placed* by God in *this place*, to love and to serve.[2]

In the life of our church, when two full-time professionals reduced their
hours of paid work to start new ventures, everything changed. Sally, an ac-
countant, ran a café on the pavement outside of the church building. The

[1] Lesslie Newbigin, *A Word in Season: Perspectives on Christian World Missions* (Grand Rapids, MI:
Eerdmans, 1994), 53.
[2] Mark R. Glanville, "Reframing Mission: Loving a Place," unpublished article, 2010.

> *Being* for *a place means more than running evangelistic programs; it is an orientation toward a local community from within that community, displayed in a deep investment of time and love in its individuals, families, and structures.*

café was open for a few hours each week and offered free food, conversation, and a big heart. Around the same time, Dave, a high school English teacher, began an English as a second language (ESL) class for newcomers. (Sally and David were in stages of life that allowed this flexibility.) Both ventures were high contact ministries, responding to the needs of our neighbors. In both, believers spoke about Jesus naturally and authentically, but they didn't feel they needed to do so for the day to be successful. In the ESL class, participants were invited to stay after class to translate a passage of Scripture.

God knit us into the lives of our neighbors, and it was as if these two programs were God's knitting needles. Yet loving a place runs deeper than programs. Loving a place means being a part of the place ourselves, moving in time with the rhythms, aesthetics, and natural resources of our local area. And it means taking a posture of humble service within the neighborhood in Jesus' name, whether at work or in sporting groups, schools, creeks, colleges, or front yards. How wonderful it is when every member of our congregation affirms: *we have been placed here by God to love our neighborhood and to be loved by our neighborhood, in Jesus' name.* How wonderful it is when our people hear and respond personally to Jesus' words, "As the Father has sent me, so I send you" (Jn 20:21).

But let's pause to notice our surroundings. What does it look like to belong to a place? Imagine a group of people sitting on and around a bench in your local park and singing the blues. Can you hear them? Take a few steps closer in and listen. Deep within their sound you can hear both lament and celebration. The blues always joins these two together—"the gospel shout and the blues moan" as Otis Moss III puts it.[3] These neighborhood musicians are aware of the spirituality of the blues. They know that the blues

[3]Otis Moss III, *Blue Note Preaching in a Post-Soul World: Finding Hope in an Age of Despair* (Louisville: Westminster John Knox, 2015), 22.

moan is the brokenness of the cross and the gospel shout is the freedom and joy of the empty tomb.[4] All of this brokenness and freedom tumbles out as they sing. In this way, the blues helps them to grieve what Christ grieves and to celebrate what Christ celebrates in this place that they love. Perhaps in a similar way, the task of the church is to sit on a local park bench and to sing the blues, so to speak.

To sing the blues is to nourish faith. In Western culture today faith in Christ must not be presumed but must be nourished with care. A community that loves a place in Christ's name, a true *ekklēsia* (church), is a womb for nourishing faith. This is because a church that engages its neighborhood becomes a community of hope, embodying our hope in Christ. Rebecca Pousette is an expert on local housing initiatives who we will learn from in this chapter. Rebecca reflected to me: "Society is completely overwhelmed by global problems right now; we are paralyzed by global issues. So a church that is locally invested, for the life of the neighborhood, is very hopeful." Rebecca is spot on.[5] We cannot heal the world, but we can love one neighborhood in the name of Jesus—as a prayer for God to heal the world. This in turn kindles our own faith and hope.

Scripture as a Narrative of God Redeeming Places

Let's walk through Scripture with the motif of place as our map. We can describe the biblical story as the narrative of God's redeeming places and of God's calling a people *to* places for witness.

Old Testament: human fate intertwined with ecosystems. God placed the first humans in a particular place, namely a garden (Gen 2:8). The Hebrew word for garden (*gan*) refers to a garden with discrete boundaries, such as a vegetable plot or royal garden (Deut 11:10; Jer 39:4). God gave the first humans responsibility to steward that place (Gen 2:15). According to Genesis 2, humanity not only belonged *in* the garden, humanity also belonged *to* and *with* the garden. Adam, who stands for all of humanity at this point in the story, is taken from the *adamah*, the ground (Gen 2:7). The play on words—Adam and *adamah*—demonstrates a mutuality of being, an intertwining of fates.

[4]Moss III, *Blue Note Preaching*, 2, 35.
[5]Rebecca Pousette, personal communication on March 28, 2023.

Steven Bouma-Prediger and Brian J. Walsh put it lyrically. In the beginning:

> God had made a home.
> This was a place of dwelling,
> a place of belonging,
> a place of homecoming . . .[6]

Yet as a result of human rebellion, humankind is cast out of the garden (Gen 3:23-24). Our displacement from the garden is a fragmentation of human relationship with a place, a movement from *somewhere* to *anywhere*.

In light of the fragmentation of the fall, God sets off on the long road of redemption, a road that runs along the *adamah*, connected to places. At the road's start, God tells Abram (later Abraham) to leave Haran and his family and to sojourn south to Canaan (Gen 12:1). As Abraham obediently enters Canaan, God promises: "To your offspring I will give this land" (Gen 12:7). Abraham journeys through the Promised Land, building altars at Shechem and Bethel as a sign of the bond between his household and the land (Gen 12:7-9).

At Mount Sinai, Israel receives God's law. Yet what is the relationship of God's law to place? Throughout Christian and Jewish history, the Pentateuch has often been interpreted as universally applicable to every culture in every place in a way that is rather flat and removed from its original context. But in fact, the law is highly contextualized, specifically to ancient Israel's agrarian life within the unique strip of land of Syria-Palestine.[7] For example, Deuteronomy distinguishes between the land of Egypt from which Israel had come, with its vein-like irrigation canals, and the land of Canaan with its precarious dependence on seasonal rain (Deut 11:10-12). Or consider the oft-repeated reference to the Mediterranean triad of foodstuffs: olive oil, bread, and wine (e.g., Deut 24:19-21). Like Adam's relationship with the soil, Israel's fate is intertwined with the ecosystem of its particular place.

[6]Steven Bouma-Prediger and Brian Walsh, *Beyond Homelessness: Christian Faith in a Culture of Displacement* (Grand Rapids, MI: Eerdmans, 2008), 30-31.

[7]To be sure, the Pentateuch is God's Word for all time, but we must interpret it as shaped and addressed to ancient Israel.

New Testament:* ekklēsia *as the soul of a place. Jesus himself, the Messiah of Israel, ministered within particular towns and particular streets. The gospel writers are surprisingly purposeful in locating Jesus' ministry in *places.* Matthew begins his description of Jesus' ministry by firmly locating it geographically, as the fulfillment of Isaiah's prophecy:

"Land of Zebulun, land of Naphtali,
 on the road by the sea, across the Jordan, Galilee of the gentiles—
the people who sat in darkness
 have seen a great light . . ." (Mt 4:15-16)

These words were laden with significance for Matthew's Jewish audience. In the late Old Testament period, the tribal lands of Zebulun and Naphtali were not desirable locations, at least for the people of Yahweh. Located in the North, this was the first place to fall when the Neo-Assyrian army advanced. Some people of means were able to move south, into Samaria or Judea. But 750 years before Matthew wrote these words, Isaiah had said that *this* was where the Messiah was going to come (Is 9:1-2), to this particular place and people, mostly poor and vulnerable, who made their home in the hills and valleys of Galilee. Light was to dawn on *this place.* Among these towns and terraced agriculture, muddy creeks and countless hills of Galilee, Jesus walks, prays, heals, preaches, trains, and raises the dead. It is the soil of these hills that clings to his feet and dirties his hair.

As a younger pastor living in a government housing area, I was deeply encouraged by this passage. I realized that if Jesus became incarnate in our day, then our neighborhood is just the kind of neighborhood where he would choose to be born! I would often imagine Jesus being born in anonymity, under the eaves of our local pub.

Place is all the more present in the Pauline epistles, where the apostle Paul uses the Greek word *ekklēsia* to refer to the body of believers. For example, Paul begins his first letter to the Corinthian believers:

"To the church [*ekklēsia*] of God that is in Corinth." (1 Cor 1:2)

In the broader cultural context, the *ekklēsia* was a public assembly to which all the citizens of the city were summoned. The town clerk issued a call, and citizens gathered and discussed issues relevant to the life of the

city.[8] By referring to the body of Christ-followers as an *ekklēsia* of God, Paul was communicating that a church meets as the visible body of Christ within a local community, by God's summoning authority.[9] As an *ekklēsia*, the life of the early Christians was public, even if they worshiped behind closed doors for reasons of safety. The *ekklēsia* of Christ was public in the sense that Christ was the true king of the city, whether or not people acknowledged his kingship. And the *ekklēsia* existed to demonstrate and proclaim God's loving rule in Christ, as an outbreaking of the kingdom of God in that place.

It cannot be stressed enough that the phrase "*ekklēsia* of God" creates a tension between intimacy and oddity for its original audience. This phrase knits God's people intimately into the life of their community as servants, and yet the *ekklēsia* of God gives allegiance to God alone, which makes them odd. In its intimacy, the church was the servant of its neighbors, demonstrating compassion and sacrificial service. The Epistle to Diognetus, written around 130 CE, beautifully captures the early church's sense that they were to be the compassionate heart of a city: "What the soul is in the body, that Christians are in the world."[10] The *ekklēsia* had a public identity, but this was not a public identity concerned with political power, for the early church had no political power. Rather, it was a public identity shaped by the cross; that is, sacrificial service and spiritual power.

The social location of the early church, which was both public and marginalized, has similarities to the social location of jazz musicians and other artists today. I observe in the next chapter that artists practice art in their role as the soul of a city, a soul that is located outside of the center. When the church today is tempted to seek after and wield power, it can learn from the artists in its midst—as from the early church—how to step back from power and to create and embody beauty.

We need to recognize that the primary work of witness among the first Christians was not that of Paul and his associates (Paul "planted," 1 Cor 3:6),

8"ἐκκλησία," in Walter Bauer, William F. Arndt, F. Wilbur Gingrich, and Frederick W. Danker, *A Greek-English Lexicon of the New Testament and Other Early Christian Literature*, 2nd ed. (Chicago: University of Chicago Press, 1979), 141.

9For a helpful discussion of the word *ekklēsia*, see Michael W. Goheen, *"As the Father Has Sent Me, I Am Sending You": J. E. Lesslie Newbigin's Missionary Ecclesiology* (Zoetermeer, Netherlands: Boekencentrum Publishing House, 2000), 166.

10"The Epistle to Diognetus," in Philip Schaff and Henry Wace, eds., *The Ante-Nicene Fathers*, vol. 1 (Grand Rapids, MI: Eerdmans, 1991), [VI] 23-30, at 27.

but of the regular lives of the *ekklēsia* located in the urban centers of the Empire. This distinction between Paul's work as an itinerant apostle in cities in which the gospel had not yet been proclaimed (see Rom 15:19-21) and the steady witness of the *ekklēsia* helps us to understand a similar distinction today. While the church still sends missionaries to unreached people groups today (what we might call crosscultural mission), the primary witness of Christians today continues to be in the *ekklēsia*, the daily lives of women and men in the locations God has *sent* them to dwell (what we might call witnessing communities or incarnational communities).[11]

The biblical story ends with a kind of return to Eden, a renewal of the creation. This is not a *new* creation as in a different world, but a *renewed* creation. Revelation 22 pictures the tree of life, two of them in fact, standing by a river that flows from the throne of God. Lest a reader think that the book of Revelation presents a future within any other place than this earth, notice Jesus' promise at the end of Scripture, "Surely I am coming soon" (Rev 22:20). Jesus is coming here, to restore this place, indeed every place in God's good world.[12]

Bouma-Prediger and Walsh rightly reflect that we can summarize the arc of the biblical story as a movement from being placed, to displaced, to replaced (that is, creation, fall, redemption).[13] So we must tease out what it can look like for a church today to be placed, to be the soul of a neighborhood.

Nourishing Belonging

Many people experience fragmentation along three axes: dislocation, disassociation, and loneliness.[14] *Dislocation* is a process of living disconnected from a place, from its native history, colonial history, ecology, beauty, local arts culture, climate, seasons, agriculture, and so on. *Disassociation* refers to a process of becoming disconnected from our bodies, emotions, relationships,

[11]Consider the church in Antioch. Through the witness of this vibrant church, the leadership began to reflect the diversity of the city. The church also "sent" Paul and Barnabas to bear witness in the Province of Galatia (Acts 13:1-3).

[12]See further, Carmen Joy Imes, *Being God's Image: Why Creation Still Matters* (Downers Grove: IVP Academic), 174-75, ebook.

[13]Bouma-Prediger and Walsh, *Beyond Homelessness*, 28.

[14]Willie James Jennings uses the words "disassociation" and "dislocation" to describe "the prescribed habits of mind for those who would do scholarly theological work." See Willie J. Jennings, *The Christian Imagination: Theology and the Origins of Race* (New Haven, CT: Yale University Press, 2010), 7.

and personal stories, in a particular place. *Loneliness* is endemic and is con-
nected to our fragmented experience of place and self. Once we've been
uprooted from our place and community by a relocation or two, we may feel
lonely and displaced. We may then grasp for the "high" of yet another relo-
cation, a temptation that can lead to endless rootlessness.

Let's return to our blues musicians, sitting on the park bench. Happily,
you don't need to play blues guitar to rest in the rhythms and seasons of your
place. How can your community immerse in your place like these blues
musicians? Who can teach your community the history of your place? Can
you hike together? Camp together? Are there leaders from indigenous com-
munities who can share their knowledge of the ecosystem? Do you know
your local artists? Who in your community is investing in the city, offering
a voice in decisions affecting the community? Are you getting to know your
street-adjacent neighbors? Do you know your city well enough to grieve
what Christ grieves there? Belonging means different things to different
people. My personal homecoming is bustling into a bar, keyboard under my
arm, for a gig with local musicians. Have you thought about what your
homecoming looks like?

First Christian Reformed Church in Hamilton, Ontario, Canada, ran a
creative photography project to enhance their sense of being called to
their city.[15] Following their lead, our church did the same. Members of our
church photographed the places in our area that they loved and that had
meaning for them. Teenagers and children snapped pictures with their
mobile phones. Disposable cameras were distributed to older members
of the congregation who didn't own camera phones. Grassy hills, ponds,
cafés, shops, and indigenous murals were lovingly photographed. Twenty-
five of these images were framed and hung in our church foyer. Our
church motto, painted tastefully on a canvas, hung there too: "Making
known the truth, hope, and love of Jesus, *here*."[16] In this way, each time
the church gathered for worship we were reminded that Christ has called
us to this place.

[15]My wife, Erin, was a member of First CRC Hamilton (Ontario) at the time, and Andrew Zant-
ingh was lead pastor.
[16]The word "here" was added to the church motto, which was: "Making known the truth, hope,
and love of Jesus."

Migration and Locatedness

It is realistic to balance the invitation to stability unfolded in this chapter by acknowledging the historical reality that migration has been crucial to the growth and flourishing of Christianity from the very beginning up until now.[17] Noted church historian Andrew Walls writes, "Migration is a more significant factor in Christian history than the Reformation itself."[18] Indeed, whenever the church embraces its identity as a "sent" people (see Jn 20:21)—even while serving the Lord embedded within a specific place—we acknowledge our solidarity with refugees and vulnerable immigrants. In our book *Refuge Reimagined*, my brother and I reflect: "When Christians are tempted to see people on the move as the other, whom we should keep out, this is likely because we have become settled, become forgetful of our own identity as aliens called to serve others in weakness."[19]

For immigrants, there is a tension between our experience belonging to a place and our experience of immigration. The biblical reference to Christians as "aliens and exiles" (1 Pet 2:11) is more than a metaphor for many refugees and immigrants, it's our lived experience. My friend Sarah, a 1.5 generation Korean Canadian, reflected to me: "Many immigrants don't feel grounded in Vancouver. So we can relate to Israel's experience of meeting God in the wilderness" (Ex 16-18).[20] God may be inviting us to embrace rootedness, and to be

> *Whenever the church embraces its identity as a "sent" people (see Jn 20:21)—even while serving the Lord embedded within a specific place—we acknowledge our solidarity with refugees and vulnerable immigrants.*

[17]On migration in the early church, see Alan Kreider, "They Alone Know the Right Way to Live," in *Ancient Faith for the Church's Future*, ed. Mark Husbands and Jeffrey P. Greenman (Downers Grove, IL: IVP Academic, 2008), 169-86, at 174-75.

[18]Andrew Walls, "The Great Commission 1910–2020," a lecture delivered at the University of Edinburgh in 2003, cited in Sam George, "Introduction," in *Refugee Diaspora: Missions amid the Greatest Humanitarian Crisis of Our Times*, ed. Sam George and Miriam Adeney (Pasadena, CA: William Carey, 2018), xvii.

[19]Mark R. Glanville and Luke Glanville, *Refuge Reimagined: Biblical Kinship in Global Politics* (Downers Grove, IL: IVP Academic, 2021), 105.

[20]Communicated in a personal conversation on March 28, 2023.

curious about what it might mean for us to be alive together as the "soul" of the city. For all of us, whether immigrant or native born, the witness of our community is stronger when we are connected to *place*.

Rooted Suburban Churches Versus Commuter Churches

Not only urban churches but also many suburban churches are becoming increasingly engaged in the local neighborhood. (*Suburban* here refers to middle class, medium density residential areas.) For example, David Groen is lead pastor of Hope Community Church, a growing suburban church in British Columbia. David takes a prayer walk around the area on Fridays, by himself. He notices that new people who walk through the church doors don't have a strong denominational loyalty. But they do desire to belong to a church that is blessing the neighborhood. David prioritizes collaboration with local schools, local NGOs, and other local churches, including an inter-church initiative, Cloverdale Community Kitchen.[21] Most people at Hope Community Church live within a ten-minute drive of the church building. This is important, as Dave comments, "How deeply can you love a place that you don't live in?" At Hope there are people who live further out, but—an important rule of thumb—the leadership doesn't accommodate for a commuter church mentality. There's no doubt about it: suburban churches can sing the blues on a local park bench!

Just the same, you may be a part of a commuter church where it is simply not feasible for households to relocate into the neighborhood. To be incarnational, commuter churches require special creativity and an unusual depth of commitment to witness. One approach is to form home groups by locality, with an emphasis on embeddedness and service within each home group's local communities. Or satellite congregations may be birthed, with an explicit identity as witnesses in their local neighborhoods. Commuter churches can also foster a vision for loving their city. The bottom line is: the more connected to *place* we are, the stronger our witness.

[21]Cloverdale Community Kitchen was birthed by Pacific Community Church in 2011, www .mycck.ca.

Local in All We Do

Local can be a key motif for all that we do; we can think "local" through every aspect of our shared life. And if our shared life is to be shaped by our locality, we can be alert to the ways in which we naturally default to globalized products and aesthetics, ranging from globalized worship music to globalized agribusiness.

For example, in chapter five on worship, we will observe the troubling dominance of globalized worship music. It hardly needs saying that a handful of 30-something White males who take center stage in American and Australian megachurches cannot possibly write songs that will adequately nurture the lives of diverse witnessing communities in their distinctive neighborhoods. So how can we nurture our potential songwriters? On another topic, can we consider our practices around food, perhaps supporting local farmers by purchasing locally grown food? Additionally, can we seek to dialogue on other local issues, such as housing, homelessness, loneliness, and creation care? And in our church attendees, can we seek to embody the diversity of our neighborhood? Diversity will require a change in posture and making sacrifices. The key for a diverse congregation is a diverse staff team, as we will see in chapter six, "Shared Life."

As we consider our locality, we can become aware of the ways in which *where* we live affects *who* we interact with and eat with, who shapes our lives and imagination. David Leong, a professor of urban and intercultural ministry, observes that people tend to cluster into "pockets of homogeneity." Where we live tends to be related to income level, education, race, and more. "We accept this division as normal," Leong reflects. One response is to learn the histories of our neighborhoods. For example, racially restrictive housing covenants may still impact the character of our neighborhood beyond their lifetime as formal policy, Leong reflects.[22] Instead, we can be alert to the temptation to live in neighborhoods that are homogeneous, full of people just like us. We can follow Christ into marginalized places.[23]

[22]David Leong, "Reimagining Belonging: Race and Place in Christian Communities," Regent Exchange public lecture, www.youtube.com/watch?v=7jaOOp2ZxQo.

[23]For a helpful discussion of exegeting a neighborhood, alert to systemic injustices, see Amy L. Sherman, *Restorers of Hope: Reaching the Poor in Your Community with Church-Based Ministries that Work* (Wheaton, IL: Crossway, 1997), 47-56.

Housing

Finally, housing is an arena for creative Christian discipleship. Housing has become an issue of anxiety for people in almost every suburb and city: housing is a global crisis. Rebecca Pousette, the housing expert mentioned earlier, commented to me, "When God made the world, God designed it to be a home . . . *We* are designed for home; we are made to live in a place that is stable, where we can root."[24] Rebecca reflects that our ability to stay in a place is dependent upon our housing, and yet housing is now a commodity. While housing is seen by the United Nations as a human right, it is ultimately governed by market forces.[25]

Rebecca notices that there is very little imagination and hope around housing in cities. And yet imagination and hope are the church's currency. So the issue of housing is a crack in the wall of Western culture (so to speak) for Christian witness. Here are two examples of creative witness around housing.

Years ago, God gave Dawn Humphreys, lead pastor at Strathcona Vineyard Church, a vision for the community. Dawn "saw" a row of houses with warm lights glowing from within. In the following years the church began to reclaim rundown houses as a "beautiful symbol of God's healing," as Dawn put it. Today, Strathcona Vineyard manages seven houses on Cordova Street, Vancouver, providing a space for people from diverse backgrounds to share life together for the long term. The vision that Dawn received has become a reality.[26] Our Vancouver church took a different creative route. The church repurposed our double-lot carpark to create room for a four-story building, called the Co:Here building. The building provides integrated housing for people from diverse walks of life. The tag line for Co:Here is, "Home for Good."[27]

A church that engages its neighborhood becomes a community of hope, a womb for nourishing faith, embodying our hope in Christ. Loving a place can entail creative and entrepreneurial vision, and yet so much more

[24]Rebecca Pousette works as project manager for the Co:Here Foundation.

[25]"Global Housing Crisis Results in Mass Human Rights Violations—UN Expert" (United Nations press release, 2020): www.ohchr.org/en/press-releases/2020/03/global-housing-crisis-results -mass-human-rights-violations-un-expert.

[26]Dawn Humphreys, personal communication on March 28, 2023.

[27]For further information, see the Co:Here website: www.coherehousing.com.

important are small acts of faithfulness offered in the context of a common life in a neighborhood.

Our discussion of the aesthetics of a local neighborhood turns our attention to the importance of beauty itself. Beauty and aesthetics are rarely spoken about in the church. Yet in the next chapter, I will argue, on the basis of Scripture, that beauty is vital for the witness of the church.

Beauty

I PAID MY WAY THROUGH MUSIC SCHOOL by teaching piano to children. My experience of teaching one ten-year-old, Anna, was transformative. Anna's mother, Jenny, taught at the same elementary school. Jenny was a brilliantly creative teacher and a performer in musical theater. In short, Anna's mother was an artist. After just a year, Jenny pulled Anna out of lessons, and she sat down with me to explain why. Jenny said that she had chosen me assuming that as a jazz pianist I would approach teaching creatively. She had thought that perhaps I would teach Anna to improvise or I would use out-of-the-box teaching strategies. Jenny expressed her disappointment that I hadn't done so.

Even as she was speaking, I knew that Jenny was right. As a child I was trained in the classical tradition, training I am grateful for. Now as a teacher, I was simply replicating my own childhood learning process for my students. Even though jazz was my life, I hadn't integrated the creativity and ingenuity of improvised music into my pedagogy. From that conversation onward, I began to do this integrative work. These days when I teach piano, I get children improvising from the very first lesson, while still teaching fundamentals like scales, theory, and reading music.

My journey as a piano teacher mirrors the experience of many Christian leaders, whether vocational pastors or lay leaders. Many Christian leaders are creatives who come alive with creative expression. And yet they may struggle to bring their creativity and imagination into the life of the church, instead bringing their best imagination and fresh energy to parenting, cooking, coaching a sports team, or throwing a party (places where no one will complain!). Like my early piano teaching, it can be difficult for our

imagination to soar above the predictable expressions of church that we grew up with.

This chapter argues that beauty and creativity are exactly what the church needs. Churches need to excel at creating art and in living artistically. This is so that our faith in Jesus can shine out in a way that is evocative, beyond words. "Beauty is an experience of God, a taste of God."[1] No amount of verbiage, not the most neatly packaged homily (or learned book!), can express the gospel with the same humanity and discernment as the arts.

So we need to make space for artists, bringing their inspiration and heightened perception into the flow of our shared life. We need to be creative in just about every aspect of church life, from housing arrangements to worship liturgies. This chapter is about beauty. It is about art, making art, and the art of church. This chapter is an invitation to switch on the creative, imaginative part of our brains, not only for when we might have inspiration to pick up a paintbrush or drumsticks, but for all our ministry among the people of God.

That Little Something

Recently I read Makoto Fujimura's wonderful book, *Art and Faith: A Theology of Making*. When I was halfway through reading, I posted a quote on Facebook. I want to share with you the Facebook thread, as it offers a deep dive into the complex relationship between art and the church. I quoted Fujimura in my initial post:

> Beauty and mercy [justice] invoke the New Creation precisely because they may be unnecessary for survival in the Old Creation. A theology toward New Creation makes an audacious argument that mercy and the creation of beauty are the foundational essence for how we, fallen human beings, can participate in the sacred creation of the new. Without beauty and mercy, the gospel will not change the world. They are two "upside down" paths to imagining the Kingdom of God, and it is as we travel along these avenues of imagination that we are transfigured into what God has intended for us.[2]

[1] Steven Gomez, in a personal communication on March 23, 2023.
[2] Makoto Fujimura, *Art and Faith: A Theology of Making* (New Haven, CT: Yale University Press, 2020), 28.

In response, a friend in Australia pushed back: "Can you help us see where . . . the basis for these assertions can be found in Jesus' words?" I read this comment just before I went to bed (as you do). The next morning, I replied in this way:

> I'm up out of bed! Oatmeal bake in the oven for the kids' breakfast, and I sit down to reply to you. Where are beauty and mercy found in Jesus' statements? I will proceed on the basis of the whole of Scripture, because Jesus taught that Scripture found its fulfillment in him. (see Lk 24:25-27; Jn 5:37-47)
>
> Jesus' words, "Blessed are the merciful," will do for the second of the pair, mercy. In the Sermon on the Mount, Matthew 5–7, Jesus is doing little more and little less than gathering the eschatological people of God, the remnant of Israel, in the light that now in his person, the KOG has come in power. In this context, mercy is a characteristic of what happens when God is in charge, a characteristic of the community of God.
>
> The first of the pair, beauty, is more implicit in Scripture, yet I think that it is nonetheless deeply present. Beauty is that aesthetic sense. We encounter beauty in that little something that makes life worth living. It's a bow in a little girl's hair. Or it is that grand gesture of a sunset or of a jazz drummer whacking the snare at the beginning of a trumpet solo, reminding you that even though life may feel unlivable, you want to stay around nonetheless to hear what the drummer does next. That's beauty.
>
> Beauty is in the forms of the biblical text itself. Think of Paul's poem in Philippians 2:5-11. Fujimura cites N. T. Wright, who reflects that New Testament poems like this began their life *as poems* rather than as theological treatises: "It isn't the case that people sorted things out theologically, and then turned them into poems."[3] And we see beauty in the work of the Old Testament scribes, as they translated the barbaric literary form of a covenant (a militarized treaty to keep subjugated kings sufficiently terrorized that they wouldn't think of revolt) into a vehicle to communicate God's grace. (There is beauty in ethics, too.)
>
> Beauty is also in the arc of redemption disclosed in various ways in Scripture. I haven't heard many sermons analyzing the ten curtains surrounding the tabernacle courtyard, their specific dimensions, their loops of blue material, and their fifty gold clasps used to fasten the curtains

[3]N. T. Wright, from an email correspondence with Makoto Fujimura; cited in Fujimura, *Art and Faith*, 6.

together. It doesn't make for beautiful writing, but it looked beautiful! (Ex 36:8-38)

This beautiful sanctuary displays for the community the presence and the holiness of God. Via regular cultic rhythms in this beautiful space, God is encountered with the eyes, the ears, the hands, and the nose. Yahweh is demonstrating by this that God is committed to the journey; Yahweh will go the full distance with Israel (Ex 33:12-17)—which is beautiful in itself. Further, beauty is connected to sacrifice, which could take another post.[4]

A few minutes after I posted this text, a Vancouver pastor (who is also a jazz pianist) commented on my comment:

> Beauty is like a drummer . . . you want to stick around for what comes next. Yes! It's also like a gracious theologian who responds to a question on Facebook, once breakfast is ready, with openness, care, and wisdom.

This final comment was both encouraging and helpful for me. Human relationships and interactions have an aesthetic too. Interactions may be beautiful; they may be ugly. I am not always so patient on social media or in face-to-face relationships. Thanks to this comment, in the weeks following, whenever I felt pain in an interaction, I said to myself, "Respond beautifully."

There is so much more that is useful for us in this thread. Fujimura's quote begins with the idea that we don't need beauty for survival. This is true. In fact, many of the activities and things surrounding our lives are not necessary for survival. You don't need a table to eat, you don't need perfumed shampoo to clean your hair, you don't need to remove your dirty shoes to enter the house, you don't need to wear faded jeans to be clothed. These things aren't necessary to survive, but they give meaning and significance to our lives, connecting us to one another and to culture.[5] That's the purpose of beauty and the arts. Beauty isn't necessary to live, but beauty gives us reason to live.

> *Beauty isn't necessary to live, but beauty gives us reason to live.*

[4]The discussion of the tabernacle reuses material from Mark R. Glanville, *Freed to Be God's Family: The Book of Exodus* (Bellingham, WA: Lexham, 2021), 81-91.

[5]Wynton Marsalis makes a similar point in the documentary miniseries *Jazz*, directed by Ken Burns (Florentine Films, 2001), episode 6.

The pushback that my post received is another fascinating aspect of the thread. It displays what we well know, that Protestant churches have had an uneasy relationship with the arts. Often, we have all but abandoned the arts and artists, ignoring artistic spaces in culture and neighborhoods. Why? For some, an otherworldly Christianity views the world as a wrecked vessel. Discipleship is reduced to saving all we can off a sinking ship. This worldview offers little motivation for making art, which may be seen as a frivolous indulgence. More subtly, others have been formed by a seminary education that tends to privilege rationalistic knowledge within an enlightenment paradigm. Within this paradigm, the intuitive or tactile knowledge of the artist may be seen as second-tier knowledge at best and a threat to truth at worst.

Both an otherworldly eschatology and the dominance of rationalism reduce the embodied nature of Christian faith. And both are at odds with the biblical story, a story in which God creates before God instructs—and God creates a very good world, at that. "God the artist communicates to us first, before God the lecturer," Fujimura reflects.[6]

Neglecting artistic expression and beauty comes with an enormous cost for faith. In his book on multicultural ethics, Bernard Adeney explains that a part of the crisis of faith experienced by many Christians in pluralistic contexts is the expressions of beauty and attention to the senses that they see in other faith traditions. Appeal to a sense of smell, bodily posture, and visual beauty in other faiths leaves many Christians wondering about the relevance of their Protestant Christian faith, which is commonly overly rational at the expense of other dimensions of human experience.[7] For this reason, creating art and pursuing creativity as Christian communities is a way of nourishing our faith. Through beauty we experience Christ's beauty, and so beauty becomes a part of our witness.

Artists and the Arts

Lamentably, the marginality that artists experience in the church mirrors their experience in society at large. Artists and the arts are marginalized in our cities and neighborhoods, though this marginality is complex.

[6]Fujimura, *Art and Faith*, 7.
[7]Bernard T. Adeney, *Strange Virtues: Ethics in a Multicultural World* (Leicester, UK: Apollos, 1995), 164.

This is especially curious because both artists and the church are similarly marginalized. (I am speaking from the perspective of post-Christian cities, rather than from the perspective of cities in which the church still has a privileged place.[8]) Artists occupy a similar marginal location to the church in post-Christian cities like Vancouver, as those who are rarely welcome at the center where decisions are made, concerns heard, and values prioritized. Like the church, artists discern a calling to engage society, yet they engage as the soul of the city rather than as the executive arm. In this way, there exists a weaved kinship between artists and Christ-followers, as those who are engaged with culture from within culture, for the sake of culture.

Yet the marginality of artists and the arts is complex. On the one hand, the megastars who dominate the music industry, whose posters adorn teenage bedrooms, possess inordinate wealth and are anything but marginal. Some are talented, and many are mediocre. Meanwhile, local musicians in every city and town may work day jobs to fund their craft. Some have talent that exceeds the megastars, some don't. For myself, working as a full-time musician, jazz was my life, with long days of practice in addition to gigs and rehearsals. And yet when I came to pay my taxes, I had earned so little that I could write off my earnings as a hobby! The visual arts world is similarly skewed toward a lucky few, insufficiently sensitive to talent and to cultural and gender diversity.[9] Globalized capitalism flagrantly misshapes the arts.

As a result, many professional local artists feel profoundly discouraged, wondering whether they made the right decision in pursuing the life of an artist. So it is pertinent to consider how the Bible views the arts and artists: Is the gospel good news for artists? Is this a leak in the pipe of globalized capitalism, presenting an opportunity for witness?

To answer this let's return to the construction of the tabernacle in the book of Exodus. God chooses two craftspeople of artistic genius to lead the creative enterprise, Bezalel and Oholiab. God says of Bezalel:

[8]Historically, during times when the church has had political power, art has sometimes become constrained in how and to what extent it can function. Cecilia González-Andrieu argues that so long as artists are telling the truth, they will be a critical force in the face of corrupt authority, whether they intend to be or not (*Bridge to Wonder: Art as a Gospel of Beauty* [Waco, TX: Baylor University Press, 2012], 103).

[9]Jerry Saltz makes this point: Barnes and Noble Podcast, "On Art is Life": www.youtube.com /watch?v=S2eCCMw0iQE.

> I have filled him with divine spirit, with ability, intelligence, and knowledge
> in every kind of craft, to devise artistic designs, to work in gold, silver, and
> bronze, in cutting stones for setting, and in carving wood, in every kind of
> craft. Moreover, I have appointed with him Oholiab son of Ahisamach, of the
> tribe of Dan; and I have given skill to all the skillful. (Ex 31:3-6)

The Hebrew word for "skill" here is *hokmah*, which is often translated "wisdom." *Hokmah* in the Old Testament refers to the art of living skillfully in God's world. According to the Hebrew mind, artistic skill and craftsmanship are a kind of wisdom that is connected to other expressions of wisdom such as wisdom in social relationships (Prov 11:13), finances (Prov 10:4), and fearing the LORD (Ps 111:10). The use of this word, "skill" or "wisdom," communicates that the work of an artist is not a peripheral activity; rather it is a way of living skillfully in the world that is organically connected to other expressions of wisdom in the community.

In the book of Exodus, while God has given instructions for the construction of the tabernacle and its furnishings (Ex 25–30), there are nonetheless thousands of creative decisions to be made. Using their creative intuition, Bezalel, Oholiab, and their fellow craftspersons will exercise a particular way of knowing that is peculiar to the artist, and in doing so they will offer leadership for the worship of the whole community.

Perceiving Clearly

Yet what is this way of knowing that artists seem to possess? The mystery of art and of the artist's vocation has to do with an artist's ability to sense aspects of reality with unusual clarity. An artist's genius is found not only in technical skill or natural ability, as important as these are, but in their growing ability to sense and discern realities in a way that is beyond capture.

To illustrate, the jazz-inspired poet Micheal O'Siadhail has likened the art of jazz to the improvisation in our lives. O'Siadhail tries to find words for the wrestle of the jazz musician during a performance, with this couplet:

> Between moments endured and moments of the dream,
> Singleness of purpose, utter obedience to a theme.[10]

[10]Micheal O'Siadhail, "Flightline," in *Our Double Time* (Bloodaxe, Newcastle upon Tyne, 1998), 100.

There are times when we feel like we are wringing music out of a dry rag—these are "moments endured." Then there are times of electrifying musical conversation, "moments of the dream"—there is nothing like this feeling. Yet whether endured or dream-like, if the music is worth playing then we are relentlessly pursuing a melody, "a theme." In order to trace one theme to its conclusion, we must allow one hundred musical ideas and opportunities to pass us by—"utter obedience to a theme." In my experience, this discipline of the artist is an intuitive seeking after truth.[11]

The artistic gift of intuitive discernment, of expressing reality with clarity and soul, surely relates to the gospel. For we enter into the gospel story by discerning the truth about the world: "Blessed are those who mourn" (Mt 5:4). Disciples learn to see the world how Jesus sees the world, grieving what Christ grieves and celebrating what Christ celebrates. In a similar way, jazz expresses the truth about the world, both in the world's joys and griefs. Jazz deals with *what is*, expressing it with tears and offering hope; and the gospel deals with *what is*, affirming what is good and redeeming what is broken. So an artist's work of perceiving creation connects to the gospel and even expresses the gospel, at least in part. Artists point to the lavish embroidery of creation, to the holes that need mending, and to the detailed work of repair (this is the case whether the artist knows Christ or not).[12] Of course, the artist's view is distorted, like anyone else's. And yet there is a woven kinship of artists with Christ-followers, for we are they who seek to hear clearly, engaged with culture from within culture, and yet marginal in our culture.

> *Jazz deals with* what is, *expressing it with tears and offering hope; and the gospel deals with* what is, *affirming what is good and redeeming what is broken.*

[11]Unlike popular forms that are consumed en masse, art is not always tailored to its audience. Carol Becker reflects that to assimilate art is to "defeat the necessary tension that allows it to be subversive." ("Herbert Marcuse and the Subversive Potential of Art," in *The Subversive Imagination: Artists, Society, and Social Responsibility* [New York: Routledge, 1994], 126.)

[12]In her book on art and empathy, Mary W. McCampell argues: "Love itself is an act of abundant creativity birthed out of a connection to the creator" (*Imagining Our Neighbors as Ourselves: How Art Shapes Empathy* [Minneapolis: Fortress, 2022], 192).

Artists in Church

Given these peculiar sensitivities, how can worshiping communities embrace such strange creatures, artists? Barbara Nicolosi writes, "There are two kinds of people in the world: people who are artists, and people who are supposed to support them. Figure out which you are and do it with vigor."[13] It is such a blessing to discover that an artist has found a home in your church, and there is much we can do to encourage a sense of belonging for them . . . and, unfortunately, to discourage it! Here are some ideas. Our church has a resident artist program, where a visual artist is appointed as a resident artist for a one-year term. The role includes a small stipend. Our resident artists produce art that reflects the liturgical season and relates to the theme that we are exploring as a church. They help to curate the sanctuary space. One liturgical season each year, the resident artist leads collaborative art making with the congregation.[14]

On the musical side, I lead an annual jazz vespers service at our church. Our jazz services are a time of worship through art, music, and spoken poetry and liturgy. I work with creative liturgists within the church, and I invite musicians who don't know Christ to play in the band. My musician friends are amazed as they experience our Christian community worshiping with a full heart and when they hear about our work in the neighborhood. Also, as a pastor, I take time to mentor professional artists, taking a personal interest in their vocations. Once your eyes are opened to the gifts that artists bring to the community, that of sensing and discerning the creation in a way that seems beyond capture, then you will naturally look for ways to learn alongside artists.

Creativity and Beauty in Just About Everything

When I was studying jazz at the Sydney Conservatorium of Music, master jazz pianist Mike Nock led our "band workshop" class. We would play as a jazz ensemble and Mike would coach us, teaching us the skills and concepts necessary to play together. One class, Mike stopped the band in the middle

[13]Barbara Nicolosi, "What Exactly is an Artist, and How Do We Shepherd Them?," in W. David O. Taylor, *For the Beauty of the Church: Casting a Vision for the Arts* (Grand Rapids, MI: Baker, 2010), 104.

[14]My former colleague Joy Banks, herself a woodcut artist, worked with our resident artists.

of a tune, and he started to dance. (Most jazz musicians can't dance, and Mike is no exception.) Mike said to us: "Jazz music is a dance! It's got to feel good! It's got to make you want to dance!" Mike was training us to play with that lilt, with that bounce, which gets people feeling the groove and tapping their feet. Church, at its best, is a dance.

We cannot improvise our part in the biblical story without creativity, which is our imaginative response to a new cultural moment, in the movement of our own stories. We can get creative in just about anything: around housing, how we conduct church meetings, how we respond to marginality in our neighborhood, how we care for our staff, and in sourcing locally grown food. Of course, there should also be plenty of space for tradition, for annual rhythms, for beloved liturgies, for the familiar. Yet it takes creativity to embrace traditions thoughtfully, in a way that is reflective of our neighborhood and of the unique gifts offered within our ever-changing church community.

Perhaps the first creative steps are small, maybe some walls in your church need a fresh coat of paint. Or maybe you preachers can find a new creative form for an upcoming sermon—and so "Submit to the Spirit and be possessed by divine imagination," as Otis Moss III puts it.[15]

Christ-followers can create "rainbows for the fallen world," as Calvin Seerveld's book title famously reminds us.[16] Surely, we are all artists as we improvise the next chapters of the book of Acts, in our shared life together. Surely we are all artists as we pursue locally based aesthetics and resist globalized and commercialized art forms, including in our worship music. These are all creative acts. We can learn the skills and disposition for such creativity from the professional or amateur artists in our midst, creativity even for aspects of our shared life and witness that wouldn't usually be associated with the arts.

Creativity and the Arts in Worship

How can we bring creativity and the arts into worship?

Every year on the first Sunday of Lent, we "pack away our hallelujahs." In this tradition, the children each carry a piece of paper to church on which

[15]Otis Moss III, *Blue Note Preaching in a Post-Soul World: Finding Hope in an Age of Despair* (Louisville: Westminster John Knox, 2015), 26.

[16]Calvin Seerveld, *Rainbows for the Fallen World* (Downsville, ON: Toronto Tuppence, 1980).

they have decoratively written, "Hallelujah!" A travel-worn suitcase sits on the stage of the sanctuary, with a label that says: "Headed for Easter Sunday." During worship, the children bring their hallelujahs to the front of the church and place them in the suitcase. We close the suitcase, explaining that we will open it again on Resurrection Sunday. Until then we won't sing songs with the word "hallelujah" in them, because during Lent, we are journeying toward the cross, we explain.[17] Then, on Easter Sunday, we can sing "hallelujah" with full-hearted joy! Our annual tradition of "packing away our hallelujahs" illustrates how creativity and the arts (including children's art) can help us to embody the story of which we are a part, entering it with our senses and our imagination.

Yet historically Protestant worship has had an uneasy relationship with the arts and creativity, and this negative inertia is still with us today. Because the mass was in Latin during the medieval period, visual arts, including visual representation of the Scriptures, of the saints, and of God, was an indispensable means of engaging faith.[18] But hand-in-hand with the translation of Scripture into the vernacular, the reformation of worship during the Protestant Reformation included what is known as "iconoclasm," or the prohibition of images in worship. The primary motivation for iconoclasm was theological: a rejection of idolatry. This was especially on the basis of the Second Commandment, which prohibits creating an image of God and worshiping such an image (Ex 20:4-6; Deut 5:8-10). There was also a broader ecclesial motivation, as possession of images and relics was the special privilege of the wealthy, contributing to corruption. So the Reformation created a shift from visual engagement to aural engagement, focusing on the written and spoken word.[19]

To be sure, the Reformers' emphasis on the Word and sacraments and their rejection of idolatry and corruption in the church of the sixteenth

[17]This arises out of a traditional liturgical practice of not using "hallelujah" in the Communion service during Lent.

[18]See further, James F. White, *A Brief History of Christian Worship* (Nashville: Abingdon, 1993), 90.

[19]In Reformed thought of the Reformation era, what is known as the Regulative Principle of Worship limited the elements of worship to what is instructed in Scripture. In this vein, the Westminster Confession of Faith states: "The acceptable way of worshipping the true God is instituted by himself, and so limited by his own revealed will" (21, 1.). Richard L. Pratt provides a helpful discussion of the Regulative Principle ("The Regulative Principle," Thirdmill, www.thirdmill .org/articles/ric_pratt/TH.Pratt.Reg.Princ.html).

century was an important corrective. And yet it is a costly mistake to universalize the iconoclasm of the Reformers, as if this is the necessary corrective for every moment.[20] Today, the heart of the tension surrounding the arts in Protestant worship is the Protestant commitment to God's Word, both written and preached. There arises in some traditions a sense that the arts, especially visual and musical art, could distract from the Word or distort how it is received.

The three-part structure of the book of Exodus provides a way through this apparent tension. The book of Exodus opens with God the liberator (Ex 1–17). At the center of the book stands the law given at Sinai, with Moses as a mediator (Ex 18–24). The third section of the book is given to creating. Bezalel and Oholiab lead a team of artists, under Moses' overall direction, in constructing the tabernacle and its furnishings (Exod 25–31; 35–40). This three-part structure to the book of Exodus—liberation, Word, and making— can steer us toward balance. We need not fear that the Word (rightly understood) will quench our creativity, any more than that our creativity will distort the Word.[21] The book of Exodus demonstrates that a community that desires God's powerful indwelling (Ex 25:8) requires both the Word and the arts. Based on all three sections of Exodus we might propose that the *Word, justice,* and *arts* together form a hearth for faithful Christian community.[22]

How can we express our creativity in worship, beyond singing six or seven worship songs? First, don't rush it. It is easy to be creatively kitsch; anyone can be kitsch. But it takes time for deep creativity to emerge and for fresh rituals to develop, as we become open to ancient traditions, native aesthetics, and the gifts in our community. To stir your imagination, here are some practical ideas that have been meaningful to us. I mentioned how our community packs away our hallelujahs on the first Sunday of Lent.

[20]Think of the many images for God in both Testaments, some of which are reflected in the earliest Christian art. God is a lamb, rock, lion, bread, light, water, wind, wings, fortress, deliverer, mother, father, and so on.

[21]Jeremy S. Begbie makes the same point regarding Christian doctrine and the arts (*A Peculiar Orthodoxy: Reflections on Theology and the Arts* [Grand Rapids, MI: Baker Academic, 2018], vii).

[22]The hesitation around the arts in worship that we have inherited from the Reformation era creates a cluster of false dichotomies that do not hold up in light of Scripture. These dichotomies include the separation of logic and creativity, spirituality and embodiment, veneration and imagination, tradition and spontaneity, and cognitive knowledge and sensory knowledge. Each of these dialectics collapses before the incarnation of Christ.

Throughout the season of Lent we stand a cross on the stage. We run burlap (Hessian) fabric from the cross to the Communion table, which represents Christ's journey to the cross. Each Sunday service begins by a lighting of the Christ candle. Each week the leader moves the candle (on a stand) one step farther along the "road" toward the cross. The journey of the Christ candle evocatively enfolds us into Christ's journey, framing our worship and our shared life together during Lent.

One year, anticipating Lent, Erin ran a training retreat for worship leaders. Erin invited the retreaters to write a melody to accompany the ancient words, "Lamb of God, who takes away the sins of the world, have mercy." Participants were also coached in song writing. The result of the retreat was eight beautiful songs, some of which are still sung today. Another Lenten season, Joy Banks (who is both an artist and a pastor) worked with our resident artist on an expressive pottery project. Ceramic pots were broken into shards, and congregants were invited to write on the shards an area of their lives in which they long for Christ's healing. The shards were then strung together with string. The ribbons of shards were suspended from the roof, representing our longings rising to God in prayer. As you can imagine, this was a beautiful experience of holding one another's burdens, and of experiencing God's loving care in worship.

These are all examples of creativity in worship that appeal to our intuitive awareness, to our smell, sight, hearing, and touching. These practices display a value for aesthetics, beauty, and symbol. Ideally, we will seek to merge liturgies and practices from tradition with aesthetics that are native to the neighborhood and to the diverse cultures represented in the community.

Churches need to excel at artistic expression, making, singing, and writing in a way that expresses the joy and grief of the human experience, and of God. We need to do this in the church, just as well as the artists outside of the church do it. "Beauty is an experience of God, a taste of God, and we pursue beauty because our neighborhood needs that connection with God."[23] The discernment of the artist highlights the value of nuance and interpretation for Christian witness. To explore this further we now turn to Part II of the book, Rhythm.

[23]Steven Gomez, in a personal communication on March 28, 2023.

Part II

Rhythm

IN MUSIC, RHYTHM REFERS to how a series of notes relate to the passing of time. In jazz music, there is more give in what is considered as "on time" or "on the beat" than you might think. Jazz musicians can strike a note right on the beat, slightly ahead of the beat, or slightly behind the beat. If this is done intentionally (and not through sloppiness!), all these note placements can be correct. Where we place the note can have a significant interpretive effect on the music. Consider the well-known tune "So What" from Miles Davis's *Kind of Blue*—the bestselling jazz album of all time. On this track, bass player Paul Chambers takes the melody, playing back on the time (on the back end of the beat). Meanwhile, drummer Jimmy Cobb is playing time on the ride cymbal, striking at the center of the beat. The rhythmic tension between the bass and the ride cymbal produced by this note placement gives the music incredible energy and anticipation, even though there are only two instruments playing.

Part II of this book, Rhythm, concerns our next four notes for improvising church: worship in polyrhythms; shared life; healing, kinship, and maternal nurture; and creation. Each of these four notes can be interpreted with nuance and in musical dialogue with the other three. If we place these notes thoughtfully, responsive to the personalities of our community and the aesthetics of our neighborhood, they can then animate our community with incredible energy, shifting our imagination of what is possible in the kingdom of God.

Worship in Polyrhythms

INCARNATIONAL COMMUNITIES WORSHIP with a lot of heart. In one moment, we may draw from ancient Christian tradition, in the next the liturgy may be homegrown. Either way, we worship thoughtfully. One example from our Vancouver church is that every Pentecost Sunday, before the service, someone climbs a long wooden ladder toward the ceiling and heaps fresh rose petals on the top of the ceiling fan blades. During the service, as Acts 2 is being read and we come to the part where the Holy Spirit fills the house in which the apostles are sitting, a person turns on the ceiling fans that send the petals flying! As the swirling petals gently fall, finding a new home in the hair of the faithful, they speak to me about beauty, playfulness, creation, care, time invested, detailed work, community, the Holy Spirit, and an old, long wooden ladder. Every year.

There is so much potential for fresh biblical creativity in corporate worship, and yet there is a strange lack of creativity surrounding worship in Western churches. So much of Protestant worship seems to merely mimic the worship of prominent American megachurches, with a few personalized practices thrown in. The key evaluative measure seems to be *How close is our church to Bethel or Hillsong? The closer the better.* This form of corporate worship tends to be globalized (rather than global), skirting local aesthetics and intercultural riches. It is individualistic, symbolized by a White man in his thirties sporting an acoustic guitar and sneakers. This widespread mimicry short-circuits the opportunity for local creativity, and does

> *This form of corporate worship tends to be globalized (rather than global), skirting local aesthetics and intercultural riches.*

so paradoxically, because corporate worship engages artists and the arts, the very domain of originality and creativity. Black and Latino/a churches, with their rich aesthetic traditions, are an important exception to this critique.

I have noticed that many of my friends who have a rich understanding of the biblical story and an imagination for incarnational community can nonetheless unwittingly enter into this kind of mimicry. It shifts their hopeful journey toward intentional community into reverse. You might preach the most incarnational homilies since Jesus uttered the words, "This is my body . . . ," but if the rest of your worship is shaped by a different story—by Western cultural stories—then this work will be undone. The problem is that the missional conversation has been isolated from the worship conversation (and the preaching conversation, for that matter). When this happens, our witness never gets into our bones; it fails to shape our shared life. This chapter explores a path for refreshing Christian worship in incarnational communities, our fifth note for improvising community.

The way we worship shapes our witness and the kinds of communities we are becoming. As a way forward, I suggest that we reconceive worship, in polyrhythms. Worship in polyrhythms is not the only possible metaphor for renewing worship, but it is helpful. Let me explain. Polyrhythms are two or more overlapping rhythmic patterns (where the patterns are not derivative of one another). The simplest polyrhythm is two against three. Try tapping a 1–2–1–2 count with your left hand. Then add a 1–2–3 count with your right hand, completing this in the time it takes to tap 1–2 with your left. Difficult, eh? But once you settle into it, feeling it in your body, it opens a new reality.

Polyrhythms take on a new depth when jazz musicians play a time feel within a time feel. Sound strange? The well-known jazz tune "Someday My Prince Will Come" (from the old Disney movie, *Snow White*) is in 3/4 time. If you divide each 3/4 bar in half and add an accent in the middle of the bar, then you can have two counts per bar, one at the beginning of the bar and one in the middle. If you overlay this two-feel with the 3/4 pulse, which is the time signature of the tune, then you have a two against three feel, the polyrhythm that we just tapped.

When the jazz pianist Dave Brubeck played "Someday My Prince Will Come," he sometimes focused on the two count instead of the three count, swinging in two instead of three. The rest of the band played in three, but Brubeck played in two. You can hear him do this on his recording of "Someday My Prince Will Come"—check it out.[1] Hearing these skillful musicians overlay different time feels not only sounds good, but it also shifts your sense of what is real—the room seems to move around you.

With the goal of nourishing incarnational communities, we can learn to worship in polyrhythms. In fact, I think this is essential if the church is to attain the depth necessary for flourishing in post-Christendom. (I developed this way of thinking worship as polyrhythmic in partnership with Erin.) There are four rhythmic layers especially suited for incarnational communities that can be superimposed to create rich worship: 1. The rhythm of the biblical story; 2. The rhythm of our community; 3. The rhythm of our neighborhood; 4. The rhythm of the wider church (global and historical).

Before we take up our drumsticks to play these rhythms, let's remind ourselves of the significance of what we are speaking about: worship. All of life lived in response to God is worship. We cook, hold yoga poses, commute, work, and so much more *coram deo*, before the face of God (Ps 56:13). And on the Lord's Day we gather to worship with unique intensity; the Spirit turns up in a special way, re-narrating us into the biblical story, forming us to live faithfully amid the competing stories that surround us Monday through Saturday. On the Lord's Day we get to rehearse what we are always doing on every other day.

My wife, Erin, occasionally trains worship leaders in our church. I have heard Erin begin her training by reflecting: "I love worship. It's the place where stuck things shift; it's the rhythm I center my week around; it's the place where God meets me most powerfully." In this chapter, we use "worship" to refer to what happens when we gather on the Lord's Day. In chapter twelve, Prayer, we will show how worship in prayer and the Word can spill over into the whole week.

[1] Brubeck plays in this way near the end of the third chorus of the piano solo (at 5:00) on "Someday My Prince Will Come," on the album *Dave Digs Disney* (Columbia Records, 1957).

Worship in Polyrhythms

We need some imagination for an alternative to the globalized megachurch model described earlier. With this in mind, we can think of worship as poly-rhythmic, incorporating: 1. The biblical story, 2. Our community, 3. Our neighborhood, and 4. The wider church.

The rhythms of Scripture. Worship attends to the rhythm of the story of redemption in Scripture, inviting our communities to enter in, in tempo. The various elements of worship connect with the biblical story in different ways. For example, confession connects with Genesis 3 and with Israel's exile (among other things). Another example, the sending at the end of the service re-embodies Acts 1–2.

The rhythms of our community. In the design of a worship service, worship can be crafted pastorally, as we discern what the Spirit is doing among us. Worship can reflect the ways in which God has met our com-munity on the road. The Pentecost ritual that opened the chapter is an example of overlaying the rhythms of Scripture with the rhythms of our community.

The rhythms of our neighborhood. Incarnational communities can create their own "homegrown" liturgies, songs, and prayers that reflect the aes-thetics, symbols, and values of our local neighborhood. While traditional liturgies are incredibly valuable, each of these was nonetheless composed for its own context, responding to its own unique challenges. We can create liturgies that nourish and form us for the opportunities and challenges facing our own communities!

A simple example of worship that reflects our East Van neighborhood is our waving cedar branches on Palm Sunday. The scent of cedar drifts through the forests and streets of Vancouver, and it feels natural to wave cedar branches in celebration at the start of Holy Week. An example re-quiring more effort is the folk style of the worship music. Our neigh-borhood is unpretentious and relaxed, the kind of place where every person either carries a mandolin or else wears a plaid jacket big enough to hide one. So worship music is played in a folk style. And some musicians write songs in that style, songs that express how God has met the community on the journey. I wonder what aesthetics and symbols reflect the life within your neighborhood.

The rhythms of the wider church (historical and global). Liturgical traditions from Christian history connect us with the community of saints, as we commune with God using rich expressions of the faith arising from other contexts and times. Christian worship of the past two thousand years has been deep and broad, varying greatly across time and across cultures. As a window into the riches in historical liturgy, consider this ancient liturgy for "bringing in the lights," recorded in the *Apostolic Tradition*, an early third century document. Picture a dispersed network of house churches in Rome. To begin evening worship, a deacon processes a lamp into the household, while a bishop (like a pastor today) re-narrates the day they have just experienced. The theme of divine gift is prominent:

> We give you thanks, O God, through your child Jesus Christ our Lord, through whom you have illuminated us, revealing to us the incorruptible light. Therefore we have completed the length of the day and we have arrived at the beginning of the night, being sated with the day's light which you created for our satisfaction . . .[2]

What profound words with which to conclude the day together, linking Christ's light with the sun's light that has fully satisfied us all that day.

Yet this is just one tradition of thousands! Great places to start learning about historical traditions are *African American Christian Worship*, by Melva Wilson Costen, and *Celtic Daily Prayer*, produced by the Northumbria Community.[3]

Our worship should also reflect the diverse cultural traditions present in our church and neighborhood, as we discuss in chapter six, "Shared Life." To this end, it is vital to have diverse cultural voices designing and leading worship. A helpful resource on intercultural worship is Sandra Maria Van Opstal's, *The Next Worship: Glorifying God in a Diverse World.*[4]

Worshiping in polyrhythms involves layering these rhythms together as we design worship. In any given movement, one or two of these layers may

[2]Alistair C. Stewart, *On the Apostolic Tradition: An English Version with Introduction and Commentary* (New York: St. Vladimir's Seminary Press, 2015), 133-34 [25].

[3]Melva Wilson Costen, *African American Christian Worship* (Nashville: Abingdon, 1993); *Celtic Daily Prayer: Prayers and Readings from the Northumbria Community* (New York: Harper One, 2002).

[4]Sandra Maria Van Opstal, *The Next Worship: Glorifying God in a Diverse World* (Downers Grove, IL: InterVarsity Press, 2016).

be more prominent. If you are feeling overwhelmed at the thought of keeping these four rhythms in mind, an illustration from jazz may help you to begin.

Master jazz drummer Art Blakey left his mark on jazz as the leader of the Jazz Messengers for over thirty-five years. The Jazz Messengers was not only a world class jazz group, it was also the training ground for generations of young musicians. Some nights, when a musician was struggling during a solo, Art Blakey would call out from behind the drums, "Tell your story!" Blakey's words helped the musician to focus, to find coherence in their solo, and to play with heart. Perhaps Blakey's advice can help you to focus as you prepare for worship: "Tell your story!" Blakey's phrase reminds us, at a very visceral level, of the weaving together of the biblical story, the story of our community, the story of our neighborhood, and the story of the church (global and historical). Just tell your story.

Deuteronomy 16:1-17

In order to enrich our imagination of how to play these polyrhythms, I want to take us to my favorite text in all of Scripture, Deuteronomy's festival calendar (Deut 16:1-17). This is an ancient call to worship with feasting. Come on: let's take our instruments to the feast and play our polyrhythms there.

Deuteronomy 16:1-17 calls God's ancient people to annual seasonal harvest feasts before the Lord. Yahweh's generosity in gifting the land and the joyful work of bringing in the harvest stirs the community to share in feasts of thanksgiving. Watch God's people at worship!

First, at the beginning of spring, just before the wheat and barley harvest, God's people pilgrimage to the "chosen place" to share in Passover and the Festival of Unleavened Bread (Deut 16:1-8). They then return to the family farm for the wheat and barley harvest. Seven weeks after the harvest is the Festival of Weeks, Pentecost (Deut 16:9-12). As the heat rises during the summer months (with temperatures similar to Sydney or Toronto) the fruit is ripening on the vines and trees. Then comes the fall harvest of grapes and olives; grapes are pressed underfoot for wine, olives are crushed for oil. After the fall harvest we celebrate for a whole week at the chosen place in the Festival of Booths (Deut 16:13-15). This feast of all feasts is the highlight of the year! In the Jewish tradition, the Festival of Booths is simply called, The Feast!

In these ancient feasts, we find a four-part movement for worship: (1) *Lament.* God's people remember the suffering of Egypt and liberation; (2) *Gift.* Yahweh gives the land and its produce; (3) *Thanksgiving.* God's people respond in thanksgiving with celebration; and (4) *Creative kinship.* Generosity and inclusion for vulnerable people, namely the refugee, the fatherless, and the widow. These rituals and feasts had one main purpose: to forge a worshiping community that responds to the generosity of God with lament, celebration, and creative kinship.

Let's trace the four-part theological movement in this passage to the skills for worship in polyrhythms, outlined earlier.

1. Lament: connecting with the rhythm of the neighborhood. The festival calendar begins with lament. Rituals of Passover and Unleavened Bread recall the suffering of Egypt and Israel's hasty flight. God's people share in the "bread of affliction" (Deut 16:3), a key term for the Hebrew's oppression in Egypt. Through Passover and Unleavened Bread every new generation embodies (or ingests) the exodus story as their own.

The festival calendar begins with lament because lament puts us in touch with brokenness, opening a possibility for something new. It is only as we face up to the neighborhood's groaning that we can begin to seek its healing. This connection is the logic behind the phrase, "Remember that you were a slave in Egypt" (Deut 16:12). Israel's own past of horrific enslavement becomes the motivation for lavishly enfolding the weakest among them. Truly, in lament, we are opening our doors to the pain of the world and to our own pain. For example, last Christmas our family lamented the thousands of people fleeing Afghanistan as the Taliban gained control of the country. We sang Liz Vice's "Refugee King," a beautiful song of lament that connects Jesus' nativity with the story of refugees and vulnerable immigrants.[5]

Take stock for a moment: How many Top 40 Christian worship songs lead us into lament? Not many, if any at all. If these songs remain the main diet of corporate worship, there indeed is a "costly loss of lament" in many Christian communities, as Walter Brueggemann has claimed.[6] In contrast,

[5]Liz Vice, "Refugee King," www.youtube.com/watch?v=20g05lJm0D8, 3:37.
[6]Walter Brueggemann, "The Costly Loss of Lament," *Journal for the Study of the Old Testament* 36 (1986): 57-71.

the Psalms of lament teach us to bring our complaints *coram deo* (before the face of God), to weep on the Father's shoulder, to rage at the Father's side (e.g., Ps 6, 109). These psalms as much as declare: "It is God's obligation to change things."[7] We also can reverse the direction of flow: *Christ* feels emotions of grief and joy when he encounters the world. As Christ's people, we should feel these emotions too. *We must grieve what Christ grieves and celebrate what Christ celebrates* (cf. Rom 12:15). This is the beginning of witness, the heart of incarnational community.

Yet our emotions can be so stunted! How can we learn to grieve what Christ grieves? One important step is to live in community and solidarity with people who are on the margins of our neighborhood. We can be students of our cities and of the global community, sifting our stories. Who are the experts in your church and neighborhood on pressing issues, such as global warming or mental health? Can you listen to them and learn from them? Can you gather others to learn, maybe in a reading group? We will talk more about this in the coming chapters.

> *We must grieve what Christ grieves and celebrate what Christ celebrates (cf. Rom 12:15).*

Seek out songs of lament to sing as a community. (They can be hard to find.) The Porter's Gate has an album, *Lament Songs*.[8] My favorite bard is Tom Wuest. His song "Something Like Scales" grieves our blindness to injustice and suffering.[9] And his song "He Shall Reign" declares Christ's victory over evil forces and evil structures.[10] Liturgies of lament, too, are vital. In liturgies of lament we can speak out our grief and brokenness to the Lord.[11] Our community sometimes holds a special service of lament on a pressing issue to bring our grief before the Lord.

It seems to me that we need to confess our sins in every Sunday gathering. For in confession the Spirit of Christ heals us, opening up the possibility for something new. In confession we attend to personal, communal, and societal brokenness and evil (though not always in the same prayer). Erin crafts

[7]Brueggemann, "Costly Loss," 62.

[8]*Lament Songs*, Integrity Music, 2020, www.theportersgate.com.

[9]Tom Wuest, "Something Like Scales," in *Unless the Seed Falls*, Brass Trumpet Publishing, 2006.

[10]Tom Wuest, "He Shall Reign," in *Rain Down Heaven*, Brass Trumpet Publishing, 2008.

[11]A helpful liturgical resource is Douglas McKelvey, *Every Moment Holy, Volume II: Death, Grief, and Hope* (Nashville: Rabbit Room, 2021).

prayers of confession by considering the liturgical season and by discerning how the season intersects with our community's story. She teaches worship leaders to write their own prayers of confession by inviting them to fill in the blanks in this short prayer:

Lord, we confess our _____, _____, and _____. *(personal sins)*

As a community we have (or have not) _____. *(communal sins)*

We feel powerless in the face of _____ *(structural sin)* and yet we continue to _____.

We need your _____ to _____ us. *(attribute of God and a verb of redemption)*[12]

Lament is vital, and yet so is celebration. There is much to celebrate in the neighborhood! I once asked a refugee-d friend of mine why she left our church. She responded that we are too dour! (Our community was so weighed down with the burdens of the world that we had forgotten how to have fun.) My friend has suffered through enough difficulty in her life, now she wants to *celebrate* with God's people! Lesson learned. We are invited to experience a range of emotions, from a blues moan to a gospel shout:[13] *to grieve what Christ grieves* and *to celebrate what Christ celebrates.*

2. Gift: connecting with the rhythm of Scripture. Divine supply flows through the festival calendar. Every movement of the text and its ritual reminds the worshiper that God gives generously. For example, Moses commands: "Then you shall keep the festival of weeks to the LORD your God, contributing a freewill offering in proportion to the blessing that you have received from the LORD your God" (Deut 16:10). To be sure, at the heart of reality is a generous God. The late Dutch Reformed theologian Gordon Spykman wrote compellingly: "God's creation is evidence of the caring hand of the Creator reaching out to secure the well-being of His creatures, of a Father extending a universe full of blessings to His children."[14] Gift is the heartbeat, the pulse of Scripture. So the generous

[12]Prayer prepared by Erin Glanville.

[13]Otis Moss III, *Blue Note Preaching in a Post-Soul World: Finding Hope in an Age of Despair* (Louisville: Westminster John Knox, 2015), 22.

[14]Gordon J. Spykman, *Reformational Theology: A New Paradigm for Doing Dogmatics* (Grand Rapids, MI: Eerdmans, 1992), 178.

gifts of God are a melody that should rise in the music of worship, prayer, and preaching.

Our worship must nourish our conviction that *this world matters to God*. Often our worship teaches just the opposite. For example, the hymn "Rock of Ages" is quite unhelpful when it fervently declares: "When I soar to worlds unknown . . ." In singing these words, worshipers imagine *escaping* God's world. You might avoid (or reword) songs that wrongly suppose that our true home is elsewhere.[15] How can our worship express the goodness of God, reflected in the creation? My favorite hymn is "This Is My Father's World."[16] The words are wonderful, and I wish I could play this on the piano for you right now as we would all feel joy at the goodness of the creation just from the music! Or consider the third stanza of "Joy to the World":

> No more let sins and sorrows grow
> nor thorns infest the ground;
> he comes to make his blessings flow
> far as the curse is found . . .

The writers of these hymns recognized that at the heart of a biblical worldview is God's generous gift of creation: of human bodies, of the harvest, of music, of sports, of work, and of one another. And because the world matters to God, our work in the world as those who bear the image of the Creator also matters to God.

The theme of gift is also expressed in the *benediction* (blessing) at the end of a service. Both the call to worship and the benediction have in mind the gathering and scattering of the congregation. Having gathered for nourishment by Word and Spirit, the congregation is now sent out into the neighborhood and places of work to extend the healing of Christ— knowing that we will regather in seven days. The benediction is perhaps the most profound exchange between the leader and the congregation in the worship service. There is a dual movement as the leader both *sends* the congregation to minister the healing of Christ throughout the week and

[15]To be sure, upon death we will go and be with Christ (Phil 1:22-26). Yet the Christian hope is that God will restore and beautify *this* world.

[16]Composed by Maltbie D. Babcock (1901).

also *blesses* them. The leader offers the benediction prayerfully and sin-
cerely, and as they do, the congregation extends their hands to receive the
blessing, being strengthened for the week to come. Psalm 67:1-3 captures
the double movement of blessing and sending for witness, as Richard
Bauckham has recognized.[17]

Another aspect of gift is the command to *remember*: "*Remember* that
you were a slave in Egypt," the festival calendar states (Deut 16:12). Re-
membering in Scripture isn't so much cognitive recall, like remembering
your best friend's birthday. No, remembering is a ritual practice of reexpe-
riencing the power of a story, of which you are already a part. Think of
Jesus' eucharistic motivation, "*Do this* in remembrance of me." In Deuter-
onomy, as God's people feast with the slave and the stranger, they re-
member that they, too, have been strangers, in Egypt (Deut 26:5) and then
enslaved (Deut 16:12). Through embodied ritual they reexperience Yah-
weh's story of redemption, being drawn more deeply into its grace, its
communitas. Remembering is an important dimension of the Eucharist: in
it we reexperience the power of the story of Jesus' death and resurrection,
of which we are a part.

**3. Thanksgiving with celebration: connecting with the rhythm of our
community.** The third movement is responding to God's generous supply
with thanksgiving. Twice the festival calendar commands ancient Israel:
"Feast!" (Deut 16:11, 14). And in case anyone loses the party invitation, it
adds: "You shall surely celebrate!" (Deut 16:15). The word "feast" is some-
times translated "rejoice" in English Bible translations. However, in ancient
Israel, emotions were often associated with a ritual. In Deuteronomy, the
command to rejoice means, "Share in a feast!"[18] What a great way to give
thanks! Think of the joy, the community, the recipes! In daily life, ancient
Israelites didn't often eat the meat of calves and lambs. This was mostly
preserved for the joy of the feast. And while wine was an important part of
daily nutritional nourishment, a significant portion of alcohol was con-
sumed at communal feasts.

[17]Richard Bauckham, *The Bible and Mission: Christian Witness in a Postmodern World* (Grand
Rapids, MI: Baker Academic, 2003), 39.
[18]Gary Anderson, *A Time to Mourn, a Time to Dance: The Expression of Grief and Joy in Israelite
Religion* (University Park, PA: Pennsylvania State University Press, 1991), 20.

The closest I have come to experiencing the joy of Israel's feasts is at Latino/a festivals in Sydney, Australia. Thousands of people from the Latino/a community would gather for food and dancing. Our band would kick in with a Latin groove (I was sometimes the only White guy in the auditorium), and within three seconds the whole place was moving. People of all ages knew the dances: senior citizens, teens, and even children. This is how Israel's festivals would have felt—singing and dancing, all with deep gratitude for God's generosity.[19] What a rich life God calls this people to, a rhythm of gift, harvest, celebration, and generosity!

Thanksgiving is one way of connecting with the rhythm of our community. How can we teach one another to give thanks? My grandmother taught me about gratitude. In her final years (Gran died aged 93) she suffered from insomnia. Gran explained to me that when she went to bed she would lie still and pray prayers of thanks until she fell asleep. "Sometimes I give thanks for a lot of things," she laughed, "because I find it *very* difficult to get to sleep!" Gran would begin by giving thanks for her children, which included my mother, and then for her grandchildren, which included me, and so on from there. Prayer by prayer, she dropped off to sleep. Maybe you have experienced what Gran experienced: when we are grateful the stress somehow drips away, and we feel at peace. The anger that we may be holding fades, the hurts soothe, and our mind clears.

Again, we desire to experience the four-part movement of Deuteronomy 16 in our worship. So how else can we teach our congregations to give thanks? Popcorn prayers of thanks in corporate worship can work well, though you might want to line up a few people beforehand to start things off. Occasionally, following the homily, I ask our people to write prayers of thanks on sticky notes. Everyone is invited to stick their prayers on the walls of the sanctuary. Then (during the Eucharist) we take time to mill about and read the prayers, praying into one another's prayers.

And can we teach our people to feast? Feasting is different from consumerist consumption. We feast to become family, sharing our food and sharing our lives. Feasting together nourishes a deep, communal, ritualized joy that can help to free us from dissatisfaction. (I have a hunch that feasting may

[19]Read Psalm 117 out loud, a few times over, and see if you can stop yourself from dancing!

be an antidote to consumerism.) If there is one day on which we should feast, it's Easter Sunday! On this day we remember that Christ has risen as the first fruit of the renewed creation! So, on Easter Sunday we should cook up a storm.

Erin and I love setting a large table for a diverse group of friends. Our street-adjacent friends feast together with people who are housed. We often include a time of sharing around the table. We find it helpful to invite people to share an answer to a specific question (such as, "What is something from the past year you are thankful for?"). In this way, the group has an opportunity to hear and to bless each person who attends.

4. Creative kinship. The fourth movement in the festival calendar is creative kinship. Creative kinship and generosity are a reflex response to thanksgiving, the other side of the coin of gratitude, as it were. As a family pilgrimages to the chosen place, it is a crowd! The male and female servant, the refugee, the fatherless, and the widow among us must be there too. Deuteronomy lists the participants twice (Deut 16:11, 14).

> Rejoice [feast][20] before the LORD your God—you and your sons and your daughters, your male and female slaves, the Levites resident in your towns, as well as the strangers [refugees], the orphans, and the widows who are among you—at the place that the LORD your God will choose as a dwelling for his name. (Deut 16:11, 14)

What does this incorporation of vulnerable people into the community mean for our worship today?

The question of what is "right worship" or "biblical worship" is a central tenet of the Reformed tradition. Richard L. Pratt, for example, rightly reflects: "We must have positive biblical support for all that we do in worship."[21] Agreed. And what does Deuteronomy teach us? To come before the Lord aright, we must come before the Lord with vulnerable people by our side:

[20]In the Old Testament world, emotions are often experienced as rituals. Here, rejoicing is experienced in the context of a feast. See further, Gary Anderson, *A Time to Mourn, a Time to Dance: The Expression of Grief and Joy in Israelite Religion* (University Park, PA: Pennsylvania State University Press, 1991), 1, 14-18.

[21]Richard L. Pratt, "The Regulative Principle," Thirdmill, www.thirdmill.org/articles/ric_pratt /TH.Pratt.Reg.Princ.html. Here Pratt offers a nuanced articulation of what is known as the Regulative Principle of Worship. The Regulative Principle asserts that Scripture alone provides the form and content for Christian worship. See, for example, John Calvin, *On the Necessity of Reforming the Church* (Sanford, FL: Reformation Trust Publishing, 2020).

people who have been refugee-d, vulnerable immigrants, people who have run out of money, people suffering from addictions. We are not permitted to come before the Lord in any other way. We will unpack this element further in the following chapter.

Conclusion: Feeling the Groove

This chapter began with an urgent call for creativity in worship, for worship that resists the strong pull toward mimicry. A rich pathway for incarnational communities is to conceive of worship as polyrhythmic, layering rhythms of 1. Scripture, 2. community, 3. neighborhood, and 4. wider church. Having played these polyrhythms, we then carried our instruments to the festal gathering of ancient Israel to share in food, dancing, and worship! At the feast, we played our polyrhythms before the Lord. We lamented. We celebrated the good gifts of God with thanksgiving. And we responded to God's embrace by embracing the most vulnerable among us as kindred.

> *To come before the Lord aright, we must come before the Lord with vulnerable people by our side: people who have been refugee-d, vulnerable immigrants, people who have run out of money, people suffering from addictions.*

There is much to consider here. If this list feels overwhelming to you, or too much for your community to take on, what piques your curiosity? Are there one or two baby steps that the Spirit is inviting you to consider?

Or perhaps you have the opposite experience: perhaps you are ready to jump in and renew worship in your church. If you feel a growing passion to nourish polyrhythmic worship in your community, praise God! But pause for a moment. Don't go changing everything, even if you can. Your community has its own history, its own symbols and rituals, and you will need to work with these. Discern prayerfully: What is a baby step for my community?

As we refresh our worship, we should keep in mind that for most of Christian history worship has not been confined to the Lord's Day as it tends to be today. Other practices throughout the week, such as keeping hours of prayer, household worship, confession, healing prayer, and teaching have

also been part of Christian worship. In this light, chapter twelve on prayer should be seen as an extension of the present chapter.

Worship shapes our distinctive life together, our shared life. Next, we explore directly this much misunderstood dimension of witness: shared life.

Shared Life

A JAZZ ENSEMBLE is a community in which each member listens deeply to the others, senses the energy and emotion of the others, in order to create something new. Walking onto the stage, we agree to engage in a shared life that is nothing less than a communication, a witness to others. Wynton Marsalis reflects:

> When you are playing music (it is hard to explain verbally), you enter another world; it's very abstract. And your sense of hearing is heightened. You are listening to another person, and you are trying to absorb everything about them: their consciousness, what they mean when they are talking to you, what they are feeling like, where you think they are going to go.[1]

Marsalis goes on to say that while this interpersonal connection is characteristic of jazz music, it is rarely experienced with intensity. I think the same can be said of church: shared life is characteristic of the church (Mk 3:34-35), and yet a rich expression of our shared life is rare. However rare, this rich expression of our shared life is important because Shared Life, the sixth note for improvising community, is the beginning of witness.

With its high highs and low lows, our shared life is where embodying Christ within our neighborhood begins. Through our shared life of worship, welcome, and work, we begin to experience what it means to witness to Christ in *life*, word, and deed. While this aspect of witness took me the longest time to understand, in fact, this is the heart of witness: our contrastive *life* (1 Pet 1:12). Our shared life is, in many ways, the heart of this

[1] Wynton Marsalis, from the documentary miniseries *Jazz*, directed by Ken Burns (Florentine Films, 2001), episode 6.

book. Scripture and prayer are in some ways more vital, and yet in our shared life all of these themes not only converge, but we experience them with depth and power. That is to say, we can only discover the full expression of Scripture, prayer, worship, place, conversation—all that we discuss in this book—as we go deeper into our shared life.

I sometimes have the joy of speaking with church groups about the shared life that God calls us into. People tend to be captivated by the vision, and yet people often ask me whether we need Jesus to live this way. "Can't you just live it?" they ask. "It doesn't have to be Christian, does it?" I often respond to this question by speaking about my friend David's experience.

David left the church with a deep and ongoing admiration for it. He explained to me, even as he slid out of the church, that he continued to cherish the Christian vision for community. He wanted Christian community, but without the Christianity. David painted a picture of the rich community that he had experienced within the church to two of his work friends. *Maybe this vision for a rich shared life would engage his work mates?* he hoped. *Maybe they could start something together?* One day, David reported to me: "They did it, Mark! My workmates have started a community . . . but they didn't invite me." I sensed that David was both excited that this vision was being lived out and at the same time hurt that he was being excluded.

I found David's report profoundly significant: they started a community, but they neglected him. At times David can come across as a little socially awkward, a little odd, though he is creative, bighearted, and as sharp as a tack. I wondered whether David's social awkwardness is why he was overlooked and whether there is a lesson here for the church.

David's workmates started a community, and yet they excluded my friend. Many attempts at community turn into affinity groups. It is very difficult to live inclusively and sacrificially without Jesus as our model: Jesus as he comes to us in Scripture, as the fulfillment of the whole biblical story. It requires the indwelling Spirit who rebirths those who are in Christ as "new creation" (2 Cor 5:17).

This chapter casts a vision for the shared life of an incarnational community. Incarnational communities are churches that seek to be a makeshift family together, sharing in worship, meals, dwellings, rest, play, prayer, creation care, advocacy, celebration, grief, justice seeking, art making, and

more. They share life in a particular place. They bring the weakest among them into the center of the community.

Here's a glimpse into our Vancouver church: one evening, the regional minister called a meeting with some leaders. We gathered in the living room of one of our people, and the regional minister thanked us all for coming. The host responded casually, "Oh, we are always doing this. We are always hanging out, bumping into each other, doing things together!" And we do. We worship together and we do the Lord's work together, in the neighborhood that we love.

It's hard to illustrate this kind of community in words, and there is no single model. The little row of houses we live in will give you a peek into one way it can look. Our three houses all belonged within the same worshiping community (until I left my pastoral role). We hold different aspects of Christian discipleship for one another—in partnership with other households in our community. In our house, the Glanville house, we are particularly active in advocating for refugees. Next door is involved with land and food justice. This house organizes twenty or so households in our community to buy from local farmers. The next household up the hill (we live on a steep hill) has converted their garage into a prayer space. Life's not perfect, and people aren't perfect. But there is a feast before us when we are committed to one another for the long haul, in Christ. As Dawn Humphreys, of Strathcona Vineyard in Vancouver, reflects, "It takes our whole life to live this way, and it's so hard to live against the grain of culture." Dawn wisely adds, "It takes tons of worship and prayer."[2]

Deuteronomy's Festive Kinship

Chapter five, "Worship in Polyrhythms," examined the festival calendar of Deuteronomy 16:1-17. There we traced a four-part movement that is at the heart of a biblical worldview: lament, gift, thanksgiving, and creative kinship. In this chapter, we will take a deeper dive into creative kinship.

Remember from chapter five that a whole household would pilgrimage together to the chosen place for the feast. A household would likely include grandparents, who would join in the journey if they were physically

[2]Dawn Humphreys, lecture on incarnational community given at Regent College, 2022.

able. En route too are servants, refugees, the Levite (who is a resident priest), the fatherless, and the widow. The invitation-command to feast lists the participants:

> Rejoice [feast] before the LORD your God—you and your sons and your daughters, your male and female slaves, the Levites resident in your towns, as well as the strangers [refugees], the orphans, and the widows who are among you—at the place that the LORD your God will choose as a dwelling for his name. (Deut 16:11, 14).

The repeated list of festal participants is emphatic, communicating that the participation of the weakest in the community at these cultic feasts was of utmost importance to God.

Imagine the transformative experience of participating in Deuteronomy's feasts! Imagine sharing together in the winding pilgrimage, the ascent into Jerusalem, the recipes, the smell of boiling meat, the dancing, and the laughter! And God's gifts are given to every person in the community, to be enjoyed by all.

The shared experience goes deeper than simply the sharing of resources. Cultural anthropologists tell us that in feasting cultures, social relationships can be rearranged through a feast. People are knit together as a family as they celebrate.[3] As the community eats and dances in Yahweh's presence, a nuclear family is joined together with the weakest among them as a makeshift family. Elsewhere I have called this joining together of human lives through feasting, "festive kinship."[4]

In the Old Testament, through feasting, the people of God are being reshaped as family, a family that brings the weakest among them into the center. Today in God's household, the boundaries of our lives can be softened, allowing others to enter in, to make themselves at home, and even to move the furniture around a bit. We can welcome others because we ourselves have been welcomed by God. Scripture's vision of embracing one another as family together is far richer than mere charity. God's invitation to

[3]To be sure, meals have the capacity to both unite and divide. However, here Deuteronomy's feasts display elements of *communitas*. See further, Mark R. Glanville, *Adopting the Stranger as Kindred in Deuteronomy* (Atlanta: SBL, 2018), 151-74.

[4]On "festive kinship," see Mark R. Glanville, "'Festive Kinship': Solidarity, Responsibility, and Identity Formation in Deuteronomy," *Journal for the Study of the Old Testament* 44 (2019): 133-52.

become a makeshift family means reassessing which relationships we prioritize. The truth is, we all choose to knit together as family with someone or another, and yet we often select people who are just like us.

Though we do so imperfectly, Erin and I seek to shape our lives according to biblical kinship. Before Erin and I had met, we each had a habit of prioritizing relationships with people who experienced marginality. We both loved bringing people who felt like they belonged on the margins of society into the center of our communities—Erin in Canada and me in Australia. As you can imagine, this is now a value that we share as a family. We practice festive kinship, Deuteronomy-style (or is it Jesus-style?). We think intentionally about who we eat with.

And I'll let you in on a secret about our dining space: our plates and glasses don't match too well. Now, I really love visiting friends who set a beautiful table, but that's not us. A few years ago I noticed a curious pattern here. I noticed that when we have well-to-do guests to dinner, I feel self-conscious of how our table appears, that it doesn't look classier. But when we share meals with our friends who experience vulnerabilities, I feel self-conscious of how nice our table and home look. I realize that our comfort can make our guests feel uncomfortable, that they don't really belong here. This reminds me of my abundance and of how I need to be generous, both with my money and with my heart. Of course, this curious pattern also shows the tremendous importance of being a makeshift family with people who are different from us. Our friends can save *our* souls.[5]

Returning to Scripture, we see Deuteronomy's ethic of kinship in the life of Jesus. New Testament scholars have reflected that Jesus ate his way through the gospels! In Luke's gospel, Jesus seems to do as much eating as he does teaching. More accurately, Jesus does a lot of his teaching while sharing a meal. In Jesus' day, people with honor used meals to establish and to maintain boundary markers (see Lk 14:7-11). But Jesus did just the opposite. He had a reputation for eating with the "wrong" people according to the customs of the day, people who were in fact the "right" people from the perspective of the kingdom of God. So, the Pharisees and the scribes

[5]Our vulnerable kin can "save our souls" in the sense that they point us to Jesus, the suffering servant (Is 52:14-15; Mt 25:34-40), to our dependence on him, and to Jesus' call to biblical kinship.

grumbled against Jesus: "This fellow receives sinners and eats with them!" (Luke 15:2). Jesus didn't invent the idea of sharing meals with outsiders. Rather, reading forward from Deuteronomy, Jesus was simply being what Old Testament Israel was always supposed to be. He was sharing in festive kinship, in communion with the Father. Those whom first-century Judaism shunned, Jesus tended to privilege as his kindred.

In sum, an incarnational community reflects a *biblical ethic of kinship*. A biblical ethic of kinship reshapes our relations as a makeshift family, bringing the weakest into the center of the community. And our creative kinship is crucial for our witness.

Our Shared Life Is the Heart and Hearth of Witness

The shared life of an incarnational community is the heart and hearth of witness. Our shared life, with its thrills, creativity, intangible connections, and pain, is where communicating Christ within our neighborhood begins. We receive the healing of Christ in a particular neighborhood as we are knit together as family. And we extend that healing of Christ into the neighborhood as Christ moves within us and through us. Coming before God together in worship and working together for the life of the world, we begin to experience what it means to witness to Christ in life, word, and deed.

In my own journey of understanding the biblical story, I was quick to recognize what it means to witness in word and deed. Yet it took a few years for me to comprehend what it means to witness in our life. It is clear from Deuteronomy 16:1-17, the ancient festival calendar, that our witnessing life isn't an individualistic enterprise, rather

> *A biblical ethic of kinship reshapes our relations as a makeshift family, bringing the weakest into the center of the community.*

it is the shared life of a community. Think of festive kinship, think of communal celebration and lament, think of bringing the weakest to the center, think of a community of people living for the life of a neighborhood in the name of Christ—that's our witnessing *life*. The shared *life* of an incarnational community is the beginning of witness. While this aspect of witness took me the longest time to understand, in fact it all starts here: witness to Christ starts with our contrastive *life* (1 Pet 1:12). As a makeshift family we talk, eat,

love, cry, protest, dance, worship, discern, enfold, pray, study, wound, forgive, heal, and more. And as we do, people often get curious.

What a Shared Life Requires

Our shared life requires much Spirit-filled effort and imagination (chapter four, on beauty, explored the need for creativity). Here I offer some stepping stones for a rich shared life. First, a rich shared life requires all of the attributes of incarnational communities represented by the chapters in this book. Shared practices of prayer, kinship, Scripture study, worship in polyrhythms, conversations, creativity, and being leader-full: all of this is vital. Locality is vital too: we share in these practices in a particular place. We receive and extend the healing of Christ *here*. In what follows I will focus on qualities of a rich shared life that don't already have a chapter devoted to them.

A rich shared life requires dying to idols of large numbers and of a large budget. Incarnational communities are often smaller in size and less sensational on the surface. To be sure, large churches can be faithful and exciting too. And yet the slow work of incarnational faithfulness is often suited to smaller communities. In the norm, Western churches seek to be attractional, numbers-driven, and oriented around a dynamic senior pastor; however, we are called to something different. We are called to be faithful right where we're planted, with the people we've been given, the resources and tasks that are ours. Let's not pray for a large church, let's pray for a faithful church, whether small or large. Let's pray for a church that displays the tenderness of Christ in a neighborhood you love. Was this not the shape of the house churches of the earliest Christian centuries? Their beautiful lives raised curiosity, stirring questions about what was behind it all. Consider this description of the life of the early church from the Epistle to Diognetus, circa 130 CE:

> They love all men, and are persecuted by all . . . They are poor, yet make many rich; they are in lack of all things, and yet abound in all.[6]

A rich shared life requires bighearted leaders. By bighearted I mean full of love, emotionally healthy, able to defer to others, free from any

[6]"The Epistle to Diognetus," in Philip Schaff and Henry Wace, eds., *The Ante-Nicene Fathers,* vol. 1 (Grand Rapids, MI: Eerdmans, 1991), [V] 23–30, at 27.

psychological need to lead, and reliant on God. Bigheartedness includes learning to be kin-keepers (kin-keepers are people who keep the family connected). And bigheartedness means being a makeshift family with people from vulnerable backgrounds.

For example, Simeon Pang, director of the Thursday night community meal (for our street-adjacent neighbors), is one of my heroes. After the meal on Thursday evenings, at around 10 p.m., Simeon would sweep the floor of our church eating hall. Inevitably someone would stay behind and seek Simeon's company and conversation while he swept and cleaned. For myself, come 10 p.m. after a big event, I am emotionally spent and have nothing left to give. But whenever I walked in on Simeon at this time, he was always listening, responding, and chatting away. Simeon is the kind of a bighearted leader who is the heart and hearth of a community.

A rich shared life requires bighearted followers. Vibrant communities require faithful Christ-followers whose secret service only the Father sees and promises to reward. For every one of us, our lives can be characterized by hidden acts of kindness, generosity, forgiveness, and service. No matter our role in the band, we can all take turns at supporting others as they take a solo.

A rich shared life requires the fruit of the Spirit. Living in community for the long haul, we inevitably hurt one another and tire one another out, time and time again. For a shared life to be sustained, we must be committed to growing in the fruit of the Spirit. This includes, especially, being ready to forgive one another. The apostle Paul writes, "The fruit of the Spirit is love, joy, peace, patience, kindness, generosity, faithfulness, gentleness, and self-control" (Gal 5:22-23). For some years, I found the fruit of the Spirit puzzling, for it seemed so individualistic—and yet the Bible is so communal! I don't know if you, too, have puzzled over the fruit of the Spirit in this way. Then one day it clicked for me: these characteristics are the clothing we need to put on if we are to be the *beloved community* (Col 3:12). We are all responsible to demonstrate this fruit in our life together. As Dawn Humphreys reflects, "Christian community requires humility, character, formation, and a lot of breaking bread."[7]

A rich shared life requires us to be generous and to rely on one another. The paradigmatic description of the early church in Acts 2 emphasizes

[7]Dawn Humphreys, personal communication on March 28, 2023.

generosity and mutual reliance: "They would sell their possessions and goods and distribute the proceeds to all, as any had need" (Acts 2:45). For the Glanville family, generosity from friends and family has enabled us to get by. Just when we were scraping the bottom of the barrel, God provided for us through the generosity of others. Generosity can be a double blessing when the giver is also willing to be a recipient, whether of gratitude, friendship, or other intangible gifts. If you are able to give to someone, then you should also be ready to receive from them, alert to ways that God is blessing you through the relationship. In this way, your relationship can be mutual, a two-way street, a shared life.

A rich shared life requires protocols for safe ministry. Maybe this requirement takes you by surprise. But I am convinced that abuse, whether sexual, spiritual, physical, or psychological, occurs in almost every Christian institution, from time to time. Children, teenagers, vulnerable adults, and women are most often the victims. As a rich shared life brings the blessing of close proximity with one another, we need protocol for safe ministry. Whether you are starting in a new leadership role or have been in a leadership role for years, consider taking initiative in drafting and establishing safe ministry protocols if this is not already a part of the culture of your community.[8]

Discipleship

I hope you can see that our rich shared life together has everything to do with *discipleship*. And yet, discussions around discipleship in evangelical circles are worryingly thin. Discipleship is all too often reduced to knowing your Bible and apologetic evangelism, with sexual purity thrown into the mix.[9] This is a tragic reduction of the Christian life and of Christian community. Taking the whole Bible into account, I suggest that *we receive and offer discipleship as we share together in the welcome, worship, and work of God.* In other words, discipleship takes place in the context

[8] As you proceed, it is best to partner with an organization that specializes in protection protocol, such as Plan to Protect, an organization based in Ontario, Canada.

[9] Discipleship all too often tends to be viewed individualistically (e.g., Bible knowledge, marriage course) and institutionally (e.g., how to lead a small group). While these activities are good in and of themselves, discipleship in the gospels involves following Jesus in the context of the contrastive life of Christ's family (e.g., Mk 2:13-14; 3:31-35).

of our shared life, and it includes just about everything that we explore in this book. Is this not how Jesus discipled his disciples, by sharing life with them?

There is a moment in the story of jazz that illustrates how biblical discipleship works. In 1922, the young Louis Armstrong moved from New Orleans to Chicago to apprentice with King Oliver and his band. Both Oliver and Armstrong played the cornet, and both were on the leading edge of the emerging tradition of jazz improvisation. On the stage, they would weave melodies around one another in a way that gave the impression that each musician knew what the other was going to play before they played it. In those days in Chicago, everyone seemed to play an instrument. One dazzled young musician remembered: "There was so much music in the air, that if you held up a horn, it would play by itself."[10] This is how biblical discipleship works. We can't help but be transformed by the "music in the air" as we are immersed together in the welcome, worship, and work of the kingdom.

> *Taking the whole Bible into account, I suggest that* we receive and offer discipleship as we share together in the welcome, worship, and work of God.

Intercultural Communities

Intercultural competence is a final requirement for a rich shared life, and we now turn to this important topic. My friend Tama is a creative Christian leader. Tama once commented to me that when she walks into a café and sees a diverse group of people sitting together and talking with deep connection, she intuitively knows it is a church group. She buys a coffee and sits down next to the group to listen in and see if she is right! Tama's image of Christ-followers from diverse backgrounds sipping coffee, joined together in love reminds me that diversity is in our DNA.

Yet not everyone agrees. A keystone in the Church Growth Movement has been the call to pursue homogeneous congregations. The pathway to growth is to appeal to common preferences and cultural experiences. What has become known as the "homogenous-unit principle" is sage advice accepted by tens of thousands of Christian leaders. A more subtle approach

[10]Wynton Marsalis, *Jazz*, episode 2.

that tends to produce the same result is to zero in on a "target group," as a guide for church marketing and worship. How does this all square with Scripture? Not too well.[11]

In Old Testament times, outsiders profoundly shaped and enriched Israelite culture, community, and experience of God. For example, the book of Ruth is at pains to point out that the Moabite Ruth contributed to the Davidic lineage (Ruth 4:13-22). And in the book of Job, Job, a foreigner from Uz, teaches Israel how to stay connected with God under profound suffering (Job 1:1). Or—I love this one—remember Jethro the Midianite's counsel to Moses regarding the complexities of administration (Ex 18:1-27)? The very words of Jethro are taken up within the Pentateuch itself, in the law offices and the judiciary (Deut 1:8-18). The Midianite's words become the very words of Scripture! And, we might add, we have already seen that the stranger participated in Deuteronomy's cultic feasts (Deut 16:11, 14). We should imagine that strangers weren't merely recipients, but that they arrived at the feast ready to contribute distinctive spice blends, cooking styles, dance moves, and rhythms from their own culture.

These texts offer a preemptive glimpse into the richness of intercultural community that unfolds in the New Testament. In the book of Revelation, for example, the unity of the body of Christ does not erase ethnicity and cultural expression. Rather, this rich diversity is brought before the throne of God in worship (Rev 7:9; 21:24-26). These texts remind us that no one cultural group can fully understand the gospel or know how to share the gospel alone. Each culture brings unique insights to the table.

The biblical story compels us to nourish *intercultural* worshiping communities. While the term *multicultural* refers to communities that consist of people from a diversity of cultures, the term *intercultural* is used where these diverse cultures are brought into conversation with one another, where people from diverse cultures take turns at leading, and where the distinctives of each culture are not diminished. Churches that are seeking to be

[11]For a detailed scriptural critique of this view, see C. René Padilla, *Mission Between the Times: Essays on the Kingdom*, rev. ed. (Carlisle, UK: Langham, 2013), 158-83. A "target group" approach is not always misguided. For example, a church may seek to reflect the cultural demographic of its neighborhood by reflecting certain cultural aesthetics in its worship and leadership.

intercultural are displaying the diversity and humility of the body of Christ in unique ways, as an example to the wider church. It seems to me that this is one of the most exciting movements of the Spirit today. And yet nourishing intercultural communities is slow work.

Intercultural communities seek to reflect the cultural diversity of their neighborhoods. Let's briefly consider seven trajectories for communities that are seeking to be intercultural. The first trajectory is fostering intercultural competence among church leaders. "Intercultural competence is the capability to shift perspective and adapt behavior to cultural difference and commonality."[12] My friend Elsie Lo trains leaders in intercultural competence. I asked Elsie what she wishes every White pastor would know. She answered:

> They should have an awareness that they also have a culture. It's not just minorities that have a culture. Culture is the way that they see the world; all that has shaped them. That's the biggest blind spot. "I don't have a culture," they assume. "You have a culture—you are swimming in it."[13]

For White leaders (like myself) to recognize that we have a culture and then to respond appropriately requires internal changes, as well as external changes. Do I have the humility to slow down and to watch how others move in a space, to quiet down and to listen to how others speak?

Second, sharing deep and ongoing relationships across cultures is a pathway for nourishing intercultural communities. The nearer these relationships are to our most intimate circle the better. Elsie commented to me, "The transformation happens in ourselves when some of the most trusted relationships that we have are intercultural." Sharing food with one another across cultural groups can be a stepping stone.

A third trajectory is diverse leadership. Ideally the top level of leadership in your church reflects the cultural diversity of the community. This means, especially, board members and preachers—the cultural diversity of these key leaders predicts the cultural diversity of what your community is becoming. Our eleven-year-old daughter attends a summer camp run by African

[12]*Intercultural Development Inventory* (Mitchell R. Hammer and IDI LLC), "Individual Profile Report," 3.

[13]Elsie Lo, personal communication on June 19, 2023.

Canadian leaders. One sunny afternoon as I sat waiting for the camp to finish, the director sat down next to me. She said to me, "This might be the only time in her life that your daughter is mentored by a Black person. It's very important for her development." The director's impromptu lesson has stuck with me. Since that conversation, where possible I try to arrange for non-White leaders to mentor White mentees.

Fourth, be alert to the tendency of multiethnic churches to merge diverse cultural expressions into one style, erasing the cultural distinctives of various cultures—usually into a generic Western style. Soong-Chan Rah states, "Our goal in cultural intelligence . . . is not to erase cultural differences but rather to seek ways to honor the presence of God in different cultures."[14]

> *The cultural diversity of these key leaders predicts the cultural diversity of what your community is becoming*

Fifth, intercultural fellowship requires learning and understanding our cultural, institutional, and local histories. Whether we recognize it or not, the momentum of our histories defines our lives and relationships.[15] Take time to learn one another's cultural stories.

Sixth, some immigrant churches have unique intercultural challenges. In immigrant churches, often an older generation that immigrated seeks to re-create home by preserving cultural languages and practices in the church. The second generation (or 1.5 generation) is often largely enculturated into the new context. The second generation desires ways of being together and worshiping that reflect the surrounding culture. The result is often a profound tension, with the younger generation all too often walking out. These intergenerational contexts require leaders with sky-high emotional intelligence who can facilitate complex conversations (see chapter ten, "Conversations"). And as we strive to live well together in cultural diversity, we need something bigger than culture to shape our lives together. We need Christ as our center. We explore the seventh trajectory, intercultural worship, below.

Intercultural community is exemplified in the jazz art form. Jazz musicians who have never met one another before, often from diverse cultures,

[14]Soong-Chan Rah, *Many Colors: Cultural Intelligence for a Changing Church* (Chicago: Moody, 2010), 29.
[15]See further, Rah, *Many Colors*, 41-59.

join on stage and call a tune. From the first note to the last, musicians are listening to one another, bouncing off another's rhythm, co-creating a shifting kaleidoscope of harmony. As Marsalis puts it: "That's our art. We can now have a dialogue. We can have a conversation. We can speak to each other in the language of music."[16] In a similar way, Christ desires to be our center as we negotiate our shared life in Him, listening well to one another, bouncing off another's unique riffs to create something that is greater than the sum of the individuals—while never erasing the individual or their culture—a spiritual community offered to God.

Intercultural Worship

Seventh, intercultural communities can worship interculturally. In chapter five we named intercultural worship as contributing to the poly-rhythms for renewing worship. Worshiping in a way that genuinely expresses the diversity of the people of God is essential for knowing God in all of the richness with which God is revealed to us in Scripture (Eph 3:9-10). Worshiping with my African friends, I am sometimes reminded that God speaks in visions and dreams. Worshiping with my Latino/a sisters and brothers, I am sometimes reminded of the delight of a warm embrace and of celebration! For myself, in my Aussie-ness I bring lighthearted warmth (surely that, too, has a place in the kingdom of God!). Intercultural worship is not an attempt at being progressive, rather it is responding to Scripture's call to worship, a call that resounds out to every people group of the world, inviting us to worship in unity (see Ps 117, for example).

How do we nourish intercultural worship in our church? Intercultural worship requires more than singing songs in a diversity of languages, though this is certainly helpful. Intercultural worship requires us to invite leaders who are not a part of the dominant culture to shape worship and to lead worship. Sandra Maria Van Opstal compares this to hosting a party: if the hosts only represent one cultural group, then there will only be one kind of decoration, one kind of music, one kind of cuisine, she explains.[17] In the

[16]Wynton Marsalis, *Jazz*, episode 1.

[17]Sandra Maria Van Opstal, *The Next Worship: Glorifying God in a Diverse World* (Downers Grove, IL: InterVarsity Press, 2016), 80.

same way, when it comes to worship, "All leaders have strong preferences, even about leadership, that are shaped by social and cultural location."[18] So the leaders who are shaping and leading worship need to reflect the diversity of our community. As we invite people into leadership, we need to also release people from diverse backgrounds to be genuinely themselves and to shape the worshiping life of the community. It is not always easy. Taking steps in intercultural worship will require your community to grow spiritually and emotionally, to move beyond personal preferences for the sake of the body of Christ.

Preaching that Forms our Shared Life

In light of our discussion of a shared life, it is helpful to make some comments on the task of preaching. Many seminary graduates enter pastoral ministry with the impression that preaching is 95 percent of the job (thanks to the mode of training they have just received). However, you can probably sense that shepherding an incarnational community calls forth much more of our humanity than only our homiletical gifts. Pastors are kin-keepers, guests, worshipers, pray-ers, facilitators, neighborhood-lovers, siblings, artists . . . And yet, *we preach*. So preaching must nourish our shared life.

We preach Christ to nourish the witnessing life of our particular community, at a particular moment. There is no such thing as an abstract sermon, a sermon that will do for any old location. Rather, we preach at a particular moment in the journey of the shared life of a particular Jesus-community, located in a particular neighborhood. The preacher has a unique and spiritual role of discerning and of naming what God is doing among us as we journey together.

Here is an experiment, one practice that you can try. Think about how you offer an invitation to your congregation, often done at the end of a homily. Try refocusing these invitations on finding new imagination for your community. Consider, for example, how using first-person plural pronouns, "we" and "us," could facilitate this goal. For example, you might say, "Is there an invitation here for us?" "How is this text shaping us, as we . . . ?"

[18]Maria Van Opstal, *The Next Worship*, 81.

The visual image of Deuteronomy's festivals might get you thinking: What other biblical images and metaphors can stir our imagination for the outward movement of the church? The next chapter offers three such biblical images: healing, kinship, and maternal nurture.

Healing, Kinship, and Maternal Nurture

IN JAZZ, TRIPLETS are profoundly important and yet strangely inscrutable. Triplets are a group of three notes that are played in the place of a group of two notes. The "triplet" has to do with rhythm. We experience the triplet feel many times a day in our everyday speech. Try saying the phrase, "Go down the street," stressing the words "go" and "street." The first three beats in this phrase form a triplet. This is a triplet feel! In fact, the swing feel, which is that feeling in jazz that makes you want to dance along, depends upon the triplet. Barry Harris, thought by many to be the greatest jazz piano teacher who has ever lived, claims that the triplet feel is sacred, being related to the Holy Trinity—Father, Son, and Spirit.

The seventh note for improvising community is played as a triplet. Healing, kinship, and maternal nurture are a triplet of themes—a triplet of tenderness. These three motifs, played together in Christian community, become a melody of beauty, the sound of the tenderness of God in Christ. This triplet of tenderness is expressed most powerfully by a community that believes that it is sent by God into a particular neighborhood. While a chapter like this would normally be titled something like "Social Justice," the biblical themes of healing, kinship, and maternal nurture are motifs for witness that can give us fresh vision for compassion within an environment in which calls for justice have become lost in the noise of ideological debate.

Be assured that I'm not claiming any special authority for this chapter based on the number three! However, biblical healing, kinship, and maternal

nurture *are* metaphors from sacred Scripture. And together they give us a glimpse into the tenderness of God as a pathway for living well in the world.

Yet why introduce these three metaphors? Currently in the missional conversation there is a crisis of theological imagination. At risk of oversimplification, if the dominant biblical themes within Western Protestant discourse of the twentieth century were the covenant (in the Reformed tradition) and the atonement (in the evangelical tradition), the dominant metaphor for the global missional conversation in the past decades has been the kingdom of God.[1] To be sure, much is gained by centering the kingdom of God in biblical theology and witness. The theme of the kingdom emphasizes Christ's redeeming lordship over all the creation. And we can and should keep using it. Nonetheless, this metaphor is highly contextualized to the imperial rule of ancient Rome, and in that context was a means of declaring who is the true King and what his kinship entails. When retelling the gospel in post-colonial, post-Christian contexts, themes of kingship and rule need additional explanation. While the metaphor of the kingdom of God helpfully emphasizes Christ's lordship, it also requires some clarification before Christ's tenderness is on display to people unfamiliar with the church. Thus, it is timely for us to explore three underutilized biblical metaphors for Christian witness: healing, creative kinship, and maternal nurture. These metaphors can be both an avenue for speaking about Jesus and also a pathway for the life of the church.

Healing

In Western cultures today, many people pursue physical health, emotional health, and spiritual health as pathways for living well. People eagerly draw from healing practices found in diverse spiritual and cultural traditions, appreciating the physical and holistic benefits of practices such as yoga and meditation. Could healing be a point of connection between culture and Scripture? Could it be timely for us to draw on the biblical motif of healing as an image for the witness of the church that believes it is called to its neighborhood? This past week, my brother-in-law, Pastor Dave Groen,

[1]For a thoughtful discussion of the kingdom of God that emphasizes its centrality to the biblical story, see N. T. Wright, *Scripture and the Authority of God: How to Read the Bible Today* (New York: Harper One, 2013), 28-30.

attended his church youth group for a Q and A session. Dave was impressed as a thirteen-year-old girl asked the group, "How do I love people who are dangerous, whether physically or emotionally?" Dave was struck by the perceptiveness the teenager displayed in recognizing the importance of both physical and emotional safety. This is characteristic of her generation. Surely, our churches need to be speaking and acting in ways that support and connect with these good desires. Healing is holistic, like the gospel itself.

We begin with the Old Testament. Soon after the exodus event, at the waters of Marah, thirsty Israel grumbles to Yahweh, and Yahweh provides drinking water. Then Yahweh declares:

> "If you will listen carefully to the voice of the LORD your God, and do what is right in God's sight, and give heed to God's commandments and keep all God's statutes, I will not bring upon you any of the diseases that I brought on the Egyptians; **for I am the LORD who heals you.**" (Ex 15:26, adapted from NRSV)

In this verse, not only is Yahweh Israel's healer—which is a wonderful thought—but the very keeping of Torah (the law of the Old Testament)[2] is the conduit for divine healing. This is reminiscent of Psalm 19, which describes the perfection and beauty of the law, which is sweeter than honey. How does the law heal? Yahweh's law is attuned to the rhythm and harmony of the creation itself. So in keeping God's law, Israel's communal life joins in the "groove" of the created world, no longer contributing to the cacophony. In this way, Yahweh's law brings healing.

In the moral logic of the text, the opposite is also true. Pharaoh's accumulative and oppressive rule had resulted in Yahweh bringing disease on the Egyptians. Now, Yahweh has emancipated the Hebrew people and is shaping them into a contrastive community, a community of tenderness, through the law. Healing in Exodus 15:26, then, is metaphorical, at least in part. Healing expresses the mending and flourishing of life guided by the Word of God, which is sweeter than honey dripping from the honeycomb (Ps 19:10).

[2]The three major law collections of the Old Testament are found in Exodus 20–23, Leviticus 17–25, and Deuteronomy 12–26.

Turning to the New Testament, Jesus taught and demonstrated that God's kingdom effected physical healing and wholeness, restoration of purity and communion. It even restored the dead to life.[3] Consider Jesus' healing of the man with paralysis (Mk 2:1-12). Jesus not only healed this man's body, but he also forgave the man's sins. Physical healing and forgiveness of sins belonged together in first-century Judaism. When the Gospel writers speak of forgiveness of sins, they mean more than dealing with a legal verdict. The word for "forgiveness" in the New Testament has more scope. It points to the idea of release: release from exile, from sickness, from rebellion, from the influence of the evil realm, from social exclusion, from impurity, and from every other bond of sin's curse.[4] When this man with paralysis was brought to Jesus, the release from sin, impurity, isolation, infirmity, and the evil realm—that comes with the kingdom of God—saturated him.

Healing in Scripture, then, can be multivalent. For one, there is physical healing, as we would expect. Physical healing is interrelated with social and spiritual dimensions of human wholeness. In some texts, the concept of healing is representative of restoration from suffering and brokenness generally (e.g., Ps 103:3-5), or even of the restoring arc of Scripture in its totality (e.g., Rev 22:2). Healing, as a motif for witness, is simultaneously personal, communal, and cosmic.

Today, the church-as-healer must first receive the healing of Christ. In prayer and worship we reclaim our status as beloved in Christ and we bring the weakest among us into the center for our healing. By immersing in Scripture we are healed, as the "law" that is sweeter than honey drizzles through our lives and attaches to everything. And a bit like a hospital patient who provides a fellow patient with a glass of water, we extend Christ's healing. We follow Christ, who is mending

> *In prayer and worship we reclaim our status as beloved in Christ and we bring the weakest among us into the center for our healing.*

[3]This paragraph uses and summarizes a fuller discussion in Mark R. Glanville and Luke Glanville, *Refuge Reimagined: Biblical Kinship in Global Politics* (Downers Grove, IL: IVP Academic, 2021), 84-86.

[4]For further discussion see Pamela Shellberg, *Cleansed Lepers, Cleansed Hearts: Purity and Healing in Luke–Acts* (Minneapolis: Fortress, 2015), 111-13.

the fabric of human life in every dimension: physical, spiritual, familial, marital, vocational, financial, racial, and so much more. Healing is the church's posture as it loves the neighborhood toward life.

A beautiful and practical expression of healing-as-witness is the role of a parish nurse. This little-known role can be a great blessing to a community. A parish nurse blends pastoral care and prayer with medical expertise, offering a ministry of presence and of knowledgeable support. Laurie Duke is a registered nurse who also has gifting in pastoral care and in prayer. She worked part-time as a parish nurse in our community, offering care to people both within and outside of the church. I have rarely experienced Christ through another person as tangibly as I have through Laurie.

The church's ministry of healing can also be expressed as social responsibility, the church taking a role in forming healthy neighborhoods.[5] One way that our Vancouver church has contributed to the health of the neighborhood is through a small business that shares the church office space. This social enterprise provides dignified training and employment for people who face barriers to employment. The organization separates into three smaller social enterprises: one enterprise provides training and work in renovations, another serves the city in making beautiful and functional pottery, and another offers food services. Five pottery kilns fire at 2000°F in the church basement! These three social enterprises have made an extraordinary difference in the lives of individuals and their families, as well as providing high-quality services to our city.

HEALTHY PASTORAL LEADERS

The biblical trajectory of healing prompts Christian leaders to give attention to their personal health and spiritual health. I believe that this is a uniquely exciting time to be a pastoral leader, and yet we need to engage by not only tending to the needs of our people, but also to our own needs. All too often we Christian leaders can inadvertently lead from a place of emptiness and loneliness. We can forget to care for our physical

[5]In Exodus 15:26, healing is interwoven with Torah-keeping. The Torah shaped every dimension of ancient Israelite society, from labor practices to the law court. In this way, the church's ministry of healing can include forming healthy neighborhoods.

bodies, neglecting physical exercise and healthy eating. We can allow our social circles to shrink. We can stay in ministry roles far beyond their expiration date. The first work of Christian leaders is to receive the healing of Christ in every aspect of their lives. From a place of seeking health, we can extend the healing of Christ to others.

In his book, *The Emotionally Healthy Leader*, Peter Scazzero writes, "Everyone has a shadow . . . Your shadow is the accumulation of untamed emotions, less-than-pure motives and thoughts that, while largely unconscious, strongly influence and shape your behaviors. It is the damaged but mostly hidden version of who you are."[a] Each of us leads from our best attributes and also from our shadows. Why not take an hour to do a personal check-in? Or take a retreat to do the same? Assess your personal, spiritual, social, and physical health. Reflect: Is God inviting you into a baby step toward health in each of these areas?

[a]Peter Scazzero, *The Emotionally Healthy Leader: How Transforming Your Inner Life Will Deeply Transform Your Church, Team, and the World* (Grand Rapids, MI: Zondervan, 2015), 55.

Healing can be a motif for witness for a church that believes it is called to live and witness within a particular neighborhood. The social dimension of healing—our need for community and belonging—takes us to the second beat in the triplet, kinship.

Kinship

Kinship is the second motif in our triplet of tenderness, a pathway for the witness of the church in its neighborhood. We have already spoken about a biblical ethic of kinship, as a central cord of biblical ethics. "Kinship" refers to the solidarity of family and family-like relationships. It includes interdependence and a shared identity (at least in part). At first glance, it might seem strange to suggest that kinship is something to get creative with. Surely our kinship connections are stable, with not a lot of wriggle room. Yet with a little thought we realize that we all lean into certain relationships and not others. We choose who we are close to, and we make decisions about the kinds of people who will make our lives meaningful. A little more thought and we realize that some of our friendships are so important to us

that those friends are more like family. Some friends are truly friends for life, our kin.

And yet, so often our kinship connections reflect the homogeneity of Western lifestyles. Most of us naturally gravitate toward people who are like us, or toward people who exemplify the person we hope to become. Usually, we don't think about our kinship connections as an act of following Jesus. Yet throughout Scripture kinship is arguably the place where the gospel makes the biggest difference, where the biblical story turns the world upside down in the most beautiful and tender way.

Kinship is the field on which many biblical texts are moving, though readers (like me) who are immersed in the hyper-individualism of westernized cultures can easily miss it. In chapter six, "Shared Life," we saw that Scripture is reshaping God's people as family, a family characterized by tenderness. We are a family who shares a Father, our divine kinsperson (Mt 6:8-9). Following the example of our divine kinsperson, we enfold one another as family, offering belonging, solidarity, and protection (Deut 16:11, 14). We bring the weakest among us into the center of the community.

A biblical ethic of kinship has potential to stir creativity in social arrangements today. Leading cultural anthropologist Janet Carsten has written a seminal work on kinship. She reflects that kinship, "is, among other things, an area of life in which people invest their emotions, their creative energy and their new imaginings."[6] Scripture invites us into creative expressions of biblical kinship, as individuals, as households, and as church communities. It prompts us to ask: Is there an individual or family who we can embrace in a long-term relationship, perhaps someone who experiences vulnerabilities or marginality? And we can also ask: How does biblical kinship call the church to confront racism? To welcome vulnerable immigrants? To live well within creation? To advocate for those struggling with homelessness? To introduce our colleagues at work to the tenderness of Jesus?

When it comes to family, there is give and take—it is a two-way street. It's the same with biblical kinship. A key characteristic of biblical kinship is mutuality. In the kingdom of God, everyone has an opportunity to be hosted and everyone has an opportunity to host. Consider Deuteronomy's feasts,

[6]Janet Carsten, *After Kinship* (Cambridge: Cambridge University Press, 2004), 9.

for example, when the landed household feasts along with the refugee, the fatherless, and the widow (Deut 16:11, 14). Together, they share in the work of the harvest, the winding pilgrimage, the food preparation. Those who feast experience mutuality in their dependence on God, who alone gives the harvest. Or consider the mutuality of Jesus' welcome. At different times Jesus may be host or guest: Jesus serves and is served, he gives and receives (e.g., Lk 7:38). There is a deep mutuality in Jesus' way with people.

So often Christians reduce expressions of compassion to acts of charity, where the resources flow in one direction. Acts of charity, such as soup kitchens, food pantries, and the like, are certainly valuable in providing immediate assistance and sustenance; yet charity is a far cry from the kinship and mutuality that Scripture invites us into. Some staples of Christian culture, such as the timeless "orphan Christmas" or Christmas gift boxes, are better than nothing, but they fall short of the biblical invitation to share life as family in a mutual relationship of giving and receiving. (We would do well to do away with the phrase "orphan Christmas.") As we learn to live in solidarity with one another, we need also to learn to receive from one another, to be hosted by one another, to grieve together, and to be transformed in relationship with one another. "They" become "us" as we give and receive face-to-face, side-by-side sharing in the work of the gospel. Michael Rhodes and Robby Holt capture the mutuality of biblical ethics perfectly: God's vision isn't a soup kitchen where everyone gets fed but a potluck where everybody brings a plate![7]

When I began pastoring in Western Sydney, I was eager to help others, but I wasn't aware that when helping is a one-way street everyone is diminished. Over the years I have come to learn that few people want a handout. Most people desire a genuine two-way relationship. So I try to be alert to invitations to dinner, offers to pay for coffee, and willingness to help out, accepting these invitations as often as possible. And when I am praying for someone, I try to remain open to being prayed for in turn.

A great example of mutuality is the Thursday night community meal, mentioned previously. The meal was originally run on a soup-kitchen model, in which participants received a free meal. The leadership team became

[7]Michael Rhodes and Robby Holt, *Practicing the King's Economy: Honoring Jesus in How We Work, Earn, Spend, Save, and Give* (Grand Rapids, MI: Baker Books, 2018), 124.

uncomfortable with the kinds of one-way relationships the "helping" dynamic was creating. So the team transformed the meal in the direction of mutuality. In the new model, every participant was also a host. When participants entered the room, they signed up for a job. One participant, who moved around slowly on a walker, loved to carry out the compost at the end of the meal. He commented to me how much it meant to him to have a role. Mutual relationships help everyone to feel like we belong to one another: mutuality fosters healthy kinship.

> *Mutual relationships help everyone to feel like we belong to one another: mutuality fosters healthy kinship.*

In any family there are roles. One family role is maternal nurture. Maternal nurture is our third motif in our triplet of tenderness.

Maternal Nurture

As I zero in on maternal nurture as a theme for witness, it may sound unusual, even unlikely! And the idea of offering maternal nurture may not feel familiar to you. Yet let's think about this: just as any of us can be paternalistic, maybe any one of us can think of ourselves as maternal, in a sense. For me, maternal nurture signifies kinship and tenderness. And it seems to me that maternal nurture must also evoke fierce protection and advocacy for those it loves.

God's maternal nurture is, interestingly, found all over Scripture (e.g., Ps 131). God's maternal nurture is prominent, for example, in the book of Ruth, where Yahweh is pictured as a strong and protective mother bird.[8] As the story unfolds, we find Ruth, a Moabite immigrant, gleaning behind the harvesters in Boaz's field. Boaz blesses Ruth with a most remarkable phrase: "May you have a full reward from the LORD, the God of Israel, under whose wings you have come for refuge!" (Ruth 2:12). The image of Yahweh's protective wings is a maternal image that in context evokes a sense of belonging, sustenance, and protection. Yahweh's protective, maternal wings appear a

[8]For a more detailed discussion of this theme in Ruth, see Glanville and Glanville, *Refuge Reimagined*, 59-66.

number of times in the Old Testament.[9] While most references refer to Yahweh's protection of Israel, here it is an outsider, a Moabite, who is enfolded in Yahweh's maternal embrace.

The wording of Boaz's prayer for Ruth implies that it is a reliable characteristic of Yahweh to enfold vulnerable immigrants. Yahweh loves to enfold vulnerable immigrants under the divine wings. As the story progresses, Boaz himself is used by God as an instrument of Yahweh's protection (Ruth 3:9). The Hebrew word for Boaz's "cloak" (Ruth 3:9), which he spreads over Ruth when enfolding her as kin, is the same as the word for Yahweh's "wings" that was used by Boaz earlier (Ruth 2:12). Boaz, one of God's people, is God's instrument, a surrogate for God's maternal care.

My friend Isabelle, who lives in the United States, is an undocumented immigrant from Peru. Isabelle's mother has returned to Peru to be with Isabelle's grandmother, likely never to return. Because of her status, Isabelle can't visit Peru. Isabelle says now that her mother has left her for Peru, she no longer has to *explain* God as a mother, but she *knows* God as a mother. Isabelle and I spoke together about the book of Ruth. Isabelle said, "Boaz is pointing to a maternal and reliable characteristic of Yahweh. I am embraced by God my mother, in my mother's absence."

GOD'S GENDER?

These passages from Scripture might raise the question for you of God's gender. This question is pressing for many Christians: for personal devotion, for liturgy, and for sheer knowledge of God. The question of God's gender has become especially important to me as I journey with our daughter in Christian faith. She asks, why is God a "he"? This seems to cause her some concern at a basic human level.

Evangelical Old Testament scholar Gordan McConville reflected on this question from the perspective of the Old Testament.[a] McConville reflects, "Human beings find it hard to think or talk about God apart from their own experience, cultural, emotional, and intellectual."[b] To be sure, the Old Testament uses male pronouns, and often male metaphors, for God. And yet many aspects of human maleness are irrelevant for God,

[9] E.g., Ps 61:4–5; Ex 19:4; Ps 36:7–9; 57:1; 63:7; 91:4; Mal 4:2.

from biology to man-colds. Thus the most that we could say is that God is "male-ish"—that God exhibits characteristics and aspects of identity that conform to what we think of and experience as "male." And yet, when we consider that what "male" signifies varies greatly across cultures, the idea that God is "male" becomes blurrier, again.

Further, consider that common gendered depictions of deities in the ancient world are entirely missing in the Old Testament, such as the deity's consort and gendered visual images for God (these were staples in ancient Near Eastern worship).[c] Significantly, the metaphor of Yahweh's maternal nurture demonstrates not only male metaphors but also female metaphors are "a vehicle for Yahweh's self-expression," as McConville puts it.[d] There are many male metaphors for God—true!—and yet this doesn't give us permission to diminish the female metaphors. Or as Amy Peeler reflects: "Affirming what the text and tradition gives does not mean overstepping its bounds, bounds erected by other names for God."[e] We must conclude that while the Old Testament reveals God in both male and female terms, God is neither male nor female in the Old Testament.

I suspect that use of male pronouns for God is a contextualization to Israelite social norms, whereby men moved, worked, and had authority in the public sphere—whereas women moved, worked, and had authority in the private sphere.[f]

This discussion of God's gender connects with the maternal nurture of God. And yet it also connects with the whole book, in its implications for patriarchy and the participation of the whole people of God.

[a]James Gordon McConville, "Neither Male Nor Female: Poetic Imagery and the Nature of God in the Old Testament," *Journal for the Study of the Old Testament* 44 (2019): 166-181.

[b]McConville, "Neither Male Nor Female," 177.

[c]McConville, "Neither Male Nor Female," 178.

[d]McConville, "Neither Male Nor Female," 176

[e]Amy Peeler, *Women and the Gender of God* (Grand Rapids, MI: Eerdmans, 2022), 17.

[f]On women's authority in the household see Carol L. Meyers, "Was Israel a Patriarchal Society?" *Journal of Biblical Literature* 133 (2014): 8-27, at 22.

We have seen that witness as maternal nurture in Scripture entails tenderness and protection. This motif calls for a "revolution of tenderness," to use Pope Francis's phrase.[10] The church should display the tenderness of Christ, also calling our societies to do the same. Tenderness entails softening our hearts to let other people in, in all their muck and mess. It means slowing down to grieve what Christ grieves and taking time to celebrate what Christ celebrates. Tenderness demands that we extend trust and choose hope. It means noticing our fear and not being controlled by it. I have noticed in the gospels that when people encounter Jesus for the first time, they are often struck by Jesus' tenderness. "Jesus looked at him and loved him"—the rich young man. "He begged to go with him"—a man cured of demons (see Mk 10:21; 5:18).

Maternal nurture is also powerful, often entailing fierce protection. My mother exemplified this. As a therapist she powerfully advocated for survivors of sexual abuse. An intransigent clergy or school principal didn't know what had happened to them when June Glanville strode into their office! My mother sensed intuitively that witness as maternal nurture also calls us to confront toxic masculinity. We should ensure that leadership is shared equally between women and men, nourishing church cultures marked by healthy, safe, and life-giving relationships.

A wonderful example of maternal nurture in the name of Jesus is REED (Resist Exploitation, Embrace Dignity), birthed by my friend Michelle Miller. REED supports women in Vancouver who are trapped in the sex industry. When Michelle

> *Tenderness demands that we extend trust and choose hope.*

began REED in 2005 there were no human trafficking laws in Canada, and trafficked women had no protection. The work began with a commitment to provide individual care for exploited women. As they spent time with these women, Michelle and her team quickly learned that women are exploited within systems. The vast industries of internet porn and webcam prostitution rely on exploitation and trafficking. There is a level of normalization of male access to women's bodies. So REED's work expanded to interfering with the system, including the work of political advocacy and education.

[10]Laurel Wamsley, "In Surprise TED talk, Pope Francis Asks the Powerful for a 'Revolution of Tenderness,'" *NPR*, April 26, 2017.

There is another dimension to maternal nurture as witness. The apostle
Paul uses a maternal metaphor to describe his work of apostleship for the
Christians in Galatia (cf. 1 Thess 2:6-8):

> "My little children, for whom I am again in the pain of childbirth until Christ
> is formed in you . . ." (Gal 4:19)

Renowned New Testament scholar Bruce Longenecker writes: "The met-
aphor is maternal. As a mother nourishes new life within her womb, so the
corporate life of the Galatian Christians is to be the womb that nourishes
Christ in order that he might be 'birthed' among them."[11] Christ develops in
the church's body, as the church offers the devotion and longsuffering of a
mother. This, too, is witness as maternal nurture.

Paul's longing for the Galatian Christians can help us to understand tra-
ditional representations of the church as a pregnant mother. Mary pregnant
with the Christ is a common image in traditional Orthodox iconography.
Mary represents the church, in whom Christ is formed and who then brings
Christ into the world as in the pain and joy of childbearing. In the Virgin of
the Sign icon, for example, Christ is in Mary's womb praying—praying *in*
Mary, praying *for* Mary, and praying *through* Mary (cf. Rom 8:26).[12]

Maternal nurture is a posture for witness that centers tenderness and pro-
tection and a desire that Christ would be formed in others. This motif com-
pletes our triplet of tenderness: healing, kinship, and maternal nurture. By
creatively embodying these postures in a particular neighborhood, we display
the healing of Jesus, the belonging of Jesus, and the tenderness of Jesus. These
three biblical metaphors may be an evocative reframe for social justice, a term
which has sadly become mired in the mud of culture wars. Despite the reality
that these are biblical motifs, some might respond that this discussion is merely
a distraction from the gospel. How should we respond to such a challenge?

Is Social Justice a Distraction from the Gospel?

Despite Scripture's relentless concern for compassion and justice, it is not
uncommon to hear that too much social justice is a distraction from the

[11] Bruce Longenecker, "Galatians," in *The Cambridge Companion to St Paul*, James D. G. Dunn ed.
(Cambridge: Cambridge University Press, 2003), 64-73, at 67.

[12] See further, Rowan Williams, *Ponder These Things: Praying with Icons of the Virgin* (Norwich, UK:
Canterbury, 2002), 44.

gospel.[13] For example, during the time of writing this book, an independent report[14] on sexual abuse in the Southern Baptist Convention in the United States was released. The report revealed that a key leader on the SBC Executive Committee labeled the work of advocates on behalf of survivors of sexual abuse as a "satanic scheme to completely distract us from evangelism." "It is not the gospel. It is not even a part of the gospel. It is a misdirection play," the leader wrote in an internal email.[15] Antiracism work has been censured by Christians in similar ways. For example, in a public dialogue on "woke church" hosted by The Gospel Coalition, a pastor derided "wokeness, critical theory and social justice activism" as "gospel compromise."[16] Other censures are more subtle. In a sermon I was present for, a preacher first acknowledged that racism is, indeed, evil. And yet, he urged, the church should be on about the gospel. Too much attention to racism is a "distraction from the gospel."

We should weigh the "distraction" argument carefully, especially as similar arguments were made against the abolition movement's call for the end of slavery in the decades preceding the Emancipation Proclamation of 1863 in America. In the early nineteenth century, White Christians had a diversity of opinions on slavery. Many were proslavery; others were against it. And yet, as historian Ben Wright writes, "Nearly all denominational leaders actively denounced abolitionists as opponents of American salvation."[17] White Christian leaders tended to favor "conversionism" over the "purificationism" of the abolitionists. "Conversionism" (as Wright calls it) meant evangelizing the nation, including slaves, and the colonies. "Conversionism became the core of proslavery Christianity," he states.[18] Abolitionists "distort the message of Christianity into antislavery propaganda,"

[13]This section uses and adapts a previously published discussion, Mark R. Glanville, "The Old 'Distraction' Slur Against Advocates for Justice," *Christian Century* 139, no. 13 (June 2022), www .christiancentury.org/article/critical-essay/old-distraction-slur-against-advocates-justice.

[14]"The Southern Baptist Convention Executive Committee's Response to Sexual Abuse Allegations and an Audit of the Procedures and Actions of the Credentials Committee" (May 15, 2022).

[15]"The Southern Baptist Convention Executive Committee's Response," 6.

[16]Sean DeMars and Rebecca McLaughlin, "Is 'Woke Church' a Stepping Stone to Theological Compromise?," *TGC*, May 11, 2022, www.thegospelcoalition.org/video/good-faith-debate-woke-church/.

[17]Ben Wright, *Bonds of Salvation: How Christianity Inspired and Limited American Abolitionism* (Baton Rouge, LA: LSU Press, 2020), 83.

[18]Wright, *Bonds of Salvation*, 84.

White Christian leaders claimed.[19] It is sobering to realize that the greatest threat to abolition was not the nineteenth century version of alt-right White supremacists; it was moderate, White Christians.

The phrase "it's a distraction from the gospel" echoes through time uneasily. How are we to understand its resonance? When the gospel is elevated in a way that dulls the sharp edge of compassion and justice, we are compelled to ask, "So what is the gospel?" To be sure, the gospel announces pardon for sin, won by Christ (Mk 15:31-32). And yet, as we have observed in chapter one, the gospel is God's victory over death, Satan, and evil in all its forms (Col 2:15). The gospel of Christ triumphs "as far as the curse is found," as Isaac Watts put it. Wherever evil corrupts the creation, the gospel brings healing. Such sin certainly includes racism, sexual abuse, slavery, and injustice in all its forms.

James Pennington (1807–1970), a Black pastor and abolitionist, wrote, "The gospel rightly understood, taught, received, felt and practiced, is antislavery as it is anti-sin."[20] Pennington's words can help us to clear the air that plagues discourse around justice advocacy today, whether antiracism, advocacy for survivors of sexual abuse, or something else. Many White evangelical leaders today argue that much justice advocacy is not built on the Bible, but on secular ideologies.[21] And yet, Black thinkers, among others, have been challenging systemic racism and injustice from Scripture literally for centuries. Many of these Black Christians have also been passionate evangelists for Christ.[22]

By arguing that advocating for survivors of sexual abuse is a satanic scheme that distracts from evangelism, this SBC leader tore apart what belongs together: the cross and reconciliation, evangelism and discipleship, speaking and doing, love and truth, tenderness and invitation, creation and redemption. This SBC leader abstracted the good news from the tenderness

[19]Wright, *Bonds of Salvation*, 84.

[20]James Pennington, *The Fugitive Blacksmith; or, Events in the History of James W. C. Pennington, Pastor of Presbyterian Church, New York, Formerly A Slave in the State of Maryland, United States* (London: Charles Gilpin, 1850; Reprint, Westpont, CT: Negro Universities Press, 1971). Cited in Lisa M. Bowens, *African American Readings of Paul: Reception, Resistance, and Transformation* (Grand Rapids, MI: Eerdmans, 2020), 147.

[21]See for example, "The Statement on Social Justice and the Gospel," *SJ&G* (website), www .statementonsocialjustice.com.

[22]Bowens, *African American Readings of Paul*, 64, 69, 148.

of Christ, with the effect that it's not good news anymore. The gospel is comprehensive in its scope, and so Christ-followers must live as a sign to God's restoring rule in every dimension of our lives.

This chapter has explored a seventh note for improvising community, playing this note as a triplet: healing, kinship, and maternal nurture—a triplet of tenderness. These three motifs, played together in Christian community, become an improvised melody of striking beauty and creativity, the tune of the tenderness of God in Christ. This triplet of themes is expressed most powerfully by a community that is convinced that it is sent by God into a particular neighborhood, to love their neighborhood to life.

We have seen that a foundation of biblical ethics is our shared kinship with one another. And yet according to Scripture our kinship connections extend beyond human relations to also embrace the nonhuman creation. What would it look like for the church to take seriously our kinship with the nonhuman creation? We face this question in the next chapter.

Creation

Up there on Gospel First Nation, the highway feels like salvation . . .
Just need to see for yourself, does something for your health,
If we leave right now I can show you.
I swear Jesus might just live, along with all our sins, in Fisher Bay Manitoba.

WILLIAM PRINCE, "GOSPEL FIRST NATION"

IN THIS LILTING COUNTRY SONG, artist William Prince drives us to the place of his childhood, Fisher Bay. He leads us into a disused church, noticing the "tinnies [beer cans] on the pulpit." The journey of this song takes us a way toward this chapter's destination. Throughout the song, and especially in the song's music video, we become immersed in the ecology of Fisher Bay, and we find healing there. We find Christ in this neglected place (connecting with the prophecy of Matthew 4:15-16 discussed in chapter three). And all the way, we have been led on a journey of healing-via-creation by William Prince, a renowned First Nations singer-songwriter.

Here is the destination: I believe that in post-Christendom, creation will be a centering theme for flourishing churches, connecting many aspects of Christian discipleship. Kinship with creation is the eighth note for improvising community. The centering role of creation for Christian discipleship is illustrated by an approach to improvisation called "modal jazz."

From William Prince's album, *Gospel First Nation*, Glassnote, 2020.

In most jazz music, as with other music styles, the harmony of the music is formed by a progression of ever-changing chords. Standard jazz tunes often have around two chords to each bar. In modal jazz, the harmony works differently. A tone center replaces the more usual progression of chords. Modal harmony works a bit like drawing a smooth curve on a column graph, to smooth out a very jagged and detailed contour. It is an impressionistic simplification, like impressionism in visual arts. Rather than two chords per bar, a tone center may last for eight bars, or more. In modal jazz, a tone center is represented by a particular scale (e.g., D Dorian mode) that unifies and integrates the harmonic creativity of the performance. A modal scale both centers a jazz solo and provides an expansive landscape for creative freedom. The tune "So What," on Miles Davis's *Kind of Blue*, is likely the most well-known modal jazz tune (played in D Dorian mode).

In a similar way, our growing consciousness of our interconnectedness with creation and our responsibility toward it will be a key and integrating characteristic of flourishing churches in post-Christendom. Creation will be our tone center. Flourishing churches will seek to live, garden, work, and eat thoughtfully in relation to the creation, aware of their interdependence with all of creation. They may act as allies to indigenous groups in their endeavors to "walk in a good way" on the land.[1] To continue the metaphor, there will always be many responsibilities for faithful and engaged churches, many things to attend to (that's the jagged graph). Creation will be a centering reality, a unifying and integrating tonality, the smooth curve that unites these assorted callings.

> *I believe that in post-Christendom, creation will be a centering theme for flourishing churches, connecting many aspects of Christian discipleship.*

As a doorway to this exploration, let's make some general observations on the church in this singularly important cultural moment. As Western culture journeys more deeply into its post-Christendom reality, the contemporary church is located at the margins of society, in a similar way to the early

[1] "Walk in a good way on the land" is a First Nations expression for living in a way that honors the kinship between humanity and the nonhuman creation.

church. Two staggering differences distinguish our experience from that of the early church (among other differences). First, today we are faced with the history, momentum, and false identities entailed in the church's complicity in Christendom. Second, we are a part of the Anthropocene, in which humanity is a primary agent in unalterably shaping planet earth.

In post-Christendom, as we seek to live faithfully into the biblical story, and as we vacate centers of power, flourishing churches will find their identity with the poor and with the creation. Chrysostom lamented the fading of miracles in the Constantinian period of the fourth century, even as the church became increasingly enthralled with power and wealth. In a reverse movement, the church today ought to pray that as we vacate centers of power (whether willingly or unwillingly) and establish new allegiances with the marginalized and with the creation itself, we will increasingly depend on God and be filled with a similar spiritual vitality as the early church.

Communities of Devastation, Communities of Hope

In the year 2000, Nobel Prize-winning scientist Paul J. Crutzen argued that we have entered the Anthropocene, an era when humanity is the prevailing force in all of creation. Today, there is no place on the earth where human influence is not felt. Yet human impact is not only felt, but produces irreversible damage, notably global warming and species extinction.[2] While human impact is felt in every place, human-caused environmental degradation does not impact every place and every human population equally. Theologian Norman Wirzba writes:

> The economies that have done so much to facilitate human freedom and development are also responsible for the degradation of the earth and life systems on which all creatures depend. In other words, the exercise of the forms of freedom that maximize control, convenience, and comfort for some have put in jeopardy the future freedoms of many others.[3]

Ultimately, the priority and power given to neocapitalism, along with its most powerful actors, relegates the creation as a second-tier concern. As

[2]Norman Wirzba, *This Sacred Life: Humanity's Place in a Wounded World* (Cambridge: Cambridge University Press, 2021), 3.
[3]Wirzba, *This Sacred Life*, 5.

Wirzba reflects, the term "Capitalocene" (as opposed to Anthropocene) reminds us that the largest part of the damage to creation has not been perpetrated by humanity broadly conceived but by a powerful few.[4] The destructive relationships between economies and ecosystems are systemic and deeply consolidated, as powerful industrial, political, and financial systems have been established and defended, often at the cost of the creation.[5]

While the concept of Capitalocene may sound abstract, its seemingly indomitable power is felt both globally and locally. To illustrate, consider the experience of a local expression of A Rocha. A Rocha is a Christian "global family of conservation organizations working together to care for creation."[6] I am writing this chapter at A Rocha's Brooksdale Environmental Centre, about an hour's drive

> *In a reverse movement, the church today ought to pray that as we vacate centers of power (whether willingly or unwillingly) and establish new allegiances with the marginalized and with the creation itself, we will increasingly depend on God and be filled with a similar spiritual vitality as the early church.*

from Vancouver. Brooksdale is a farm dedicated to conservation and research, education, and sustainable agriculture.[7]

For the past twenty years A Rocha has been working to restore the Little Campbell River (Tatalu), a watershed that is home to endangered species and spawning salmon. The A Rocha community's detailed attention to measuring, weeding, protecting, and connecting with this ecosystem has to be seen to be appreciated, and literally thousands of children and adults have been invited onto the farm to learn about and experience our connection with the creation. Semiahmoo First Nation community live at the estuary of the river, which offers access to traditional food harvesting, such as salmon, crab, and clams.

In 2011 the city of Surrey, British Columbia, marked the Little Campbell River watershed for rezoning for large-scale commercial and industrial

[4]Wirzba, *This Sacred Life*, 10.
[5]Wirzba, *This Sacred Life*, 10-18.
[6]For more about A Rocha, see https://arocha.org/en/.
[7]For the story of Brooksdale Environmental Centre, see Leah Kostamo, *Planted: A Story of Creation, Calling, and Community* (Eugene, OR: Cascade, 2013).

development, a move that stakeholders in the river agreed would damage the health of the river.[8] While the community put up an ongoing and collaborative fight for over a decade, the rezoning was approved in February 2022 as a result of intense lobbying from industry and despite minimal consultation with Semiahmoo First Nation. While A Rocha and the Semiahmoo people will continue to defend and protect the Little Campbell River, the health of the river system will likely be significantly diminished.

This story illustrates the powerful financial and political forces at work in the larger story of the creation. While this unfinished story of the Little Campbell River is troubling, the life and work of A Rocha, animated by a contagious hope as it is, demonstrates a different way of living with the creation.

What is a pathway for the church amid ongoing human failure in relation to the creation? In Protestant circles, the usual response to news of creation degradation is along the lines of: "We've blown it, we're bad, now we've got to take care of it!"[9] While this response is certainly a start, the well-intentioned energy behind it is almost impossible to maintain. As Wirzba reflects, "We inhabit a culture, and function on the basis of an imaginary, that is unable to help us to appreciate, let alone meaningfully address, the trouble we are in."[10] How can we find another path, a deeper animating impulse than mere willpower? As we turn to Scripture now, we will become aware of our kinship with the creation, our shared life with animals, fish, and trees, those creatures with whom we share the sixth day. Might becoming awakened to our connection with the creation—which is always there whether it grabs our attention or not—be our path?

Divine Covenant with Creation

In Genesis 9, following the flood, God makes a covenant with the creation itself. When speaking of biblical covenants, pastors and scholars alike usually discuss the various covenants God made with ancient Israel through its history and the subsequent new covenant in Christ. However, there is more diversity and richness in the covenants of the Old Testament than is

[8]See "Saving Wildlife Habitat Land around Surrey, BC," A Rocha (website), https://arocha.ca /south-campbell-heights-lap/ for more information.
[9]Leah Kostamo, a co-founder of A Rocha Canada, used this phrase in a personal conversation.
[10]Wirzba, *This Sacred Life*, 21.

commonly recognized (in chapter eleven, "Sins of Our Kin," we will observe the divine covenant with the refugee, Deut 10:18-19).

In Genesis 9 God makes a covenant with the whole of the created world, displaying God's steadfast commitment to the creation (Gen 9:8-17). At the beginning of the narrative, human violence had corrupted the good creation:

> "Now the earth was corrupt in God's sight, and the earth was filled with violence." (Gen 6:11)

The undoing of the creation ("earth") by human sin stages the drama of the flood as intimately engaging with the life and future of the creation.[11]

When God announces to Noah the divine intention to bring a flood on the earth that will destroy all flesh, God also promises a covenant: "But I will establish my covenant with you; and you shall come into the ark, you, your sons, your wife, and your sons' wives with you" (Gen 6:18). It is easy enough to pass over the covenant with Noah as a well-known story that we heard as children, but don't miss the significance! Genesis 10 is a genealogy of the nations, a sort of family tree of all people groups descended from Noah. Here God is making a covenant with all of humanity, no less![12]

And it turns out that Noah is representative of more than just humanity. After the flood, God confirms the divine covenant with every living creature and even with the earth itself:

> "As for me, I am establishing my covenant with you and your descendants after you, and with every living creature that is with you, the birds, the domestic animals, and every animal of the earth with you, as many as came out of the ark. (Gen 9:9-10)

This fact is repeated six times in Genesis 9:8-17: God establishes a covenant with every living creature. And what is the content of the divine covenant? "I establish my covenant with you, that never again shall all flesh be cut off by the waters of a flood, and never again shall there be a flood to destroy the earth" (Gen 9:11). This is a relational, steadfast commitment to the life

[11]Indeed, there are profuse intertextual connections between the flood story (Genesis 6–9) and the creation story (Genesis 1–3).

[12]Noah is the father and representative head of all of humanity (according to the ancient Mediterranean way of thinking and according to biblical theology).

and flourishing of all living things. A sign is given as a testimony to God's covenant solidarity with the creation:

> "I have set my bow in the clouds, and it shall be a sign of the covenant between me and the earth." (Gen 9:13)

God makes a covenant with the earth, ratifying divine solidarity with the created world. Think about it: God is in loving and protective solidarity with creation, its biological and inorganic components, its cellular and structural life, its history and hope. The covenant metaphor is also a metaphor of kinship, disclosing God's familial love for the creation, as its divine kinsperson.[13]

And by making a covenant with creation, God relates to the earth as if it has a life and personhood all its own.[14] This should not surprise the reader of Genesis, for the creation story of Genesis 1 cast the earth in the role of God's partner in creation, a producer of vegetation. God commanded: "Let the earth put forth vegetation." And the earth responded just so, in the very next verse (Gen 1:11-12). Indigenous scholar H. Daniel Zacharias reflects: "It is mother earth herself that actively obeys the command by producing plant life." Zacharias argues that the earth is "co-creator" with God.[15]

Human Kinship with the Creation

God's covenant with the creation has implications for humanity's own allegiances. In the ancient world, the covenants of the great kings often stipulated that a subordinated king must maintain loyalty to other subordinated kings. "A friend of mine is a friend of yours," ran the logic of these covenants. (We will see this dynamic in chapter eleven, concerning the refugee.) As a covenant partner with God, humanity is also obligated to the creation. Humanity's responsibility toward the creation is explicit, for example, in the

[13]The kinship dimension of covenant relations is discussed further in chapter eleven, "Sins of Our Kin."

[14]Potawatomi writer Robin Wall Kimmerer explains that First Nations myths ascribe personhood to the nonhuman creation. The first human was "set down into a fully peopled world of plants and animals." Robin Wall Kimmerer, *Braiding Sweetgrass: Indigenous Wisdom, Scientific Knowledge, and the Teachings of Plants* (Minneapolis: Milkweed Editions, 2013), 206. For analysis of the personhood of the nonhuman creation in the Old Testament, see Mari Joerstad, *The Hebrew Bible and Environmental Ethics* (Cambridge: Cambridge University Press, 2019), 95-98.

[15]H. Daniel Zacharias, "The Land Takes Care of Us: Recovering Creator's Relational Design," in *Theologies of Land: Contested Land, Spatial Justice, and Identity*, edited by K. K. Yeo, and Gene L. Green (Wipf and Stock Publishers, 2020), 69-97, at 73.

requirements surrounding meat consumption found in the same chapter (Gen 9:3-6). Humanity may kill living creatures for food, but only so long as the life of living creatures is revered: "Only, you shall not eat flesh with its life, that is, its blood" (Gen 9:4). The prohibition against consuming blood is ancient code for reverencing what has been made, of honoring the living creatures with whom God has covenanted.

Yet humanity is not obligated to the creation as *other* than the creation but as a *part* of the creation. Humanity shares in the sixth day of creation with animals, fish, and shrubs. We are made from the dust of the earth: the *adam* is taken from the *adamah* ("ground"; Gen 2:7). "The dust of the ground": this is the "fertile topsoil, with all its wriggling worms, decayed matter, and fungul filaments," Zacharias comments.[16] Kathleen O'Connor writes: "The very literary structures of [Genesis 1] integrate humans with other beings, making them part of each other and dependent on one another."[17] Indeed, "Whatever else we are, humans are also earth."[18] Such a mutuality of being is what sociologists refer to as "kinship." While at first glance the idea of human kinship with creation may sound overly romanticized, when we recognize with cultural anthropologists that kinship is a "mutuality of being,"[19] an entangling of fortunes, we can see that kinship is exactly how Scripture presents human relationship with the nonhuman creation.

Indeed, human kinship with the creation in the context of God's covenant with the creation contributes to the foundation of Old Testament ethics. In this spirit, Leviticus restricts which animals God's people can eat (Lev 11:1-8), also giving careful instructions for their consumption (Lev 17:10-16). Scholars generally agree that Leviticus's limitations on consuming meat reflect God's valuing every living creature.[20] And Leviticus's concern for the value and flourishing of the creation is mysteriously intertwined with its concern for human value and flourishing. For in the same spirit, the book

[16]Zacharias, "The Land Takes Care of Us," 77.

[17]Kathleen M. O'Connor, *Genesis 1-25A* (Macon, GA: Smyth & Helwys, 2018), 40.

[18]Loren Wilkinson, ed., *Earthkeeping in the Nineties: Stewardship of Creation* (Grand Rapids, MI: Eerdmans, 1991), 284.

[19]Marshall Sahlins, *What Kinship Is—and Is Not* (Chicago: University of Chicago Press, 2013), 23.

[20]See Ellen Davis, *Scripture, Culture, and Agriculture: An Agrarian Reading of the Bible* (Cambridge: Cambridge University Press, 2009), 95; Jacob Milgrom, *Leviticus 1–16*, The Anchor Bible 3 (New York: Doubleday, 1991), 733-36.

of Leviticus associates the appalling practice of offering a daughter in prostitution to the prostitution of the land itself. In this way, humanity and the land are "related in their creaturehood and their vulnerability," as Ellen Davis puts it.[21] Davis summarizes the commitments of the Holiness Code: "Its point of orientation is the web of relationships uniting the various members of the land community: earth, animals, and humans."[22]

Some thinkers have reflected that human interdependence with the creation should give us pause to wonder whether "creation care" is always the most helpful phrase. The phrase "creation care" may give the impression that this relationship is a one-way street, or that creation stewardship is merely one of many things that the church ought to get involved with. We can overlook what ancient Israelite farmers could never overlook: that we are relentlessly interconnected with the earth. To be sure, humankind is called to care for the creation, and yet our care will need to be aligned with the reality that we ourselves are nourished by creation at every point. Creation is our mother, North American First Nations tradition says. As Dr. Ray Aldred, a Cree elder and theologian in Vancouver, puts it, "We don't care for the creation; the creation cares for us!"[23] Zacharias states sharply, "There has not and will not be a time when humanity gives more to the creation than it has given and continues to give to us."[24]

Human kinship with the nonhuman creation is central to First Nations worldviews and practices. For example, Aldred tells the story of hunting moose with his brother. When Aldred and his brother shoot a moose, they immediately walk to the animal, lay their hands on it, and declare, "Thank you brother for giving your life so that we can eat."[25] Such an expression of kinship resonates with the ethical impulse of the prohibition on consuming blood: humanity must live in familial solidarity with the creation as God's covenant partner.

Our kinship bond with nonhuman creatures is always there, whether we are aware of it or not. For as long as we are breathing, we are feeding trees carbon dioxide, and trees are feeding us oxygen. The same can be said at a

[21]Davis, *Scripture, Culture, and Agriculture*, 91.
[22]Davis, *Scripture, Culture, and Agriculture*, 90.
[23]Ray Aldred, lecture delivered at Regent College, 2021.
[24]Zacharias, "The Land Takes Care of Us," 70.
[25]Aldred, lecture, 2021.

microscopic level. Consider that there are one hundred trillion bacteria in your digestive tract.[26] And there are trillions more bacteria up and down your body, inside and out. "The human body is one vast ecosystem."[27] Our lives and fortunes are so thoroughly intertwined with bacteria—these microscopic, created beings—that it is quite impossible to *be* a human being without them!

God's allegiance to the earth disclosed in the covenant of Genesis 9 demonstrates for us once again the comprehensive scope of the gospel. The biblical narrative is moving resolutely toward the renewal of the creation, not its eradication, and the renewal of human life in its embodied, organic, relational, and artistic fullness. In other words, as renowned Australian Old Testament scholar William Dumbrell argues, the creation is not merely the precondition for the covenant or the sphere within which the covenant occurs, but a full participant in its grace.[28]

For this reason, Keetoowah Cherokee scholar Randy S. Woodley recommends the metaphor of the "community of creation" as a shorthand expression for the sphere of God's redemption. "Community of creation" highlights the biblical movement of the reconciliation and healing of the creation, Woodley argues.[29]

Reintegration

Leah Kostamo, a co-founder of A Rocha Canada, was invited to present at the University of Ottawa. She spoke on the topic, "The Future of Religion in Canada: Utopia and Dystopia?"[30] Margaret Atwood, who is arguably Canada's most renowned novelist, also presented. In her presentation, Kostamo told the story of an intern at Brooksdale. The intern rose one morning with a conviction that God would surprise her that day. (When Kostamo said this,

[26]Wirzba, *This Sacred Life*, 72–73.

[27]David R. Montgomery and Anne Biklé, *The Hidden Half of Nature: The Microbial Roots of Life and Health* (New York: Norton and Company, 2016), 126. Cited in Norman Wirzba, *This Sacred Life*, 73.

[28]William J. Dumbrell, *Covenant and Creation: An Old Testament Covenant Theology* (Flemington Markets, Australia: Paternoster, 1984), 41.

[29]Randy S. Woodley, *Shalom and the Community of Creation: An Indigenous Vision* (Grand Rapids, MI: Eerdmans, 2012), 38-40. Woodley here argues that the metaphor of the kingdom of God is unhelpful on Western society today, in light of the colonial project.

[30]This story is told in Rev. Dr. Kara Mandryk and Dr. J. Keith Hyde, "Leah Kostamo and Margaret Atwood in Ottawa," A Rocha (website), https://arocha.ca/his-eye-is-on-the-sucker/.

"You could feel the skepticism rise from the crowd," an onlooker commented.) Later that day on a routine fish count in the Campbell River, the intern gathered a fish that was identified as an endangered species, the Salish sucker. This species hadn't been identified in the vicinity for years! Leah reflected on God's role in this story: "His eye is on the sucker," she said, reappropriating the words of an old hymn. This phrase was repeated throughout the remainder of the event by both Atwood and Kostamo: "His eye is on the sucker." The Canadian university humanities context is often deeply hostile toward Christianity. Yet even there, Leah's witness was not only authentic, but it was also compelling.

When Leah returned from Ottawa and shared her story, our common friendship circles were buzzing with excitement. Through Leah's example, God showed us once again that living deeply into Christ's way and speaking authentically from that place is truly beautiful, and is often warmly received, even as it also challenges and unsettles. Stories like this make me curious: perhaps one day many Christian communities will look and sound like the A Rocha community.

Leah's testimony helps to illustrate a central thesis of this chapter: *as we journey more deeply into post-Christendom, creation will be a centering reality connecting many aspects of Christian discipleship within flourishing Christian communities. Becoming conscious of our connection with creation will reawaken the vitality and witness of the church.* Almost every aspect of Christian discipleship connects with creation, expressing, in one way or another, humanity's bond with other creatures. Creation and environmental issues are intimately related to the social, emotional, spiritual, economic, and physical dimensions of our lives. Let me enumerate some ways in which creation relates to diverse aspects of discipleship.

For one, Kostamo's experience has shown us how intimacy with the creation opens a door for genuine speech about Jesus. Second, consider the theme of hope. Many young people lack hope for the future. If violence against humanity colors how Gen-Z understands the past, violence against the creation colors how they anticipate the future.[31] Perhaps surprisingly, in her talk, Kostamo repeatedly returned to the theme of hope: the "Christian

[31]Gen-Z refers to the generation born in the mid-1990s to early 2010s.

message is one of hope," she said. Kostamo admitted that some will think that hope is "Pollyannaish." And yet the resurrection of Christ grounds Christian hope. And there in Ottawa it was the Christian community of A Rocha, with its thick and tangible connection with the creation, that gave Christian hope plausibility and form.

Third, in an era when faith is vulnerable and must be nourished with care, faith in God can be strengthened as we become conscious of our connection with the creation, our responsibility to care for creation, and the privilege of being cared for by creation. We see this dynamic in the biblical character of Job, for example. In the midst of Job's darkest dark, he is reoriented in re-lation to God by considering the grandeur and intimate wonder of the cre-ation (Job 38–41). We see a connection between faith and creation also in the creation psalms, where the creation leads the psalmist to praise God (Ps 104; 148).[32] A note for worship leaders: we shouldn't settle for merely repeating the creation Psalms verbatim, since they arose from the ecosystem of Syria-Palestine. But we can encounter God afresh when we inquire into the unique ways *our* ecosystem reveals God. In this way we follow not only the psalmist's words but also their example.[33]

Fourth, creation relates to our prayer. While we often think of our prayers as making a difference in people's lives, in the Old Testament, at least some places and objects have a spiritual dynamic that is responsive to good and evil, to prayer and repentance.[34] We might say that our prayers "haunt" a place.

Fifth, creation relates to Scripture. If Wendell Berry is right to say that the Bible is an "outdoor book"[35]—and I think that he is—then we will connect with the Bible more deeply as we become more aware of our connection with the creation.

Sixth, I have noticed that those who seek to learn about the creation tend to naturally adopt a learning posture toward First Peoples, as the ancient custodians of the land. First Nations wisdom for "walking in a good way on

[32]Psalm 19 knits together wonder at God's revelation in creation with the wonder of God's revela-tion in Scripture.

[33]For the Psalmists, singing the Psalms was deeply connected to their experience of the land. This is expressed negatively in Psalm 137, where the psalmist expresses an estrangement from the land: "How can we sing the Lord's song in a strange land?" the exiles in Babylon sang (Ps 137:4).

[34]For example, see Deut 21:1-9; Mk 5:9-17. See also Mari Joerstad, *The Hebrew Bible and Environ-mental Ethics*, 83-87.

[35]Wendell Berry, *Sex, Economy, Freedom & Community* (New York: Pantheon, 1993), 103.

the land" begins with the conviction that they don't *own* the land, but they *belong to* the land. This is the conviction of the Old Testament too. God states, "The land shall not be sold in perpetuity, for the land is mine. For you are strangers and sojourners with me" (Lev 25:23 ESV).

Seventh, the reference to strangers (refugees) here in Lev 25:23 connects our understanding of land with forced displacement. Our awareness that we don't own the land but are connected to the land should ground a joyful willingness to welcome vulnerable immigrants (Lev 19:33-34).

Eighth, and most importantly, we meet Christ in the creation, for as Irenaeus put it, the incarnation is a "recapitulation of creation." Wirzba summarizes Irenaeus, stating that Jesus entered "fully into the life of humanity and all creation so as to heal and transform it from within."[36]

We could spend a chapter on each one of these connections and more, exploring how creation is an integrating and vitalizing node for diverse aspects of Christian discipleship. In sum, in my view the church won't recover a deep and vital faith until we recover our relationship with the land. This is especially so given the violence of colonialism: the undisclosed ways in which warfare of displacement, slave holding, creation destruction, racism, and genocide have shaped (and are shaping) our spiritual experiences and assumptions.

This list of eight connections displays the diverse aspects of Christian discipleship that need to be engaged and reimagined in post-Christendom. Why don't you pause your reading to listen to Miles Davis's modal tune, "So What"? As you listen, notice how modal jazz smooths out the chord changes, like tracing a smooth curve on a graph. As you notice this, reflect on how creation can be a centering reality, a unifying and integrating tonality, the smooth curve that encircles our Christian responsibilities.

Creation in Incarnational Communities

How can we become more attentive to our kinship with the nonhuman creation? I noted that when we come to a fresh recognition of human-caused environmental degradation, we often respond with browbeating: "We've done so badly—let's do better from now on!" And yet I find in my own life

[36]Wirzba discusses Irenaeus's concept of the recapitulation of creation in *From Nature to Creation: A Christian Vision for Understanding and Loving Our World* (Grand Rapids, MI: Baker, 2015), 23.

that the energy behind this kind of self-pep-talk quickly fades. Alternatively, forcing our way into the next creation care project-extravaganza, as promising as it may be, may recapitulate our sense of human mastery rather than forging the deeper transformation that is needed.

Instead, deep roots form through connection over time. We need to nurture our awareness of our mutual interdependence with our fellow sixth-day creatures. Our kinship with other creatures—from trees to bacteria—is always there, but can we see it, can we seek integration in our lives? "To live well with other creatures. This is a missing piece for the church," Andrea Ramos Santos of Brooksdale commented to me.

Andrea Ramos Santos lives and works at Brooksdale, A Rocha. I once asked Andrea where she sees hope in the church. She told me that she sees hope when she sees people gardening, caring for neighbors, carrying out small acts of compassion, and getting involved in grassroots initiatives. "That's where the spiritual energy is, because it leads to transformation. Not big numbers or big testimonies, but transformation," Andrea said.

Incarnational communities can connect with the creation in the way they live in their neighborhood. For example, by purchasing food from local farms as a group, we can be a part of sustaining healthy food systems. (We are fortunate that our next-door neighbors organize group purchases from local farms for our community.) We can partner in solidarity with indigenous groups as they take the lead in defending natural habitats. Our church building is used by First Nations groups for land defense meetings. I receive an education by simply sitting at the back in these meetings and keeping quiet. And churches can partner with NGOs such as A Rocha in their education and sustainability efforts.

Our church built garden boxes as a way of acknowledging our kinship with the creation, inviting our neighbors to participate. Another church, in Hamilton, Ontario, took responsibility for building a set of stairs in a high traffic part of the local forest to prevent erosion. Yet another church, in Bellingham, Washington, ran a series of educational forest walks. Word about their forest walks got around, and their local school invited the church to take newly arrived refugee-d children on forest walks. The church cherished this opportunity to introduce the children to the ecosystem of the Pacific Northwest coast, their new home.

There are other ways churches can connect with the creation. Following the example of the psalmists, our liturgies and songs can be sensitive to the ways in which God is revealed in our locality. My friend Charlie Buhler wrote a song for Resurrection Sunday, "He's Alive," which immersed us in the ecosystem of Cascadia: "With the cedars we sway: Our God Lives!" Next is artisan work: bread for the Eucharist lovingly baked within the community (with hand-ground flour?); a table for communal meals created from a tree that used to stand in the church carpark. And then there is intentional learning. For example, our church went on a learning tour of our local watershed.

Though we need not and cannot return to preindustrial pastoralism, we can be freed from our myopic attention to the norms and assumptions of neocapitalism. And we can learn to live "as if this is the land that feeds you, as if these are the streams from which you drink, that build your body and fill your spirit,"[37] as Robin Wall Kimmerer puts it. The primary task of the church in relation to creation is one of remembering, of awakening to our connection with creation, and of "living in a good way." In cultural contexts of dislocation, disassociation, and loneliness, the church can be a place of healing, where practices for remembering our connection with the creation nourish humility, wonder, and joy.

[37]Robin Wall Kimmerer, *Braiding Sweetgrass*, 214.

Part III

Soul

PART III CONCERNS FOUR NOTES that bring expression to our witness, what we call *soul*. It's well-known that jazz is a deeply complex art form. The theoretical knowledge and technical ability required to play this music can be intimidating. Yet for jazz to connect with the human spirit it requires more than technique and theory, it requires soul. When we come to play, we should step back from the technical exercises and the theoretical constructs, in order to play what we "hear" in the moment with a full heart. And as we do, we keep an open heart toward our fellow musicians, ready to receive and respond to what they bring to the table.

Part III: Soul, offers four notes for improvising church that are full of heart. These notes cannot be forced; they need to be played as authentic expressions of who we are. Played in this way they communicate to the soul, shining a light to the human spirit. These four notes are: voice, conversations, sins of our kin, and prayer.

Voice

WE WITNESS IN LIFE, *WORD*, AND DEED. Speaking about Jesus is rarely a neutral topic, and yet it is intimately connected to our theme of incarnational community. Incarnational community is the warm hearth from which our words about Jesus can be made visible and personal. To understand the crucial role of words, the following illustration from music will help. When you think of a band playing soul music, what do you think is the most important instrument in that band? When excellent musicians play a groove together, it is the bass that anchors the music. The bass (whether electric bass or double bass) bridges the rhythmic elements and the harmonic elements of the overall sound. It does this by locking in with the kick drum. We can think of the kick drum as bringing the pulse, the heartbeat of the band. Locking in with the kick drum, the bass has a percussive role. The bass also contributes the lowest note of the harmonic structure. In essence, the bass *puts a note on the kick drum.*

Speaking words about Jesus has a similar role to the bass in a band. Jesus is the heartbeat of our community. The kick drum represents the attractive behavior of the community that reverberates with Jesus' way, in such a manner that we can feel it in our hearts. And rather like the bass, which puts a note on the kick drum, spoken words put a "note" on the shared life of the community. With words we point to the source of our beautiful life, Jesus. To put it another way, our words give content and personhood to our life and deeds. And our deeds demonstrate the truth and meaning of the words. Like the bass in an awesome band, our words about Jesus are full of soul.

This first soulful note we play is voice: speaking about Jesus to those who don't know him. Voice is our ninth note for improvising community. Almost forty years ago, Lesslie Newbigin wrote:

> From whence comes the voice that can challenge this culture on its own terms, a voice that speaks its own language and yet confronts it with the authentic figure of the crucified and living Christ so that it is stopped in its tracks and turned back from the way of death?[1]

With these words, Newbigin points to the pressing need for fresh ways of speaking of Christ with speech that both embraces and also challenges culture. If Newbigin felt the urgency for compelling witness back in the 1980s, how much more should we feel this urgency today? Yet despite the vast inroads into post-Christendom covered in the intervening period, there is hardly any more creative imagination for speaking about Jesus now than there was back then. And while most preachers still tip their hat to traditional approaches to evangelism, few parishioners take up the call.

Moreover, when it comes to speaking about Jesus, many of us (but not all) are immediately triggered by the topic, and often for good reason. Some have experienced evangelism done badly. Some are so ashamed of the church's sins that they have little stomach for inviting others to join in. Whenever I speak about this topic to a Christian group, I always begin by inviting people to air their dirty laundry around evangelism; it can be hard to think generatively about speaking about Jesus until we have expressed our deep frustrations with evangelism as it is traditionally conceived.

Yet there are a variety of experiences of evangelism. I was speaking with a White Australian businesswoman about this topic just this past week. She remarked, "The church is responsible for so much damage, and it is all over the headlines. People can't understand how anyone would be a Christian!" Then again, a Korean Canadian pastor said to me this week that every time he tells someone about Jesus, he feels very happy, even when he receives criticism, for he knows that he is being obedient. Interestingly, many Y2K (Gen-Z) Christ-followers don't share the hesitations of their Gen-X parents around evangelism. Gen-Zers tend to be ready to dialogue and to learn from

[1]Lesslie Newbigin, *Foolishness to the Greeks: The Gospel and Western Culture* (Grand Rapids, MI: Eerdmans, 1986), 9.

one another. In fact, there is a new interest in hearing people's stories in culture more broadly.[2]

Our hesitations around evangelism are important. Without abandoning any critique that you may have, reflect for a moment: Can you recall a time when you heard someone speak about Jesus in a way that was authentic and beautiful?

For myself, my mother is an example of someone who spoke about Jesus naturally and beautifully. Mum died four years ago. Professionally, she was a therapist with an extraordinary capacity to listen to people and to love them. Whether in her therapy room or in the neighborhood, just about everybody who spoke with Mum ended up sharing their life story and their pain with her, both men and women. Mum walked closely with Jesus. She brought Jesus into conversations often and naturally, for Jesus was a crucial and personal part of her life. It made little difference if someone knew Jesus or not, Mum spoke about Jesus either way, for Jesus was a part of her.

> *Can you recall a time when you heard someone speak about Jesus in a way that was authentic and beautiful?*

In her work as a therapist, Mum thought a lot about the quality of coherence. Coherence is when a therapist's words align with their heart and mind. A good counselor seeks to be fully present with a person and with themselves, with alignment of heart, facial expression, mind, and speech. If the words we say don't match what is going on in our heart, then people realize that we are not fully present with them or even with ourselves. I think that the idea of coherence is an important lens for speaking about Jesus. Mum was completely coherent when she spoke about Jesus, and people felt it. They may not have shared her experience of Jesus, but no one doubted her experience. They knew it was real, and that in that moment her experience of Jesus was touching their own life.

We could refer to this kind of speech about Jesus as "authentic utterance." Everyone who has encountered Jesus has an authentic, or genuine, utterance within them. We have all experienced Jesus differently, but we have all experienced him (that is, if you are reading this book). That's why we turn up,

[2]The term "Gen-X" refers to the generation born in the mid-1960s to late 1970s, and "Gen-Z" refers to those born in the mid-1990s to early 2010s.

whether to church, to home group, to prayer, or to this book. We all have an authentic utterance within us.

Given that we need fresh imagination for speaking about Jesus, and given that the word "evangelism" has disturbing connotations for many of us, I suggest we find new phrases for the act of speaking about Jesus. "Authentic utterance" is one phrase I use. I also use "genuine voice" and "authentic speech." The phrase "speaking for the kingdom" is also helpful.

Early Church

We begin our journey by considering how people came to Christ in the period of the early church. It may surprise you to learn that by 313 CE, during the reign of Constantine, the church made up 10 percent of the population of the Roman Empire, numbering around six million Christians. If we assume that there were around one thousand Christians in 40 CE, then this is a growth rate of 40 percent per decade.[3] Extraordinary! What was the source of this growth?

Historian Alan Kreider suggests that what the early church did *not* do is as informative for our purposes as what the church did. The homilies from the period do not contain exhortations to evangelize. (Though the genre of *apologies*, which offered a defense of the faith, would have equipped believers to speak about Jesus with intellectual rigor.) And there weren't evangelistic programs. There was no preaching in the public square—this would have been quickly silenced. Also, the worship of the early church was anything but seeker-sensitive, for nonbelievers weren't even allowed through the door of Roman house churches due to the danger of persecution![4] Add to this the considerable disincentives to converting to Christianity in the pre-Constantinian period.[5]

So how did the church grow so quickly? In short, the shared life of believers, which contrasted with pagan lifestyles, made it attractive. According to Kreider, one way the early church was attractive was in the spiritual power evident in the community. The life-bringing power of Christ was evident among the earliest Christians, demonstrated in the powerful deaths of martyrs and in healings and exorcisms (cf. Rom 15:18-19).[6]

[3]Rodney Stark, *The Rise of Christianity* (Princeton, NJ: Princeton University Press, 1996), 5-6.
[4]Alan Kreider, "They Alone Know the Right Way to Live," in *Ancient Faith for the Church's Future*, ed. Mark Husbands and Jeffrey P. Greenman (Downers Grove, IL: IVP Academic, 2008), 69-70.
[5]Kreider, "They Alone Know," 170.
[6]Kreider, "They Alone Know," 171-72.

A second attractive aspect of the community of Christ-followers was their distinctive behavior, Kreider says. Christians defended human life in every way, rejecting the exposure of babies,[7] war, abortion, capital punishment, and gladiatorial contests. They shared possessions to a degree, provided burial for those who could not afford it (which was effectively a redistribution of income), stayed in cities during the plague to care for the sick, provided for widows, adopted unwanted babies, and were faithful in marriage.[8]

Further, in a cultural context of tribalism, the church treated one another as family across ethnic boundaries. The church was also diverse, with both poor and rich eating together, uplifting women as key participants and leaders in the community.[9] The shared life of Christ-followers aroused curiosity, and people asked questions. Kreider summarizes, "The Christians did not offer the world intellectual formulas; they offered a way of life rooted in Christ."[10]

Of course, the early Christians "were not mute," as Kreider puts it.[11] At places of work, "in women's quarters of houses, or in stairways in their apartment buildings or in the streets," the early Christians gave reason for their faith and the church grew dramatically. Yet the words that the early Christians spoke arose from their distinctive way of life and the curiosity that this stirred. In sum, Christ-followers in the early church spoke about Jesus (1) in the context of friendships, and (2) from within a contrastive shared life that was attractive to many (cf. Rom 15:18-19).[12] So Minucius Felix reflected at around 200 CE, "Beauty of life causes strangers to join the ranks. . . . We do not preach great things; we live them."[13]

[7]The common practice in Roman society of abandoning infants, who would then often die from exposure.

[8]Kreider, "They Alone Know," 171-74.

[9]Kreider, "They Alone Know," 174-75.

[10]Kreider, "They Alone Know," 177.

[11]Kreider, "They Alone Know," 178.

[12]It is worth noting that some South American theologians understand and express the gospel in similar ways to the early church, emphasizing both the truth of the gospel and the transformation that it produces. For example, Orlando E. Costas reflects, "To evangelize is to hope in the power of God's Spirit to enable those who hear the gospel and see it in action to understand its relevance for their lives, embrace it in faith, and follow in its path." Orlando E. Costas, *Liberating News: A Theology of Contextual Evangelization* (Grand Rapids, MI: Eerdmans, 1989), 19.

[13]Minucius Felix, *Octavius* 31.7, 38.5. Cited in Alan Kreider, "They Alone Know," 178.

Newbigin rhetorically asks, "From whence comes the voice that can challenge this culture on its own terms . . . ?" The location of this voice isn't as inscrutable as the question suggests—the voice comes from within a local community that is loving a neighborhood to life in the name of Christ.[14]

WHAT IS OUR POSTURE AS CHRISTENDOM FADES?

With Emperor Constantine I's ascension in 306 CE, it was not only permitted to be a Christian but also beneficial. New opportunities for Christians to seek wealth and power drastically diminished the spiritual vitality of the church. Godly leaders in the late fourth century such as John Chrysostom lamented that miracles had faded, and while many Christians once stood bravely in the face of martyrdom there, now there was a fear of death.[a]

The inspiring story of the growth of the early church ends where the story of the church in the West today picks up, in a sense.[b] In our day, the church is again being relegated to the margins of society; in some societies the process is all but complete, in other societies the church is wrestling with all its might to stay in control. Like the church in the fourth century, today's church and its members may be tempted to wield power for its own benefit, to seek wealth and honor, to control the public conversation, even to argue that the state itself should be somehow "Christian" as Christendom fades. And yet the story of the early church demonstrates how much is lost when the church gains power and wealth. So Christ-followers today will do well to live generously rather than to grasp power, to accept marginalization rather than to bustle our way into the center, to hasten the end of Christendom in its twilight, and ultimately to seek to live beautifully and tenderly before the watching eyes of our neighbors. Then, from a posture of friendship with our neighbors and from within the shared life of a community with a reputation for tenderness, we can offer an authentic utterance.

[a]Alan Kreider, "They Alone Know," 182.

[b]Here I am speaking of the Western church. The church of the Persian Empire, China, North Africa, and so on has a different and equally important story.

[14]Lesslie Newbigin knew this well. See Lesslie Newbigin, *The Gospel in a Pluralist Society* (Grand Rapids, MI: Eerdmans, 1989), 229.

Power of the Word

The apostles understood that the Word, the gospel, came with God's power, and that speaking the word released God's power into the church and into the world, by the Spirit.[15] "The word was announced as a sovereign summons, and it brought into being a new situation, new possibilities, and a new life-changing power," N. T. Wright states.[16] For this reason the apostle Paul wrote, "For I am not ashamed of the gospel; it is the power of God for salvation to everyone who has faith" (Rom 1:16).

I believe that as Christendom fades into the distance and the church is again relegated to a marginal position, we will be thrown back once again onto God's power, no longer relying on our own power. We will be gifted again with a deep confidence that the Word of God has power unto salvation, and God will move powerfully among us again—the miracles may even return![17]

> *Christ-followers today will do well to release power rather than to grasp it, to accept marginalization and persecution rather than to bustle our way into the center, to hasten the end of Christendom in its twilight, and ultimately to seek to live beautifully and tenderly before the watching eyes of our neighbors.*

What Is the Gospel?

What is the content of this powerful word? Throughout my twenties, I trained other Christians to speak about Jesus. I knocked on doors, and I trained others to knock on doors! Explaining the gospel for me at that time meant speaking about human sin, God's judgment, Christ's authority and atoning death, saving faith, and forgiveness of sins. In other words, a typical evangelistic presentation in the evangelical tradition. For a moment, think how you would explain the gospel to a friend who doesn't know Jesus.

[15]N. T. Wright, *The Last Word: Beyond the Bible Wars to a New Understanding of the Authority of Scripture* (New York: HarperSanFrancisco, 2005), 49.

[16]Wright, *The Last Word*, 49.

[17]The spiritual power displayed in the early church is manifest in some non-Western contexts today.

Around my thirtieth birthday, I began to gain a deep understanding of the gospel. Through reading two books, Colin Gunton's *Triune Creator* and Oliver O'Donovan's *Resurrection and Moral Order*, I came to realize that according to Scripture, the creation itself and every aspect of human life matters to God.[18] I realized that in the *beginning*, God made a good world with care and delight (Gen 1–2), as I say in chapter one. And I realized that in the gospel narratives, we see the Son of God striding about the creation, bringing healing, loving the world to life. In the gospels, Jesus the Son of God is renewing a "creation in thrall to evil," as Colin Gunton puts it.[19] God isn't in the business of discarding the creation but of redeeming and restoring it. *This must have implications for my understanding of the gospel*, I pondered.

On the basis of how the word *gospel* is used by the gospel writers and by Paul (discussed in chapter one),[20] the gospel can be expressed in this way: *Now, at last, God's long-anticipated time of salvation has come, in Jesus Christ, God's Son. While, because of human rebellion, evil plagues the creation, through Jesus, his life, death, and resurrection, God is restoring all things, reconciling humanity to God and humanity to one another, restoring the creation itself. The gospel calls all people to repent, for the forgiveness of sins,*[21] *and to get on board with what Christ is busy doing in the world.*

What Do We Talk About?

You can probably sense that when we understand the gospel in all of its richness, it connects with the multifaceted nature of our lives. So there is no one way to tell it. My friend Jim Mullins is a pastor in Phoenix. Jim is one of

[18]Colin Gunton, *The Triune Creator: An Historical and Systematic Study* (Grand Rapids, MI: Eerdmans, 1998); Oliver O'Donovan, *Resurrection and Moral Order: An Outline for Evangelical Ethics*, 2nd ed. (Grand Rapids, MI: Eerdmans, 1994). These two are not easy reads, so a more accessible and equally seminal book on this topic is Albert M. Wolters, *Creation Regained: Biblical Basics for a Reformational Worldview* (Grand Rapids, MI: Eerdmans, 1985).

[19]Colin Gunton uses this phrase in regard to Jesus' miracles (*Christ and Creation: The Didsbury Lectures, 1990* [Eugene, OR: Wipf & Stock, 1992], 18).

[20]See, for example, Mk 1:1-2, 14-15; Rom 1:1-2; 1 Cor 15:1-5; 2 Tim 2:8.

[21]"Forgiveness" in the Gospels refers to release: release from sickness, exile, rebellion, the influence of demons, impurity, the bond of sin's curse. See the entry "ἀφίημι" in *A Greek-English Lexicon of the New Testament and Other Early Christian Literature*, revised and edited by Frederick W. Danker, 3rd ed. (Chicago: University of Chicago Press, 2000), 156.

those people who can connect relationally with anyone. I once asked Jim how understanding the broad scope of the gospel (versus an exclusively private, otherworldly affair) has shifted how he speaks about Jesus. Jim responded: "Understanding the gospel has helped me to answer the questions that people are actually asking." In other words, if global warming is the topic of conversation, well, God cares about that. If someone's physical malady is the concern, God cares about that too and all sickness will one day be healed by the power of the gospel. If we are connecting around the arts, we can speak about our art as a prayer. The gospel connects with every facet of life, declaring Christ's redemption there.

Yet if the gospel is as broad as the creation, what should we talk about when we are dialoguing with a friend? What do we zero in on? We can view the biblical story, fulfilled in Christ, from many different angles, and it helps to focus on a part of the story that connects with a concern or passion that you share with your friend or workmate. Sometimes I picture the biblical story like a soccer ball. The different segments of the ball represent various aspects of the biblical story, including its many characters, episodes, and images. When I am dialoguing with someone, I imagine that I am shining a flashlight on one segment of the ball, opening up just one part of the story. (You might think over some of the passages we have unpacked in this book and consider whether you can unfold one or two of these passages simply and beautifully to a friend who doesn't know Christ.)

For instance, imagine that you are a player on a soccer team. One day after training, you are speaking with a teammate, who is a graduate student in ecology. She happens to come from your place of origin. You enjoy talking to one another, and then she finds out that you go to church. She is intrigued, and asks you: "What do you guys believe?" You sense that you need to be brief and to the point. What will you say? What part of the "soccer ball" (biblical story) will you shine the flashlight on? How will she hear it is good news, given the things she loves and cares about?

Authentic Phrases

You may be thinking, *Evangelism was so much simpler back in the day when all I had to do was to explain*: "All have sinned," and, "Christ paid the price!"

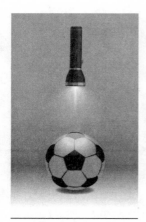

Figure 9. In conversation we can shine light on one aspect of the biblical story.

This *is* simpler, and it *is* true, and yet it's not the whole story. We need to internalize the biblical story in all its richness until it flows from us naturally. Speaking the truth in this way demands more from us. It requires knowing the Bible stories and retelling the stories. It requires light-on-our-feet creativity, with a big heart.

Whether we are dialoguing with our friends who don't know Jesus, or preaching, when we first become aware that the gospel takes all of creation in its embrace, many of us inadvertently use overly complex phrases. This is natural when we are learning something for the first time. Yet, as tempting as it is to repeat a phrase like "comprehensive scope of the gospel," it probably won't land well outside of your circle of theologically well-read friends! We need to seek new phrases and metaphors to explain the gospel, phrases that make sense to us and emerge from our own life. I will share some of mine, but you will probably want to find your own phrases and metaphors, in time.

A shorthand phrase that I often use to speak about the cross of Christ is: "Jesus died on the cross to heal the world." I first started to use this phrase with my kids, and now I use it in conversations with adults and in preaching too. The phrase seems to resonate with people, as both kids and adults seem to have a strong sense that the world needs healing and that the work of healing isn't an easy fix but comes with a cost. When they hear that the horror of Jesus' darkest hour is, in fact, a cure, a surgery, some people are curious and want to hear more.

Sometimes I refer to Jesus as the "mender of all things." Credit for the phrase goes to Tom Wuest, whose songwriting I have already mentioned. Wuest's song *Mender of All Things* is a contemplative song of waiting on the Lord.[22] The song begins, "Oh God we wait on you, in the dark of night." The metaphor of mending brings to my mind the detailed work of a sewer who is stitching clothing with care. A mender gives a piece of cloth another

[22]Tom Wuest, *Mender of All Things*, copyright 2016; used with permission.

chance, honoring its purpose. I also speak of Jesus "mending the world," and of our working alongside Jesus as he mends the world.

Yet the phrase I use most often in speaking with those who don't know Christ is, "It's all about Jesus." Truth be told, when I am in the middle of dialoguing with a friend about faith it is all too easy for me to speak about *anything but* Jesus! I often end up wandering down rabbit trails. So, to keep my thoughts on track, I make myself say the words, "It's all about Jesus." And then I continue explaining things from there. The phrase is always at the ready—more as a reminder for myself than for the person I am speaking with—"It's all about Jesus."

Finding fresh phrases and metaphors for expressing our faith in post-Christendom is a sacred project. We can seek fresh expressions for all of our speech, including preaching. We can engage this project bravely, taking the creativity of the biblical authors themselves as our example. The biblical authors displayed remarkable creativity as they sought to hold out the word of life in diverse contexts, often as they faced profound challenges.

As an example, the scribes responsible for the Old Testament appropriated concepts from ancient Near Eastern royal ideology such as covenant and election in their writing. The covenant was a militarized tool that the great empires employed to keep subordinate kings underfoot. The Israelite scribes took a risk in appropriating the covenant metaphor to reveal something new and gracious about Yahweh. Surely the first time the covenant concept was used to speak about Yahweh, eyebrows were raised! The New Testament authors similarly appropriated and adapted Roman Imperial motifs to proclaim, for example, the "peace of Christ" (cf. the *pax Romana*).

It is quite incredible to think that these key phases of Christian theology and liturgy, cherished as they have been throughout the millennia, have been adapted from the rhetoric of the great empires. Such bold ingenuity on the part of the biblical authors as they recontextualized the gospel for their generations should inspire in us wonderful creativity, not only in our speech but in every aspect of our life together. While we will continue to use these ancient metaphors, this doesn't release us from the hard work of retelling the biblical story for our own time. Do we not need similar creative work today? We should be on the lookout for our wordsmiths: Christian artists and young leaders who take risks in finding fresh expressions of the gospel

for our time. We need to give one another plenty of room to make mistakes as we seek to hold out the word of life for a new generation.

Authentic Dialogue

When it comes to speaking with people one-on-one, our authentic utterance about Jesus should come in the context of genuine conversations. An example of a genuine conversation that twinkles is Jesus' encounter with a Samaritan woman at the well (Jn 4:1-42). Having arrived at the well, Jesus' followers were thirsty. In the usual course of events, the disciples would have bargained with the woman to use her bucket and rope. Not Jesus. He uses his thirst as an opportunity to connect with this daughter of God. The conversation between Jesus and the woman unfolds as curiously as it begins, full of quirk and double meaning.

A bit like Jesus' encounter with the woman at the well, these days authentic conversations are becoming more and more interesting. People desire to hear another person's stories and to share their own. And for all the pain involved, the ideological fragmentation of the culture wars has birthed a high value on listening well to those with whom we disagree. People value dialogical conversations, where there is good listening in both directions, receiving these encounters as a gift.

As culture shifts, I am noticing in myself that the nervousness that I used to feel around speaking about Jesus is fading, as many people are eager to dialogue on spirituality, ideology, and personal experience. In hindsight, it seems to me that the nervous energy that accompanied my speaking about Jesus only a few years ago was a byproduct of latent Christendom, a period in which people were still very aware of the church. Back then, the viable options for life were essentially secularism or Christianity. But now, in my post-Christian and pluralistic city, dialogue on spiritual things is not only acceptable but even desired by many. In pluralistic cities like mine, we can often enter dialogues with ease and joy, just by being ourselves.

As we dialogue around faith, two qualities of authenticity stand out: listening and confidence in the gospel. First, listening. People are often open to dialogue, yet we must learn the art of listening. Years ago, when Erin began graduate school, she was wondering how to "be" a Christian in the

university humanities environment. A Christian woman who had just finished her PhD advised her, "Listen really well." This is sage advice.

Listening, at minimum, means seeking to hear and understand what a person is saying. Yet deep listening requires even more. Listening is costly, requiring us in some measure to die to ourselves to make room for the other person to truly exist. Daniel Coleman puts it well: "This opening up of the self, this vulnerability to others . . . is simply the product of committing herself to reaching toward an understanding of the mind of another person without commandeering them into her own framework. It is the product of paying fierce and generous attention to others *as others*, allowing them to be other than who we expected them to be."[23]

Another quality to consider when we are dialoguing on faith with someone is confidence in the gospel. As we dialogue, we don't have to offer the best arguments and we don't need to have the last word. Rather, we can have confidence that the gospel of Jesus is the power of God for salvation. As the apostle Paul writes, "I am not ashamed of the gospel; it is the power of God for salvation to everyone who has faith" (Rom 1:16). Our frail and imperfect words about Jesus come with power, not because they are our words, but because they are words about Jesus. So we can simply speak of Jesus' tenderness, tell stories from his life (understood in the framework of the whole Bible), in the context of a dialogue. And Christ himself turns up, by the Spirit. Ultimately, the life and passions of every person are touched on, reflected, healed, and fulfilled in the biblical story, in one way or another.

Finally, our words about Jesus don't deny that there is beauty and truth in other faith traditions and other stories.[24] Every faith tradition reflects something of the grandeur of God (Rom 1:19).[25] On the one hand, the biblical story fulfills the longings, the aching, and the beauty of other traditions. On the other hand, the aesthetics and ethics of other faith traditions may

[23]Daniel Coleman, *In Bed with the Word: Reading, Spirituality, and Cultural Politics* (Edmonton, AB: University of Alberta Press, 2009), 70.

[24]Stefan Paas speaks of Christianity as a "learning religion." As Christianity has been accepted and then explained in many cultural contexts, believers have necessarily learned their contexts and explained the gospel in the categories and systems of meaning of their native culture (*Pilgrims and Priests: Christian Mission in a Post-Christian Society* [London: SCM Press, 2019], 17).

[25]See Willie J. Jennings's discussion in *The Christian Imagination: Theology and the Origins of Race* (New Haven, CT: Yale University Press, 2010), 258.

help us to recognize threads within the biblical story that we have left unnoticed. We can hold these realities in concert together.

Covenantal Context for Conversion to Christ

In my experience, when a person comes to Jesus, "evangelism" is only a part of the story and often not the most important part. Most often, people are converted to Christ in the context of their participation in the covenant community, even at its outer edges. People become curious about our contrastive way of life, and they come alongside us. Eventually, some are given the gift of faith. This is the covenantal context for conversion to Christ: we are always witnessing to one another by our shared practices, whether to believers or to not-yet-believers. By "covenantal" I am referring to the church community's union and communion with Christ.

For all of us, our conversion to Christ is a lifelong process. And so, the covenantal context for conversion to Christ is ongoing, spanning our whole life. Throughout our years of knowing Christ, we are drawn to him by shared practices such as worship, Scripture reading, feasting, prayer, giving, and more. By the power of the Spirit we are swept up in the worship and practices of the covenant community and led toward Christ.

Nourishing Authentic Utterance

How do we nourish our people to speak authentically about Jesus to their friends and workmates who don't know him? Here are four practical suggestions. First, take time in a church service for people to air their grievances around evangelism. You will find that many people, even some mature Christ-followers, won't be willing to have a constructive conversation until you do. I literally make a list of people's frustrations as they call them out, right there in front of the congregation.

Second, re-narrate the biblical story for people so they come to understand the breadth of the gospel. You might read a book such as Michael Goheen's *A Light to the Nations: The Missional Church and the Biblical Story*, so that the richness of the biblical story infuses your own thinking, teaching, praying, and preaching. A friend of mine who pastors in Phoenix commented, "This work is slow. The gospel becomes broader for people very slowly, through teaching over time and especially by living and doing over time." Remember

that many of your people are full of doubts and struggling to accept the faith of their youth. So in re-narrating the biblical story you are also evangelizing your people, helping them to love Christ and to love Scripture.

Third, create low-stakes environments for people to speak about Jesus to one another. For example, during a sermon recently I invited the congregation to share with a person sitting near to them one thing they value about Jesus. People can share in their small groups too.

Fourth, it is important to nourish a conversation around following Christ in our vocations, as we discussed in chapter two. Get people in similar vocations dialoguing with one another. Get them talking about how they can work and speak as Christ-followers in their field of work. When it comes to speaking about Jesus, very often only an engineer can connect with other engineers, and only a jazz musician can connect with other jazz musicians.

In this chapter we have unfolded a ninth note for improvising community, genuine voice. This is speech about Jesus that is offered authentically, with coherence, and unfolds an aspect of the biblical story that connects with our friend's passions and with the conversation at hand.

Closely connected to our ability to have conversations with those who don't know Jesus is our ability to have healthy conversations within the church. So we turn to this theme now. Incarnational communities can be characterized by healthy and regular community conversations. Our conversations are locations for discernment around where the Spirit is leading the church and where pressing issues facing the community are discussed.

Conversations

JAZZ MUSIC IS a conversation, taking place between musicians. When you picture a jazz musician, you might imagine a saxophonist soaring into the stratosphere. But in truth, jazz musicians don't perform as isolated virtuosos; they interrelate and dialogue. Jazz musicians are always listening and responding, creating something new that surpasses the capacity of any one musician. Jazz music demonstrates both the possibility and the complexity of good conversation. Wynton Marsalis reflects on jazz in the context of American society:

> In American life you have all of these different agendas. You have conflict all the time. And we are attempting to achieve harmony through conflict . . . But it's like an argument [in which] you have to work something out, not an argument [in which] you have the intent to argue. That's what jazz music is. You have musicians, and they are all standing on the band stand. And each one has their personality and their agenda. Invariably, they are going to play something that you would not play. So you have to learn when to say a little something, and when to get out of the way. So you have the question of the integrity, the intent, the will to play together. That's what jazz music is. So you have yourself, your individual expression and then you have how you negotiate that expression in the context of that group. It's exactly like democracy.[1]

Jazz musicians show up ready to have a conversation. From the first count in, we are ready to listen, to make space for others, to offer a thought, to course-correct in response to others, to create something together.

[1]Wynton Marsalis, in the documentary miniseries *Jazz*, directed by Ken Burns (Florentine Films, 2001), episode 10, 5:45—7:00.

In a similar way, incarnational communities can be characterized by healthy and regular community conversations. This chapter attunes to this tenth note for improvising community: communal conversations. Incarnational churches can be characterized by a culture of dialogue and a desire to grow in our ability to have conversations as a community. Healthy and regular community conversations can be locations for discernment around where the Spirit is leading the church and where pressing issues facing the community are discussed. Our conversations can be a key expression of our shared life as the body of Christ, the family of God.

In his book, *How the Body of Christ Talks*, Christopher Smith explains how Englewood Christian Church in Indianapolis has been sharing in regular conversations almost every Sunday evening for over twenty years.[2] Englewood's conversations are not like a formal congregational meeting, where budgets are approved and minutes are taken. They are more like a dinner table conversation, where all manner of things can be discussed, ranging from a Sunday sermon to an emotionally charged topic that threatens to split the community. The very process of learning to have conversations has been as impactful for Englewood as the conversations themselves. Our church in Vancouver has been going through a similar learning process. We engage in conversations periodically rather than weekly, and we sometimes use other forums such as home groups to process issues, feeding back into a whole-church conversation.

However often we gather, having healthy conversations is a learned practice. A child isn't born with the ability to talk but learns to talk over the years, as they mature and grow. Similarly, a church will grow and mature in their ability to have conversations with practice, over the years.

Yet growth toward maturity is rarely pain free. Like any close community, churches periodically journey in and out of tension. Once, there was so much disagreement in our church over a certain issue that it felt like we weren't going to survive. During this period, whenever we gathered to talk there were insults and outbursts of rage. As a leadership team, we were perplexed as to what to do. Gradually, my pastoral colleague Joy Banks began to form a plan. Joy took fourteen members of the community away

[2]C. Christopher Smith, *How the Body of Christ Talks: Recovering the Practice of Conversation in the Church* (Grand Rapids, MI: Brazos, 2019).

on a two-night retreat. The retreat participants were evenly distributed on either side of the painful issue facing our community. Together they shared in times of listening prayer. They asked questions of one another to understand and appreciate what was motivating each person's opinion. The goal of the retreat was not to convince but to listen and to understand. When the group returned, they stood in front of the whole church and reported on their experience. As they stood together as a group, the love and appreciation they had for one another was palpable, cutting across divisions. Participants representing both positions spoke of their respect for those with whom they disagreed.

This experience illustrates how conversations can enhance trust and understanding. At the same time, conversations often require a good deal of emotional labor. The need for this retreat shows how difficult communal conversations can become. And on topics such as racism, where some participants are racialized in a way that others are not, the emotional labor is uneven, to say the least. Stewarding healthy conversations takes courage, sensitivity, and creativity. And the payoff can be rich, as the Spirit knits us together as family.

You can probably already sense that communal conversations require a certain kind of leadership. When key leaders trust their community to have healthy conversations, the relationship between key leaders and the congregation takes on a new quality of mutual respect. It's like that feeling when children in the family have grown into adulthood, and we now take responsibility together, as equals. When leaders provide healthy conduits for their people to talk things through, people become loyal to the community and its vision. And when leaders invite conversations on difficult issues and fresh opportunities, then our shared life is enriched and new possibilities emerge by the Spirit. Having conversations invites everyone to be co-creators—a truly leader-full community.

Like-Heartedness

Strong cultural winds blow against forming a culture of healthy conversations. Genuine fears make us hesitant to engage in communal dialogues. Our fears may arise from power dynamics or from trauma experienced through racism or sexism. Some key leaders may fear "releasing" the

congregation to have conversations, lest the engagement spiral downward into an intractable conflict. Others may worry that the church will wander off into dangerous theological territory. Each of these hesitations is legitimate and understandable. In the bifurcated and politically charged cultural environments of many churches today, differences are most often ignored in the hope that things will simmer down.

Acknowledging all this, we should nevertheless consider: Where will we learn to have conversations across cultural boundary lines, if not as a church? Christopher Smith reflects, "It is in our churches, I believe, that we learn to talk with others."[3] In our shared life of love, expressed in conversations shared across traditional boundary lines, we can exist as a contrast-community within our neighborhood. Our conversations are a part of our witness.

Our fears around having conversations often reside in the tension of simultaneously holding two values that seem to diverge: the value of truth and the value of relationships. Is it possible to speak and live truthfully, while also honoring our relationships? There is wisdom in Ephesians 4 for how these can be held together. The apostle Paul masterfully balances seeking truth with qualities that honor one another and preserve our identity as family. He famously calls the Ephesian Christians to be "speaking the truth in love" (Eph 4:15). They are to do so with a posture of humility and gentleness, and patience, "bearing with one another in love" (Eph 4:2). Paul's central theme in Ephesians 4 is unity. Yet the truth is not vague for Paul, as if he is waiting for the community to take a vote on what they believe. For the church's task is to grow up in maturity, in the knowledge of the Son of God. And leaders are given to nurture in Christ (Eph 4:11-12). So Paul holds a tension, and encourages us to do the same. As Lynn Cohick puts it, "Paul emphasizes truth *in love*, which implies a humble spirit straining after Christ."[4]

What is remarkable about Ephesians 4 is that Paul has opinions, *strong opinions*. The broader letter deals with, for example, the vexed question of the relation of Gentiles to Judaism.[5] Thus, Ephesians 4 is as remarkable for

[3]Smith, *How the Body of Christ Talks*, 8.
[4]Lynn H. Cohick, *Ephesians*, New Covenant Commentary Series (Eugene, OR: Cascade, 2010), 113.
[5]For Paul, so long as Judaism (in its wide variety) remained the conduit between Christ and Gentiles, not only would the faith of both Jews and Gentiles be distorted, but Christ would be diminished.

what it *doesn't* say as for what it does. Paul sets his own argumentation aside, and he urges the church to talk, knowing that some will say things he disagrees with. They are to speak the truth in love, seeking Christ even as they seek one another in Christ.

In speaking the truth in love, we can be like-hearted, even though we disagree. We can be like-hearted by agreeing to be present to one another, in relationship for the long haul. We can be like-hearted in our shared commitment to shine the light of Christ to one another, within a particular neighborhood, into the years. "Like-heartedness" reflects our commonality better than "like-mindedness," Smith reflects.[6] We are not called to a false unanimity but to like-heartedness. This reminds us of Marsalis's reflection, that jazz musicians come with, "The integrity, the intent, the will to play together." This integrity is the gift of our presence, with open hearts and open ears.

Church Conversations

What can communal conversations look like, concretely? Like any complex conversation, church conversations tend to go best when they are approached thoughtfully, with careful preparation.

The space in which we gather is important. Ideally the whole church can gather in the same room. In a larger church, it might be more helpful to divide into cohorts. You might consider what seating arrangement will inculcate a spirit of listening and mutuality. What room temperature will help people to feel comfortable? Will coffee and dessert foster a sense of being family together? I find that a visual focus point such as a cross or a Christ candle can help to center our conversation on Jesus. During a season when our church was discussing a highly contentious topic, we agreed that each time we gathered for dialogue we would finish by sharing in the Eucharist.

Silence and listening prayer can characterize our community conversations. It is tempting to arrive for a community conversation eager to speak our mind. Opening with contemplative prayer slows us down, nourishing in us a willingness to humbly receive. In silence, God reminds us that we are here to seek God's desire for our community, together. And we can engage

[6]Smith, *How the Body of Christ Talks*, 153.

in listening prayer throughout our time together, pausing to listen to the Spirit as a vital component of our conversation. You might spend some of your time in small groups, spread out across the room. Perhaps the facilitator invites small groups to begin with listening prayer. Perhaps she invites participants to "listen" in prayer for an image that God wants to offer the group.

My friend Brendon has facilitated conversations in our church for many years. Professionally, Brendon is a senior administrator at a local university. As you can imagine, Brendon runs lots of meetings. He has initiated the practice of beginning his work meetings at the university in contemplative silence! His colleagues greatly appreciate the wisdom of beginning meetings with silent reflection, receiving these times as a gift.

Finally, there is the question of what to talk about. Our Vancouver church tends to gather for conversations when there is something that we need to talk about. In contrast, Chris Smith is probably wise to recommend that churches gather for conversation at least once a month.[7] It is advisable to practice having conversations by engaging low-stakes topics, such as opportunities to serve in the neighborhood or the homily from the previous Sunday. When the community dialogues on more difficult topics, careful preparation and facilitation will be all the more important.

Negative Capability

Whether the topic of conversation is easy or contentious, expanding our capacity to sit with tension helps us to be internally anchored as we dialogue with others. One year our church engaged in an external review to assess our health, strengths, weaknesses, and opportunities. One of our guest reviewers reflected that we "have great capacity to hold things together that are most often kept apart." She commented that the poet John Keats called this "negative capability," a quality which he observed in poets and artists.[8] This phrase stuck with me: negative capability.

Some years later I noticed Ronald Rolheiser saying the same thing, but in a different way. Rolheiser refers to this ability to carry tension as a kind

[7] Smith, *How the Body of Christ Talks*, 36.
[8] On Keats's conception of negative capability, see Stephen Hebron, "John Keats and 'Negative Capability,'" British Library online, 2014, www.bl.uk/romantics-and-victorians/articles/john-keats-and-negative-capability.

of prayer: "prayer as pondering."[9] He holds up the example of Mary as she encounters her son's ministry and his death, carrying a tension that she cannot resolve. "There is absolutely nothing she can do to save him or even to protest his innocence and goodness—she is pondering in the biblical sense."[10] Rolheiser states, "To ponder, biblically, is to stand before life's great mysteries the way Mary stood before the various events of Jesus' life, including the way she stood under the cross." "But Mary treasured all these words and pondered them in her heart," we are told (Lk 2:19). Negative capability may be an apt phrase for Jesus' astonishing capacity to hold tensions, resisting premature resolution. In his crucifixion, Jesus didn't give into anger, hate, and retaliation. "Instead he carried hatred, anger, jealousy, and wound long enough until he was able to transform them into forgiveness, compassion, and love."[11] Rolheiser reflects that by carrying tensions and not forcing early resolutions, we allow others to be themselves and we allow God to be God.[12]

At first glance, it may feel like holding tensions is opposite to seeking the truth. Those who know me well know that I write as an exegete, one who is occupied, even obsessively occupied, with seeking God's voice in Scripture, for the sake of the witness of the church and for the life of the world. Yet as one who is constantly studying God's Word, I am convinced that Scripture itself holds in tension many of the tensions we encounter in ministry. I have learned that when I encounter a polarity, to totally collapse one pole in favor of the other one will rarely prove right in the end.

> *I have learned that when I encounter a polarity, to totally collapse one pole in favor of the other one will rarely prove right in the end.*

One time that my own capacity for negative capability was engaged was when I—a Presbyterian pastor—received an invitation to serve in a Baptist church. Responding to this call was the most difficult decision I have ever made in my life. The first issue I had to face was denominational distinctives around baptism. I am a convinced

[9] Ronald Rolheiser, *The Holy Longing: The Search for a Christian Spirituality* (New York: Doubleday, 1999), 219.
[10] Rolheiser, *Holy Longing*, 220.
[11] Rolheiser, *Holy Longing*, 224.
[12] Rolheiser, *Holy Longing*, 223.

paedobaptist and have even published on the subject. I wrestled, *Could I pastor in a Baptist church and merely dedicate children?* During this time of discernment, Christ's High Priestly Prayer in John 17 became key for me. Jesus prayed this prayer on the night that he was betrayed. Three times Christ prayed to the Father for the unity of the church: "That they may all be one . . . so that the world may believe that you have sent me" (Jn 17:21; also Jn 17:22-23). Through Christ's prayer I came to realize that the unity of the church is crucial for the witness of Christ. I gradually recognized that my convictions around baptism shouldn't be a final barrier to accepting the call to the new church. In time I did accept it. Through this discerning process, I, and our new church, needed to engage our negative capability. As for me, I agreed to dedicate children. And our new church agreed that the church would baptize *our* children, all on the basis of Christ's High Priestly Prayer.

Conversation Skills

If expanding our negative capability assists us to be present with others, then conversational skills—both individual and communal—assist us to have healthy dialogues. The skills that facilitate communal conversations may not appear flashy on the surface, but mature leaders learn to cherish these skills. These skills include listening, facilitation, guiding a group in talking through difficult issues, and cultivating healing after painful dialogues.

In a community that talks together, each person has a responsibility to grow in their ability to engage well. Engaging well is important, because every conversation affects our relationships. Every dialogue moves us along a continuum between trust and threat, as expert facilitator Tim Warkentin once reflected to me.[13] To illustrate the value of engaging well, I was surprised to learn the other day that top scientists tend to have excellent relational skills. Scientific advancement requires collaboration; scientific papers tend to be coauthored. So the most successful scientists have "a genuine interest in people, reserves of patience and generosity, and the ability to build and sustain teams that can survive the frustration of day-to-day research."[14] Top scientists know that, in the end, it's all about people. And

[13]Tim Warkentin is an organizational consultant based in Vancouver. See https://timwarkentin.com.
[14]Andy Crouch, "What I Wish My Pastor Knew About The Life of a Scientist," Biologos, September 12, 2018, https://biologos.org/articles/what-i-wish-my-pastor-knew-about-the-life-of-a-scientist.

whether you are a scientist, a congregant, or a scientist who is also a congregant, the first and most important step toward becoming a good conversation partner is growing in your ability to listen.

A friend reflected to me the other day: "The person who does all the talking always thinks the conversation has gone well." So true. Most often it is not our fine speech that earns someone's trust but our careful listening. The more listening we do, listening not only with our ears but also with our mind and our heart, the more our conversation partners will trust us. Trust grows when we listen to others not to change them but to learn more about them. We should pay attention to others not as a math problem to solve but as we would a newly released song recorded by our favorite artist. And as we listen in this way, any suspicion that may lie between us slowly evaporates. So, James writes, "Be quick to listen, slow to speak, slow to anger" (Jas 1:19). Who among us doesn't need to contemplate these words from James?

Yet so often I don't relate to others in this way! I notice (to my frustration) that when I fail to listen and dialogue genuinely, this seems to be rooted in my own brokenness and fear. Martin Buber writes that much of our dialogue is, in fact, "monologue disguised as dialogue"![15] On the surface, we think that we are having a conversation, but in reality, we are stuck in our own inner process. This is true of arguments in which we aim to hurt one another. It is also true of speech that is designed to impress. In such situations, Betty Pries reflects, "When we peel back the layers of our interaction, we observe that much of what we said was, in fact, dialogue with our wounded interior condition. We spoke more to protect our selfhood than to find a common understanding with the other."[16] So true. Growing in our capacity to participate in group conversations, or in any conversation, entails the hard and hopeful task of noticing our own fears and brokenness, and working these things through.

Noticing our own fears and brokenness works hand in glove with noticing any power dynamics in the conversation. When we have relative

[15]Martin Buber, *Between Man and Man*, trans. Ronald Gregor-Smith (London: Routledge Classics, 2002), 22. Cited in Betty Pries, *The Space Between Us: Conversations About Transforming Conflict* (Harrisonburg, VA: Herald, 2021), 102.

[16]Pries, *The Space Between Us*, 102.

power in a dialogue, are we able to quiet down enough to notice the ways in which our fears and brokenness may be preventing us from having a genuine dialogue? From allowing others to steer the conversation and shape the outcome?

Finally, when more than one culture is represented in a communal conversation (and let's hope that this is the case), then having effective conversations requires empathy and curiosity regarding cultural differences. Cultural differences around communal versus individual expectations and around hierarchy can result in vastly different kinds of conversations! To illustrate, a Eurocentric Australian like me will probably adjust quickly to church conversations in which every voice is valued and every idea is welcomed. And they would likely feel comfortable to disagree with their pastor in such a setting. However, a culturally Korean congregant's value of communal identity may lead them to engage differently. The culturally Korean brother may feel uneasy about stating an opinion that doesn't conform with the group, and his respect for elders and spiritual authority may make him hesitant to disagree with his pastor and lay elders. These cultural differences illustrate that learning to listen well ideally includes intentionally growing in intercultural intelligence. It is a beautiful expression of love, to pause mid-conversation to inquire how cultural differences are shaping the conversation.[17]

> *It is a beautiful expression of love, to pause mid-conversation to inquire how cultural differences are shaping the conversation.*

Facilitation Skills

Even with all the listening skills in the world, group conversations are inevitably complex and often unwieldy, so skilled facilitation is an asset. A facilitator guides a group of people who desire to get from one place to another place by having a conversation. The facilitator is concerned with process, with providing opportunities for the group to learn from one another, and with asking good questions.

[17]For a helpful discussion of cultural differences that may affect our conversations, see David A. Livermore, *Cultural Intelligence: Improving Your CQ to Engage Our Multicultural World* (Grand Rapids, MI: Baker Academic, 2009), 121-42.

Facilitation is one of those "soft" skills missing from the leadership manuals of twenty years ago. Facilitation skills simply weren't as necessary in Christian societies, where the authority of church office holders was sufficient to keep the ship steady and there was often little expectation of genuine participation in decision-making. In incarnational communities, however, where we seek to shape our vision together, quality conversations are vital. And quality group conversations require skilled facilitation. For key leaders, collecting in our toolbelt a range of strategies that assist groups to talk together increases our capacity for nourishing leader-full communities.

A FACILITATION STRATEGY

Here is one such strategy for groups that are smaller than thirty. We begin with grouping people into pairs, ideally randomly. Each pair grabs two sticky notes and one marker and sits down. Then each person takes a turn sharing with their partner what God is drawing their attention to. I usually allow three minutes for each person to share (six minutes in total). The listener scribes on a sticky note. Finally, the whole group gathers around a whiteboard or an empty wall. Each person shares what their partner has offered, sticking the sticky note up on the wall. This is just a simple strategy, yet it illustrates the kind of thoughtful preparation that a facilitator can bring to a gathering. For further guidance on facilitation, you might consult Roger Schwarz, *The Skilled Facilitator* and Sam Kaner, *Facilitator's Guide to Participatory Decision-Making*.[a]

[a]Roger Schwarz, *The Skilled Facilitator: A Comprehensive Resource for Consultants, Facilitators, Coaches, and Trainers*, 3rd ed. (Hoboken, NJ: Jossey-Bass, 2017); Sam Kaner, *Facilitator's Guide to Participatory Decision-Making*, 3rd ed. (Hoboken, NJ: Jossey-Bass, 2014).

Doubt and Conversations

Conversations are an important way in which we can support one another in our doubts. We have reflected that doubt is pervasive in churches within post-Christian societies. Christ-followers in multicultural neighborhoods swim in a diversity of religious beliefs and aesthetics so that our faith in

Christ can feel like a rock just barely jutting out of the ocean, awash with wave after wave of alternative possibilities.

When I first began pastoring, I felt confident I could talk people back into faith. However, by trial and error I learned that a more helpful way to journey with people in their doubt is to have a dialogue where I do most of the listening. One year, a pastoral colleague and I ran a weeknight series on doubt. The most transformative part of the series wasn't our input (though this was helpful) but our giving people the space to speak openly about their doubts and to dialogue with one another. People experienced relief in stating their sharpest doubts out loud, right there in the church building.

Around the same time, we ran a sermon series on doubt. Again, I invited people to name their sharpest doubts. As people named their doubts, we listed them before the congregation on a flip pad. You can imagine that this felt awkward at first. But as we pressed on, we felt like someone had lifted a release valve on a pressure cooker. Naming our doubts in the context of worship, in the presence of Christ, helped us to realize that our doubt could be a part of our journey of faith. Through conversations like this, we can learn that Jesus is strong enough and tender enough to hold us in our doubts.

Conclusion

Together, this chapter and chapter two (nourishing leader-full communities) have charted a new path for belonging and for leadership. We have recognized that learning to have communal conversations is one crucial pathway toward becoming leader-full. These two chapters have opened a new set of leadership skills that were all but lost on leadership training twenty years ago. The "soft skills" discussed here place a high value on relationships and the emotional intelligence and intercultural intelligence that sustains these relationships. These skills include kin-keeping, conflict resolution, restorative justice, facilitation, listening, the ability to have hard conversations, collaborative decision processes, and communication skills. You might look out for opportunities to be trained in these skills on your leadership journey.

As we have conversations about the opportunities before our church in our particular place, it is important to learn the history of our place, the stories of its people and the environs. Thus, in the next chapter we give our

attention to the histories of people and land. We focus on the church's complicity in colonialism and appropriate ways for us to respond to these histories. This sorrowful theme is the eleventh note for improvising community: sins of our kin.

Sins of Our Kin

BLUES MUSIC AND JAZZ MUSIC were birthed within the Black experience of oppression, spirituality, and community. This music expresses the suffering and also the joy of African American peoples—the "blues moan and gospel shout."[1] In his book *The Cross and the Lynching Tree*, James Cone, who is perhaps the most renowned Black American theologian of the second half of the twentieth century, asks: "How did southern rural blacks survive the terrors of the lynching era (1880–1940)?" Cone reflects:

> Self-defense and protest were out of the question, but there were other forms of resistance. For most blacks it was the blues and religion that offered the chief weapons of resistance. At the juke joints on Friday and Saturday nights and at churches on Sunday mornings and evening week nights blacks affirmed their humanity and fought back against dehumanization. Both black religion and the blues offered sources of hope that there was more to life than what one encountered daily in the white man's world.[2]

Through the genius, suffering, and strength of the Black community of the South, the most powerful force in modern music was born: the blues. So-called blue notes give blues music its distinctive sound. The musicians among us will be interested to learn that there are three blue notes in any given key, namely the flattened third, the flattened fifth, and the flattened seventh. In the key of C, these notes would be E♭, G♭, and B♭. Blue notes have a power to them: they can express lament and anger just as well as

[1] Otis Moss III, *Blue Note Preaching in a Post-Soul World: Finding Hope in an Age of Despair* (Louisville: Westminster John Knox, 2015), 2.

[2] Moss III, *Blue Note Preaching*, 12.

celebration and strength. The blues always holds lament and celebration in tension, and every modern style of Western music, from funk to Broadway, owes its life to this art form.

Our eleventh note for improvising communities is a blue note. This eleventh note, sins of our kin, sings a song of the violence surrounding peoples and land. The blues restores dignity and offers resilience to those who sing it. In a similar way, as God's people learn to sing the blues over our own story, we can begin to heal and to hope.

> *The blues restores dignity and offers resilience to those who sing it. In a similar way, as God's people learn to sing the blues over our own story, we can begin to heal and to hope.*

A group from our church visited the abandoned building of a former First Nations residential school. St. Mary's, as it was called, operated in Mission, British Columbia. We sat in a listening circle to receive the memories, pain, and reflections of two elderly women, one who grew up at the school and another who grew up at a different residential school not far away. Both women were taken from their families at five years of age. Both were prohibited from speaking their traditional language. Both were forbidden from speaking with their siblings who were fellow students. Through tears they spoke of hunger, of sadness, of the prohibition of their culture. We were struck by the strength of these women, their ability to find humor and friendship in circumstances of unspeakable loss and abuse, and their strong and gracious readiness to meet with us and to tell their story. After sitting with the women, we walked the dark halls of the school, pacing all the way from the eating hall to the dormitories where the children used to sleep. One long dormitory room, painted light blue, had a door at each end. A priest's bedroom was located by each door. Our First Nations guide explained that sexual abuse took place in the priests' rooms.

What do we do with the sins of our kin, with our devastating history of church-run mission schools in Canada? And what do we do with the church's complicity in colonial history, slavery, land-theft, genocide, ongoing racism, environmental degradation, patriarchy, and so much more? Can we face the sins of our kin and continue as the church? This secrecy,

abuse, and hubris is a part of our story. And the generational confessions of Nehemiah 9 and Daniel 9 show us that the sins of our forebears and of our community are significant for us.[3] In the spiritual realm, we can't dodge them. They are truly ours.

Scripture is our guide as we reconsider the colonial story. My goal in this chapter is to understand the colonial story in light of the biblical story so that we can faithfully play our part in the biblical story. In our journey we will only briefly touch on themes of enormous significance. We will see that themes as seemingly diverse as the displacement of First Nations groups and immigration are all deeply related in our cultural histories, our cultural psyches, and our sinful natures. We can consider a vision for a church that lives within the tension of the dark side of our history and of our being beloved in Christ.

We need to hold this tension—of lament and celebration—also for the sake of our witness to Christ. It is important to recognize that violence done in the name of Christ to lands and peoples is the lens through which many people (but not all) view the church in post-Christian societies. For example, if Vancouverites know anything at all about the church, it is our historical role in residential schools. In some other contexts, it is the church's ongoing reluctance to challenge systemic racism that first rises to the surface. And as colonialism is the lens through which many people view the church, we cannot communicate the gospel to these people without our words being "heard" through this filter.

My friend Jodi Spargur educates churches around First Nations-settler relations in Canada. Jodi calls her work, Healing at the Wounding Place. When she first announced the name to me, I wondered if I had misheard: "Healing at the Wounded Place, you mean?" I offered. "No, Healing at the Wounding Place," Jodi said pointedly. "The church is accustomed to seeing itself as the one who brings healing, but in relation with Indigenous Peoples we need to understand ourselves as the ones who have perpetuated harm and we need to come to terms with that." Jodi went on to say that she had named the organization deliberately, so that people like me would step in and express surprise, giving her the opportunity to explain

[3] Both Daniel and the community of Nehemiah's day offer prayers of confession for the sins of God's people, conceived corporately and across time.

yet again: White settler communities need to seek our own healing in Christ.[4]

We might assume that repentance means to boldly step up and try to fix what has been broken. Yet what if we instead attend to our own healing, avoiding the well-worn path of White saviors (for those of us who are White)? The conclusion of our exploration of historical and structural injustices must be to recognize and lament our own wounded participation in these injustices (whatever that may be) and to receive Christ's healing and invitation. In this chapter, we will focus especially on First Nations experiences, in order to gain focus and depth in our exploration. We begin by exploring a little-known divine covenant in Deuteronomy.

Deuteronomy 10:18-19: Divine Covenant with Refugees

Deuteronomy 10 gives us insight into God's own allegiances, via the motif of the covenant. We will see that God's allegiances honor those who are vulnerable rather than those who possess power. Deuteronomy 10 sharply challenges hubris, nationalism, and the destructive pursuit of national interest.

Deuteronomy 10:18 announces Yahweh's ongoing covenant commitment with the stranger:[5]

> [Yahweh] who executes justice for the orphan and the widow, and who loves the strangers, providing them food and clothing.

The word "love" in this text refers to the steadfast loyalty of a covenant, as we will see in a moment. But this isn't the only time the word "love" is used in Deuteronomy 10. The very next verse requires God's people to love the stranger, in an *imago Dei* correspondence:

> You shall also love the stranger, for you were strangers in the land of Egypt. (Deut 10:19)

[4]Non-White settlers may have a more indirect and complex relationship with the colonial story.
[5]I provide a thorough analysis of Deut 10:18-19 in Mark Glanville, *Adopting the Stranger as Kindred in Deuteronomy* (Atlanta: SBL, 2018), 214-221. I also discuss this text in Mark R. Glanville and Luke Glanville, *Refuge Reimagined: Biblical Kinship in Global Politics* (Downers Grove, IL: IVP Academic, 2021), 41-50 and Mark R. Glanville, "'Festive Kinship': Solidarity, Responsibility, and Identity Formation in Deuteronomy," *Journal for the Study of the Old Testament* 44 (2019): 133-52, at 138-41.

And a few verses earlier Deuteronomy has affirmed Yahweh's love for Israel:

> Yet the LORD set his heart in love on your ancestors alone and chose you, their descendants after them, out of all the peoples, as it is today. (Deut 10:15)

Here, then, are three loves: God loves Israel, God loves the stranger, and Israel is to love the stranger.

What does it mean to love in Deuteronomy? "Love" is a key motif in ancient political covenants. For example, in the Neo-Assyrian Succession Treaty of Esarhaddon (known as EST), Esarhaddon the great king provides for his son Ashurbanipal upon his death by binding the subordinate kings to a covenant pledging absolute loyalty to Ashurbanipal. The treaty warns: "If you do not love the crown prince designate Ashurbanipal, son of your lord Esarhaddon, king of Assyria, as you do your own lives. . . ."[6] King Manasseh of Judah was likely bound under this treaty with Esarhaddon, but we don't know for sure.

This imperial context for the word *love* is used to comic effect in the contemporary musical *Hamilton*. King George sings to the Revolutionaries:

> You'll be back, like before
> I will fight the fight and win the war
> For your love, for your praise
> And I'll love you till my dying days[7]

On the lips of *Hamilton*'s King George, "love" signifies political loyalty— with blood-curdling irony.

Deuteronomy (which is itself structured like a covenant document) takes this militarized imperial motif of a covenant and beautifully transforms it to describe Yahweh's absolute loyalty to Israel and to people on the move. The word *love* does some of this work.

Love also announces kinship connection. In the ancient world, people who were bound in covenant referred to one another in familial terms.[8] In this way, Deuteronomy 10:15 reveals Yahweh as the divine kinsperson of

[6]James Bennett Pritchard, ed., *The Ancient Near Eastern Texts Relating to the Old Testament*, 3rd ed. (Princeton: Princeton University Press, 1969), 537, (24).

[7]"You'll Be Back," in Lin-Manuel Miranda, *Hamilton: An American Musical* (2015).

[8]See D. J. McCarthy, "Notes on the Love of God in Deuteronomy and the Father-Son Relationship Between Yahweh and Israel," *Catholic Biblical Quarterly* 27 (1965): 144-47, at 145. See also Deut 1:31; 8:5; 14:1.

Israel. And in Deuteronomy 10:18 Yahweh is also the divine kinsperson of vulnerable immigrants who are seeking a home. Displaced people, both then and now, need protection and belonging. God's people are to step into the gap and enfold these people as family, following God's lead! Love also has an emotional dimension. While the use of *love* in EST is anything but emotional (except perhaps emotions of terror), in Deuteronomy we see the affective dimension of love that we are familiar with today (e.g., Deut 10:15). So God's people are to feel affection for vulnerable people who are seeking a home. These three aspects of the word *love*—covenant, kinship, and emotion—provide a rich hearth within which the stranger can be enfolded as our own, and in which we ourselves can be enfolded as belonging to them.

We can represent these three loves pictorially as a triangle. The relationships between the three actors in a network of belonging are represented by the sides of the triangle, and the three dimensions of the word *love* are captured in the center of the triangle.

Figure 11. Triangle of loves in Deuteronomy 10:15-19

This network of belonging is truly beautiful. What a remarkable expression of the grace and tenderness of God, that God makes a steadfast commitment of protection and love with displaced people! God calls the people of God to covenant with those with whom God covenants, to extend solidarity and kinship to people who experience vulnerability (Deut 10:19). Is this how you imagine God, as a God who makes a covenant with refugees? Perhaps this gives you fresh imagination for refugee and immigration policies at a national level? In our book *Refuge Reimagined*, my brother Luke

and I explain how a biblical ethic of kinship can birth imagination and tenderness for responding to vulnerable immigrants and refugees, both as churches and as nations.[9]

As we come to explore the significance of Deuteronomy 10:15-19 for the histories of people and lands, it is also illuminating to recall the divine covenant of Genesis 9, which we explored in more detail in chapter eight of this book, "Creation." Following the great flood, God establishes a covenant with every living creature (Gen 9:8-17). With this covenant, God demonstrates the divine commitment to the life and flourishing of all people. Genesis 10 is a genealogy of the nations, a sort of family tree of all people groups. As this massive family tree unfurls like a fern frond, as the nations spread out over the earth, we see God's covenant commitment to diverse people groups worked out in their specifics. The movement of Genesis 9 to Genesis 10 reveals the profound dignity of every human community. And Genesis 9–10 sets the covenant with ancient Israel (Gen 15) within the larger story of God's covenant with all flesh.

God's covenant with the refugee in Deuteronomy 10, set alongside the divine covenant with the earth and with every people group in Genesis 9–10, is a focused critical lens through which to view the colonial project and the postcolonial era. For God's allegiances are not self-serving. The divine covenants eschew nationalism, cultural hegemony, extractive policies, and racism. The divine covenants instead call humanity into a kinship shared among all peoples, a familial solidarity that brings the weakest into the center. We carry this lens of the divine covenants with us as we come now to view the colonial story.

History of Colonialism

South African bishop Desmond Tutu is famously misattributed with this wry reflection:

> When the missionaries came to Africa, they had the Bible, and we had the land. They said, "Let us pray." We closed our eyes. When we opened them, we had the Bible, and they had the land.[10]

[9]Glanville and Glanville, *Refuge Reimagined*, 13-15.
[10]Steven D. Gish, *Desmond Tutu: A Biography* (Westport, CT: Greenwood Press, 2004), 101.

The so-called Age of Discovery (or Age of European Expansion) catalyzed what is known as modern European colonialism. Starting in the fifteenth century, European powers, namely Belgium, England, France, Germany, the Netherlands, Portugal, and Spain, colonized lands and peoples, permanently destroying ancient ecosystems. Colonization was relentless, and by the outbreak of World War I in 1914, Europeans controlled 80 percent of the world's landmass, also imposing Christianity. In some cases, colonialists forcibly settled, uninvited by the indigenous peoples of the land, leading to the devastation of indigenous populations. In other cases, colonialists exploited local human and economic resources, leading to the violence of human trafficking and slavocracy.

Whether through stolen land, stolen labor, or both, colonialism was a process by which foreign rulers controlled a territory that was not their own for the sake of national interest and especially economic dominance. Colonialism almost always devastated age-old ecosystems. In the conquest of the Andes in Peru, for example, the Spanish introduced sheep, cows, diseases, and pests. Elinor Melville shows how both the decimation of the native human population and the permanent devastation of previously fertile land was crucial to European success, making the Europeans "almost invincible."[11]

Christianity's Role

While Christianity was not the reason for colonialism, Christianity often sanctified and animated the colonial program. Numerous papal bulls authorized the colonial project, including *Dum Diversas*, which encouraged King Alfonso V of Portugal "to invade, conquer, fight, subjugate the Saracens and pagans, and other infidels and other enemies of Christ," subjecting them to "perpetual servitude."[12] Conquest and mission sailed together, and missionaries stepped off the same boats as soldiers. In *The Christian Imagination: Theology and the Origins of Race*, theologian Willie J. Jennings tells the story of José Acosta, a Jesuit priest who traveled with the conquistadors to Peru.

[11]Elinor G. K. Melville, *A Plague of Sheep: Environmental Consequences of the Conquest of Mexico* (Cambridge: Cambridge University Press, 1997), 2.

[12]Translated at *Unam Sanctam Catholicam* website: https://unamsanctamcatholicam.blogspot .com/search?q=dum+diversas. See further, Gene L. Green, "The Death of Mission: Rethinking the Great Commission," *North American Institute for Indigenous Theological Studies* 12 (2014): 81-110.

Acosta wrote that the wealth given to Spain and to the church through the conquest of what is now Peru were "irrefutable signs of the workings of God through them."[13] For some, Jennings tells us, the so-called discovery of the colonies was on a level only a little below the creation event recorded in Genesis 1–2—this is why the Americas were called the "New World."[14]

An example from North America: in 1637, Connecticut Puritans massacred five hundred men, women, and children of the Pequot people, in what is known as the Pequot massacre. Most of those who survived were taken into slavery. Captain John Underhill justified the atrocity with reference to the conquest in the book of Joshua: "Sometimes the scripture declareth women and children must perish with their parents."[15]

Willie J. Jennings traces how colonial empires severed the traditional anchors of native land and local stories that bestowed meaning and identity. By removing people from their land and by subjecting them to violence, rape, and forced labor, colonists transformed lives that had been deeply interwoven within native habitats into racialized identities. The newly enshrined racial category of Whiteness took center stage precisely as former signifiers of meaning were fragmented and destroyed, Jennings explains.[16] Our experiences of race and belonging today come in the context of a historical story, the global stories of peoples and lands and the ongoing dominance of Eurocentric culture.

As we come to terms with the colonial story, it is vital to recognize that the story of Christianity in Africa didn't begin with the colonial project. On the contrary, many of the most influential leaders of the early Christian centuries were African, including Origen of Alexandria (185–253) and Athanasius of Alexandria (ca. 296–373). Indeed, when orthodox Christianity was forbidden in the Roman Empire for a period during the fourth century, the Ethiopian church insisted on a trinitarian orthodoxy, as Vince L. Bantu has shown.[17]

[13]Willie J. Jennings, *The Christian Imagination: Theology and the Origins of Race* (New Haven, CT: Yale University Press, 2010), 93.

[14]Jennings, *The Christian Imagination*, 122.

[15]Quoted in George Madison Bodge, *Soldiers in King Philip's War: Being a Critical Account of That War, with a Concise History of the Indian Wars of New England from 1620–1677* (Baltimore, MD: Genealogical, 1967). Cited in Randy S. Woodley, *Indigenous Theology and the Western Worldview: A Decolonized Approach to Christian Doctrine* (Grand Rapids, MI: Baker Academic, 2022).

[16]Jennings, *The Christian Imagination*, 58.

[17]Vince L. Bantu, *A Multitude of All Peoples: Engaging Ancient Christianity's Global Identity* (Downers Grove, IL: IVP Academic, 2020), 72–118.

And in the modern period, the influence of Christianity has been both positive and negative. Gambian scholar Lamin Sanneh sharply challenges a monochrome narrative of Christian mission as merely religious bigotry and Western arrogance.[18] He discusses the expansive growth of Christianity in Africa since the end of the colonial period, which he puts down to local agency (rather than Western imposition), the translation of the Bible into mother tongues, and its adaptation to African cultural forms. Sanneh argues that indigenous African cultures were renewed through Christianity, not despite Christianity.[19]

Post-Colonialism

In the decades following World War II, Western colonial powers were compelled to grant independence to colonized territories, and new national borders were drawn up among the former colonies. Yet the economic resources, natural resources, and human resources of these nations have continued to flow from the Majority World to Western powers throughout the so-called postcolonial era, via trade rules, debt servicing, global corporations, restrictive intellectual property rights, political intervention, arms trade, corruption, and more. Trade statistics are indicative of the result: Less Developed Countries (LDCs) make up 13 percent of the global population, and yet they only account for 1.12 percent of global trade.[20] All too often, Western nations pursue their own national interest at the expense of the least developed nations in the world, and all too often they continue to do this in the name of Christ.[21]

However, this runs even deeper than economics. Scholars have studied the ways in which language, writing, and speech both reflect and produce neo-colonial assumptions and biases. Even as English language dominates education, business, and politics globally, European voices and Eurocentric assumptions

[18]Lamin Sanneh, *Whose Religion is Christianity? The Gospel Beyond the West* (Grand Rapids, MI: Eerdmans, 2003), 10.

[19]Sanneh, *Whose Religion is Christianity?*, 43. See also 41-42, 55.

[20]"Least Developed Countries," International Trade Centre (website), https://intracen.org/itc /about/priority-countries/least-developed-countries.

[21]Consider, for example, how former US Attorney General Jeff Sessions cited Romans 13 to defend former President Trump's immigration policy, a policy which included separating children from parents who entered the country undocumented (Tal Kopan, "Sessions Cites Bible to Defend Immigration Policies Resulting in Family Separations," *CNN*, June 15, 2018).

and values control global discourses.[22] Postcolonial studies is a scholarly approach that seeks to unmask the Western habits and assumptions that dominate global conversation.[23]

Decolonizing the Church

While postcolonial studies contain vast insights into these habits and assumptions, we return now to our lens of the divine covenants in Deuteronomy and Genesis. The colonial project is a violation of the divine covenants on many levels, including God's covenant with land (Gen 9:13), God's kinship with vulnerable peoples (Deut 10:18), God's covenant loyalty to diverse people groups within their lands (Gen 9:9-10; Gen 10), the familial connection of all humans (Gen 10:1), and God's covenant with the church as people identified by their drawing the weakest among them into the center of the community (Deut 16:9-17). Our kinship that knots us to the loom of Christ also interweaves us with one another by the divine covenants, crisscrossing us in tenderness, while calling us to learn and discern the stories in which we have frayed and torn one another. As we learn these stories, the generational prayers of repentance of Nehemiah 9 and Daniel 9 hold us to our ongoing responsibility for the sins of our kin, while also offering hope for redemption, being confident that a new life is possible when we join together with divine grief.

It is difficult to overstate the importance of our coming to terms with the sins of our kin as the church today. This is vital for our *healing*, for our *witness*, and for our very *faith*. The possibility that our past is still with us, shaping our practices and

> *Our kinship that knots us to the loom of Christ also interweaves us with one another by the divine covenants, crisscrossing us in tenderness, while calling us to learn and discern the stories in which we have frayed and torn one another.*

[22]See Erin G. Glanville, "Creatures in a Small Place: Postcolonial Literature, Globalization, and Stories of Refugees," in *The Gospel and Globalization: Exploring the Religious Roots of a Globalized World*, eds. Michael W. Goheen and Erin G. Glanville (Vancouver: Regent College, 2009), 272.

[23]Theologian Kwok Pui-lan writes: "For many postcolonial critics, 'postcolonial' denotes not merely a temporal period or a political transition of power, but also a reading strategy and discursive practice that seeks to unmask colonial epistemological frameworks, unravel Eurocentric logics, and interrogate stereotypical cultural representations." (*Postcolonial Imagination and Feminist Theology* [Louisville: Westminster John Knox, 2005], 2).

beliefs, means that we cannot afford to ignore our history. Many indigenous spokespeople (among others) claim just this, that the patterns and assumptions that animated the colonial project still shape the church and society today. Indigenous scholar Randy S. Woodley argues that dynamics of Western individualism, of universalizing place, and of wealth accumulation are a part of the ongoing story of colonialism. These assumptions produce "rootless urbanization" that is destroying the creation and fragmenting our human experience. To be sure, these are powerful forces, and yet as Woodley reflects, "God is more powerful through our faith."[24] As we receive the Spirit's strength to name our complicity and to live a different way, our faith in Christ's power and relevance will be strengthened.

Shifting assumptions around leadership is one concrete step the church can take. The book of Acts takes time to draw attention to the cultural diversity of the leadership in the Antioch church, as a road map for the church beyond Jerusalem (Acts 13:1; cf. Rom 16:7). And yet how can the church's diversity be realized today in White-dominant churches, when key leadership positions are largely filled by White men? An implication of Acts 13 is White men giving away power and voice to women and racialized sisters and brothers. Appointing genuinely diverse upper leadership is a crucial response to the dominance of White male voices in the church in the West. We White leaders and male leaders should consider how we posture ourselves in meetings and in significant conversations, making room for others to speak and ceding the power to shape culture, decisions, and processes. A nuanced step requiring high intercultural competence is discerning how our ways of being together and of decision-making reflect the dominant culture's assumptions. How can leaders from diverse cultures be empowered to bring the treasures of their home culture to recast our ways of doing things?

The need to decolonize is visible in Christian theology today, which is dominated by White, usually male, voices. Other voices, asking different questions, are often displaced from central conversations via categorization as "liberation theology," "womanist theology," "Asian theology," "Black theology," "feminist theology," and so on. Yet we might just as well refer to the dominant discourse as "White theology," for every culture has its distinctive

[24]Woodley, *Indigenous Theology and the Western Worldview*, 59.

strengths, biases, and ways of knowing.[25] Christian leaders should take stock of who we are listening to, who we are reading, who is shaping our preaching and our biblical imagination, and who we are quoting in our preaching. God's covenant with the stranger explored above (Deut 10:18-19) displays God's familial bond with every people group, especially the most vulnerable. This speaks strongly of the need for Christians to learn from voices that have been muted historically.

First Peoples

First People–settler relations is a crucial aspect of colonialism that is often overlooked in North American public discourse. Because of its importance in the story of the church and of society in North America, Australia, and New Zealand, it needs to shape our vision for walking well in the land. During the time of writing this book, a new scar on Canadian (Turtle Island)[26] racialized history has been revealed. More than one thousand potential unmarked graves that contain the remains of First Nations children have been discovered within the grounds of three First Nations residential schools in British Columbia and Saskatchewan.[27] Since the 1850s, First Nations children had been removed from their families and housed in residential schools, most of which were run by churches from a variety of traditions and denominations.[28] The last of the church-run schools closed in 1996 (I can't help thinking that I, myself, had been out of high school for five years by this time). The goal of the schools was to educate the native out of the child. To this end, upon arrival, the children's hair was cut short. "Now you are no longer an Indian," a child was told.[29] Dr. Ray Aldred remarked that for six generations his people had been put in residential schools, from the age of five. "How do we learn to parent, when our people

[25]Woodley summarizes what he sees as the distinctive method of Western theologies (*Indigenous Theology and the Western Worldview*, 61-65).

[26]Some First Nations communities (but not all) refer to the continent of North America as "Turtle Island."

[27]Kisha Supernant and Sean Carleton, "Fighting Denialists for the Truth about Unmarked Graves and Residential Schooling," *CBC*, June 2022, www.cbc.ca/news/opinion/opinion-residential -schools-unmarked-graves-denialism-1.6474429.

[28]All First Nations, Inuit, and Métis children in Canada were compelled to attend residential school from 1920.

[29]*They Came for the Children: Canada, Aboriginal Peoples, and Residential Schools* (Winnipeg, MB: Truth and Reconciliation Commission of Canada, 2012), 22.

have not been allowed to parent their kids for six generations?" he asked. "Our people are healing, but it will take time."[30] A similar national policy was enacted in Australia, where schools for Aboriginal children were called "mission schools," a system that has devastated the indigenous community. It is probably fair to say that the United States is behind both Canada and Australia in coming to terms with its own colonial history in relation to First Nations communities, and yet all three settler states have a long, long way to go.[31]

Bradley Melle, a historian who has studied the history of evangelical Christianity in First Nations communities, commented to me that the Canadian church has been deaf to First Nations communities, missing a wonderful opportunity to become a distinctively Canadian church (as opposed to generically American). Western Christians should have learned from Aboriginal traditions, Melle commented, allowing them to point us to riches in the Christian tradition that the church has lost sight of.[32] When Melle said this, I had a deep sense that he was right, and that the same could be said for the church in Australia, New Zealand, and the United States.

I have often noticed, for example, the high value First Nations communities put on relationships. My First Nations friends spend much time sitting together, talking or eating, taking people and their stories seriously. First Nations communities also often have a profound sense of their kinship with other communities and even with creation itself. "All my relations," our indigenous friends often say, spreading out their arms in an inclusive gesture. "All my relations": they are referring to a cherished kinship with the animals, the land, the wind, the water, and with you. They share "a desire for familial relationships between all things," as Aldred puts it.[33] We have explored the theme of human kinship with the creation in Scripture in chapter eight.

[30]Seminar, Willoughby Christian Reformed Church, May 2013.

[31]See, for example, Tantoo Cardinal, "Voices from Native America," in *First Nations Drum*, December 28, 2002, www.firstnationsdrum.com/2002/12/voices-from-native-america-by -tantoo-cardinal/.

[32]Bradley Melle, private conversation. See Richard Twiss, *Rescuing the Gospel from the Cowboys: A Native American Expression of the Jesus Way* (Downers Grove, IL: InterVarsity Press, 2015), 225-29, cf. 37-41.

[33]Ray Aldred, "Indigenous and New Comers: An Opportunity for Collaboration," in Charles A. Cook, Lorajoy Tira-Dimangondayo, and Lauren Goldbeck, eds. *Beyond Hospitality: Migration, Multiculturalism, and the Church* (Toronto, ON: Tyndale Academic, 2020), 48-56, at 52.

What is the way forward, then, for nonindigenous churches? The invitation may be simply to humbly learn. Find opportunities to learn from First Nations leaders, by attending workshops, courses, and ceremonies, as our church did in gathering at St. Mary's mission school. First Nations communities are often very welcoming—our family recently attended a local salmon feast. Consider engaging in the "Blanket Exercise" as a church, as an embodied way for a church community to learn about the impact of European conquest on First Nations communities.[34] And read and listen to First Nations spokespeople, Christian and otherwise, such as Richard Twiss, Joy Harjo, Vine Deloria Jr., Tanya Taguq, Thomas King, Lee Maracle, Rosanna Deerchild, Terry LeBlanc, and Cheryl Bear, among many others.[35] Be alert, especially, to how First Nations teaching draws your attention to biblical themes that may be lying dormant in your tradition.

Interconnected Issues

Another way to deepen our understanding of ongoing colonialism is to commit to exploring how issues surrounding the histories of peoples and land are interconnected, including historical colonialism, racism, immigration, creation care, economics, and patriarchy. As we have noted, creation care and First Nations-settler relations are profoundly joined. Indigenous communities in North America and Australia are leaders in resisting thoughtless and damaging resource extraction. "The land is our soul," Cree author Dough Cuthand reflects.[36] A few years ago, members of our church drove ten hours to join with First Nations communities in Northern British Columbia as they resisted the construction of a tailings dam that was sure to damage invaluable water resources.

Or regarding immigration, surely the early welcome that First Nations communities extended to European settlers shames the nationalistic, self-interested resistance toward asylum seekers so often displayed today. Aldred writes, "North American Indigenous Identity is premised upon an

[34]Kairos Canada describes the Blanket Exercise here: www.kairoscanada.org/what-we-do/indigenous-rights/blanket-exercise.

[35]You might start a journey of learning by reading Richard Twiss, *One Church, Many Tribes: Following Jesus the Way God Made You* (Grand Rapids, MI: Chosen, 2000).

[36]Doug Cuthand, *Askiwina: A Cree World* (Regina, SK: Coteau Books, 2007), cited in Ray Aldred, "Indigenous and New Comers," 49.

understanding of land (Creation) and spirituality which assumes the identity of 'others' (newcomers) as possible opportunities of collaboration."[37] As we understand the intersections between issues of colonization, we are better able to discern the idolatry and animating ideologies that entangle us.

Patriarchy is also connected to these histories. Patriarchy—by which I mean culturally normative centering of male voices, symbols, and leadership in communities and institutions—along with the abuse perpetrated by men that patriarchy enables, is a major reason why people today are leaving the church and even leaving faith altogether. Historically, sexual violence against women characterized the colonial project. White men commonly perpetrated sexual and physical violence against indigenous women, often with the stated assumption that they were "dirty" and "unclean."[38] M. Shawn Copeland has analyzed the pervasive sexual violence perpetrated against enslaved Black women in America. It was not uncommon for White masters to rape enslaved women, speaking of them as "incapable of chastity."[39] The church needs to discern the connections between patriarchy in historical colonialism and ongoing patriarchy today. As theologian Kwok Pui-lan reflects: "This critical work . . . has barely begun."[40]

How Do We Persevere, as Christians?

How do we continue as the church, in light of these historical sins? Mark MacDonald, the Canadian archbishop of indigenous Anglicans (who is indigenous himself) shares that after every talk he delivers, someone asks him this very question: How do you persevere as a Christian, given all that has been done by the church? MacDonald chuckled: "It's a good question, but every time I speak, someone has to ask me the same question!" The archbishop says that each time he is asked, he gives a one-word answer: "Jesus." Listening to indigenous Christians can do more than challenge or enrich nonindigenous faith; it can recenter it and draw us back to faithfulness.

Randy Woodley tells a *Chickamaugan*, Cherokee story, of the terrapin and the wolves.[41] The terrapin used to be a huge animal, a warrior, who would

[37]Aldred, "Indigenous and New Comers," 48.
[38]Pui-lan, *Postcolonial Imagination and Feminist Theology*, 15.
[39]M. Shawn Copeland, *Enfleshing Freedom: Body, Race, and Being* (Minneapolis: Fortress, 2010), 37.
[40]Pui-lan, *Postcolonial Imagination and Feminist Theology*, 7.
[41]On protocol for using First Nations of communities, see "Conversation with Jo-Ann Archibald" (video), *Indigenous Storywork* (website), accessed October 2, 2023: https://indigenousstorywork.com.

walk down the road and expect that everyone else would move out of the way. One day, a brave wolf crossed the terrapin's path. The wolf refused to make way for the terrapin, standing his ground on the road. The terrapin wasted no time in killing the wolf. He cut off the wolf's ears and carried them with him. That very night the terrapin lodged in a wolf village nearby. His wolf hosts served him stew, and yet they quickly noticed that the terrapin ate the meal using the wolf's ears as cutlery, ladling the stew into his mouth like a spoon. The wolves were furious, and they took their revenge. While the terrapin was sleeping, the wolves bound him. They took him to a cliff and threw him off, shattering his shell. When he finally healed, the terrapin was a fraction of his original size, the size that we are familiar with today.[42]

Woodley reflects on this story: "This is how I understand the Western worldview: It's terrapin! It has taken up too much space, and it has insisted on its way in every single system that we have."[43] Woodley is referring to patterns of individualism, disconnection from place, and extractive consumerism inherent in the Western world. The figure of the terrapin is sobering, for it reminds us that while we genuinely seek to play our part in the biblical story, we are at the same time drawn by the gravity of the huge terrapin.

Woodley recommends four steps for dominant culture communities that seek to respond to the story of colonialism. With these steps, Woodley has in mind First Nations-settler relations, yet his suggestions address the postcolonial malaise more broadly. First, "White Western folks," as Woodley puts it, must "heal the relationships between themselves, Creator, the land, and the local indigenous peoples." They do this by growing in awareness through learning from indigenous people (perhaps the same could be said for learning from other oppressed people groups). Second, we must lament together, as a public act of calling our societies to account. For example, can your church join in with the work of local First Nations communities who are defending the future of a watershed area river? Third, we must make reparations. "Like Zacchaeus, reparations are the settler's opportunity to be saved/healed (Luke 19:8-9)."[44] What could reparations look like for your church? For example, should your community give a tithe of its income to

[42]Woodley, *Indigenous Theology and the Western Worldview*, 17-20.
[43]Woodley, *Indigenous Theology and the Western Worldview*, 20.
[44]Woodley, *Indigenous Theology and the Western Worldview*, 43.

repair what is being broken, following the lead of First Nations communities as you do? Fourth, we must find new paradigms for conceiving of society and new ways of making decisions that honor First Nations' communities' inherited wisdom for living in the land.[45]

To return to how we began, as our eyes are opened to colonial patterns and practices, our response isn't to power-up and fix things, but to slow down, to listen, to confess, to join, to share leadership, and to find new, creative ways of living together. This eleventh note, sins of our kin, is a blue note, meant to restore dignity and harmony to the stories of those who sing it in the community. When we sing this note we speak the truth, we lament, we restore our humanity, and we begin to hope.

In this book we have spoken of our kinship with one another and our kinship with the nonhuman creation. Now we return to our kinship with God, our divine kinsperson, by exploring the important theme of prayer. What is the role of prayer in incarnational communities?

[45]Woodley, *Indigenous Theology and the Western Worldview*, 42-43.

Prayer

FOR ME, PLAYING MUSIC is always a prayer. Sometimes I am conscious that I am playing piano as a prayer; other times I am less aware. It may sound strange to speak of playing music as a prayer, until considering the nature of prayer. In prayer we aren't merely asking things of God, we are resting in the community of Father, Son, and Holy Spirit, and making this our home. Prayer is our present awareness of the reality that God is with us. In prayer we are aware that God is closer to us even than we are to ourselves. "In him we live and move and have our being," Paul says (Acts 17:28).

Prayer includes our being present with God, and it includes our listening to God. For me, this includes playing music, experiencing the gifts of God most strongly when I'm in the middle of a groove!

This chapter, our twelfth and final note, is about prayer as a characteristic of incarnational communities. Witnessing communities are sustained by regular and extraordinary practices of prayer, often drawing from a range of traditions. As leaders, we can continually grow in seeking silence with God. And we can foster prayer practices in our communities, helping create "prayer spaces" in the neighborhood, and learning to guide others in prayer. The focus of this chapter isn't on prayer in general, as there are plenty of books you can read on prayer;[1] rather, we are considering how to nourish prayer as a *charisma* (gift) of your community and why this is necessary for our witness.

I have mentioned that our friends two doors up have converted their garage into a prayer space for the neighborhood. They host evening prayers

[1]E.g., Roberta Bondi, *To Love as God Loves: Conversations with the Early Church* (Philadelphia: Fortress, 1987).

on weeknights, and we can book the space for prayer during the day. Thanks to their eye for detail, the room has a beautiful aesthetic. Bench seats border the room. Piles of cushions are stacked on the bench seats, ready to be used by those kneeling or sitting on the floor. Our friends choose a prayer resource for each week. J. Philip Newell's *Celtic Benediction: Morning and Night Prayer* is a favorite.[2] Of course, the contemplative style of prayer that we practice in that space isn't for everyone. It isn't for our eight-year-old, soccer-playing son, for example. When we attend prayer as a family, our son piles up as many cushions as he can to make a perfectly soft throne, on which he perches for the liturgy. During silent prayer he squirms and occasionally grunts! Our hosts assure us that they love having him there, and whatever way we enter this prayer space, whether enthroned on cushions or more contemplatively, we are grateful for this communal hearth dedicated to prayer. These practices honor God as the source of our community, by placing communion with God at the center of our lives.

Witnessing communities can be characterized and sustained by prayer. Henri Nouwen puts it well:

> Prayer is the language of the Christian community. In prayer the nature of the community becomes visible because in prayer we direct ourselves to the one who forms the community . . . Praying is not one of the many things the community does. Rather, it is its very being.[3]

Prayer as Witness

These days, many people desire prayer, both inside and outside of the church. You may have noticed a liturgical turn in Christian communities; Millennials and Gen-Z are increasingly drawn to liturgical traditions and traditional prayer practices. I myself am a part of Gen-X.[4] Back in the nineties, when people my age were young adults, prayer was the apple on the tree that we were supposed to eat but tended to avoid. Traditional liturgies seemed

[2]J. Philip Newell, *Celtic Benediction: Morning and Night Prayer* (Grand Rapids, MI: Eerdmans, 2000).

[3]Henri J. M. Nouwen, *Reaching Out: The Three Movements of the Spiritual Life* (New York: Image Books, 1975), 156.

[4]The term *Millennials* (or *Gen-Y*) refers to the generation born in the early 1980s through to the mid-1990s; *Gen-Z* signifies those born in the mid-1990s to early 2010s; and *Gen-X* refers to those born in the mid-1960s to late 1970s.

old school, the very reason the church was shrinking. But today people feel quite the opposite. Many people today desire silence and spiritual companionship, liturgical traditions and historical practices. This desire is experienced not only by many Millennials and Gen-Z but also by many people my age and older. I assume this common desire for silence and contemplation responds both to our overload on social media and also to our anxious uncertainty about the future.

A desire for contemplative practices is so prevalent in Western and westernized cultures that Christian practices of prayer and meditation are attractive to many who are outside of the church. Faith "unbundled" (see the introduction) tends to value contemplative practices. For this reason, prayer points to the source of our shared life in a way that increasingly makes sense to people. Prayer practices themselves, entered in the name of Jesus, are an act of Christian witness.

Relatedly, prayer practices are also a key conduit for faith in times of doubt. Christ-followers may experience a troubled relationship with Scripture, and yet still be able to pray. In these times, prayer practices can nourish our relationship with God. *Lectio divina* (praying with Scripture) can keep us connected with the Bible as a practice of reading Scripture prayerfully in times of doubt. This twelfth note, prayer, is not merely a good idea for incarnational communities; it's essential. We see this clearly in Acts 1.

> *Prayer practices themselves, entered in the name of Jesus, are an act of Christian witness.*

Prayer and the Spirit

When Jesus' followers understand they are called to witness, they pray. In chapter one of this book we observed that in Acts 1, the resurrected Christ appears to his disciples and discloses to them the meaning of this time in world history. "You will receive power when the Holy Spirit has come upon you; and you will be my witnesses . . ." (Acts 1:8). With these words, Jesus is saying that the fullness of the new age has been pushed back to make space for a time of witness.

The response of Jesus' disciples is crucial for us. They returned to Jerusalem, entered the upper room where they were staying, and prayed. "All

these were constantly devoting themselves to prayer" (Acts 1:14). Because of what had just happened, I imagine they were praying about their commission. Perhaps: "What would you have us do?" "What would you have me do?" "Send your Spirit, as promised, because we need her for this task." "Bless our community with peace."

Again, when Jesus' followers understand they are called to witness, they pray. The expression "devoting" themselves to prayer translates a Greek word (*proskartereō*) that has the sense of "persisting," "continuing," "persevering" (it is used again of the first Christians in Acts 2:42; 6:4). And note that the disciples' devoted prayer in the upper room precedes the pouring out of the Holy Spirit in Acts 2.

Prayer precedes the great witnessing activity of the book of Acts. In Acts, if the witness of the church is a great, spreading tree, then prayer is its seed bed. Prayer is foundational for us too. When Christ desires to do something wonderful in and through the church, Christ also wants us to earnestly seek him for it first. The Scottish reformer John Knox would persevere in prayer. One night his wife woke to find him missing from the bed. She found him kneeling, praying repeatedly, "Lord, give me Scotland." God answered Knox's prayer, a prayer shared by many others, bringing about a great awakening in Scotland.[5]

It's the same for us. The most important step in nourishing our identity as local witnesses is prayer. In my first two years as a pastor in Western Sydney, I would invite our whole church to my house every Thursday morning at six o'clock for prayer. Six to ten people would turn up each Thursday, and I would serve English muffins with either jam or peanut butter, along with coffee. This was the first time I had ever used a French press for making coffee, so the coffee was a bit weak for six in the morning! After eating muffins, we prayed for revival. We prayed that the Spirit would fall on us as a church, showing us Christ's face and leading us into Christ's way. And we prayed that the Spirit would fall on our neighborhood. (That's the order of revival prayer: us first, then the

[5]Relatedly, the parable of the persistent widow teaches that we should earnestly bring our requests to God and not give up (Lk 18:1-8). Catherine Wright explains the parable elegantly: "The comparison is one of difference: if an evil judge will hear the requests of a persistent widow, how much more will a generous God hear the requests of God's children?" See Catherine J. Wright, *Spiritual Practices of Jesus* (Downers Grove, IL: IVP Academic, 2020), 137.

neighborhood.) It was a powerful time, perhaps the most powerful time in my pastoral ministry. After a few months of prayer, anticipation built, not only among the muffin-prayer participants but also within the congregation. Many church members were sensing that God was about to work among us and through us. A faithful older saint who was not attending prayer exclaimed to me after a service, "I just want to *do* something!" When she said those words, I knew that the Spirit was moving among us. I will never forget that moment.

As we near the end of this book, some may be feeling exasperated: "There is so much to fix!" Others may be feeling disempowered: "It feels impossible to change even one thing in our church!" Yet, the next step is given to us in Acts 1. Rather than rush into an action plan, or collapse into despair, we pray, and we invite others to pray.

> *The most important step in nourishing our identity as local witnesses is prayer.*

Prayer for the Mending of All Things: The Lord's Prayer

You may wonder, what kind of prayer can empower the witness of the church and precede an outpouring of the Spirit in power? Certainly, every and any kind of prayer can nourish our witness. And yet the Lord's Prayer is an exemplary prayer for those who desire for God's will to be done. With this prayer, we not only pray for the coming of God's kingdom, we also pledge ourselves to live as an answer to that cry (Lk 11:2-4; Mt 6:9-13).

In the Lord's Prayer, we address God as our Father, asking six things of him.[6]

The first half of the Lord's Prayer (the first three petitions) focuses on God's mending work in the world, viewing this work through three complementary lenses: the honor of God's name ("hallowed be your name"), the coming of God's kingdom, and the fulfillment of God's will. In these first three petitions, we are praying that the Father would renew the creation and humanity within it.

[6]Jewish writing at the time of Jesus most often addressed God as "King" or "Lord." While the term "Father" for God appears occasionally in the Old Testament, Jesus chose this intimate phrase to address God, evoking God's loving care and authority, teaching his disciples to do the same. (See Richard Bauckham, *Jesus: A Very Short Introduction* [Oxford: Oxford University Press, 2011], 64-68).

In the second half of the Lord's Prayer (the final three petitions) we ask the Father to give us all we need to play our role in the coming of God's kingdom. In other words, we are praying that we would live as an answer to the first half of the prayer. We ask God to give us enough to live by ("our daily bread"), forgiveness of sins, and deliverance from the temptations of the devil.

In the normal run of things, our prayers can be so small! The Lord's Prayer teaches us to desire God's will and to concern ourselves with the honor of God's name, pledging ourselves to live as an answer to our prayers. The Lord's Prayer can certainly be prayed verbatim, and it also can orient our minds and hearts toward the kingdom of God as we pray in our own words.

Jesus both modeled and taught prayer to his disciples (e.g., Lk 5:16). His disciples learned to pray by observing and experiencing Jesus' own life of prayer, as well as from his teaching. New Testament scholar Catherine J. Wright reflects, "Jesus' instructions on prayer are rooted in his own practice, a model and inspiration for us."[7] Like Christ, Christian leaders need to embody this double movement, being people of prayer and also being people who are prepared to teach others to pray.

From Forest Walks to Jazz Performance

We no longer have upper rooms in the first century sense, but we can certainly foster a life of prayer in our communities. A first step is to consider how we can invite others into prayer.

Different people connect with God differently, so different people have different prayer personality styles. My prayer life, and my efforts in inviting others into prayer, took a huge step forward when I realized this. Gary Thomas offers nine "sacred pathways" for connecting with God: the naturalist (loving God through creation), the sensate (loving God with the senses), the traditionalist (ritual and symbol), ascetics (solitude and simplicity), activists (confronting injustice), caregivers, enthusiasts (mystery and celebration), contemplatives, and intellectuals.[8] For years I thought

[7]Wright, *Spiritual Practices of Jesus*, 141.
[8]Gary Thomas, *Sacred Pathways: Discover Your Soul's Path to God* (Grand Rapids, MI: Zondervan, 2010). See also Myra Perrine, *What's Your God Language? Connecting with God Through Your Unique Spiritual Temperament* (Carol Stream, IL: Tyndale House, 2007).

that hiking in creation (bushwalking) was my most natural way of connecting with God. So I would get out into the bush to connect with God. In the past couple of years, I have realized that playing jazz music is an even stronger connection for me. Given the diversity of spiritual personality styles in our congregations, we should nourish a diversity of prayer practices for communing with God, from forest walks to justice marches to icons.[9]

People outside of the church experience spirituality and prayer in a variety of ways too. I mentioned that for me playing music is a prayer. Of course, experiencing the spiritual dimension of music is not exclusive to Christ-followers. Many of my friends who are serious musicians experience music spiritually. The spirituality of music becomes a connection point, a window through which musicians can begin to see Christ. As I embrace my experience of playing music as prayer, I can find communality with my musician friends, inquiring about their own experiences and dialoguing with them. And Jesus can turn up in our conversation. Others might find spiritual common ground while working with wood or while hiking, for example.

In prayer, one key for me is not to force myself to be someone I'm not (i.e., a Henri Nouwen–like contemplative). Only by discerning the ways in which God has created me to connect with Jesus can I shine Jesus' light to others. But that's me. You might pray best when you are working with wood or gardening, or by being still in a quiet place.

Prayer in Worship

As you seek to nourish your church as a community of prayer, you might think about prayer in your worship gatherings. In your mind, run through a typical worship service in your church. There are so many words, words, words, crowding out our corporate worship, that there is often little time to encounter God in prayer. "There are things that the homilies and hymns won't teach ya," Aaron Burr sang in the musical *Hamilton*.[10] True enough.

[9]Icons, used appropriately, are simply a window into prayer, through which we see God and God's movement toward us. On using icons in prayer, see Henri J. M. Nouwen, *Behold the Beauty of the Lord: Praying with Icons*, rev. ed. (Notre Dame, IN: Ave Maria, 2007).

[10]"Wait for It," in Lin-Manuel Miranda, *Hamilton: An American Musical* (2015).

Psalm 46:10 beckons us to be quiet before God: "Be still, and know that I am God."[11] Making time for silent prayer and for listening to God in our gatherings makes us aware of our dependance on God. Responding to the invitation of Psalm 46:10, nurture your congregation's capacity for silence. Perhaps start with thirty seconds. (It might help to save your times of silent prayer for when the kids are in Sunday school!)

> *There are so many words, words, words, crowding out our corporate worship, that there is often little time to encounter God in prayer.*

Other strategies for prayer in corporate worship include training a lay prayer team that is available to pray with people after the service or during the time the Eucharist is shared, and inviting the congregation to write prayers on post-it notes and stick them on the wall, as described in chapter five, "Worship in Polyrhythms." And of course, there is liturgical prayer. I often leave space for prayer at the end of a homily or during a homily. I might invite the congregation to pray silently, to write out their prayers, to pray with people sitting nearby, or to pray as a whole congregation.

Prayer in corporate worship is only one aspect of a prayer-rich church. The remainder of this chapter offers practical strategies for other times of prayer.

Prayer of Discernment

Listening prayer can become a regular part of our church's discernment processes. Quaker discernment circles, or clearness committees, are a way of surrounding an individual or a family in a time of decision.[12] In a clearness committee, a group of sisters and brothers gather to listen to a person facing a decision and to listen to God alongside that person. At the heart of a clearness committee is listening prayer that is carefully facilitated.[13] The gathering aims not to solve a problem but to seek clarity on the question at hand. Clearness committees are not only a gift to the individual or household

[11]See also Psalm 131 and Ecclesiastes 6:11.

[12]Pastor Joy Banks introduced Quaker discernment circles to our community.

[13]See Bruce Bishop, "Discernment-Corporate and Individual Perspectives," *Quaker Religious Thought* 106 (2006): 18-25. See https://digitalcommons.georgefox.edu/qrt/vol106/iss1/3/.

making a decision, but they also knit us together as family as we journey together on life's path.

Prayers of discernment are equally important when the whole congregation is faced with a decision or a difficult issue. We discussed the importance of listening prayer as a practice for the whole church in chapter ten, "Conversations."

Daily Office Today

Regular hours of prayer are another way for a community to be centered on prayer. It is natural for us to assume that a faithful life of prayer and worship ideally looks like a rhythm of corporate worship on Sunday, coupled with daily devotion throughout the week. However, historically there hasn't been the strong disparity between worship on the Lord's Day and daily devotions as there is in Protestantism today. For example, the early church met throughout the week for worship and the Eucharist.

And historically, the church has placed a high value on daily prayer at set times, known as "hours." It is very likely that the first house churches continued traditional Jewish prayer hours (see Ps 3, 4, and 5). And Paul's instruction to "pray without ceasing" (1 Thess 5:17; cf. Eph 6:11, 18) probably connects with set hours of prayer. The *Didache*, a church order from late in the first century, instructs Christians to pray three times a day, which would seem to indicate three regular times of daily prayer.[14]

In the medieval period, regular hours of worship were most fully expressed in the monasteries. The vigorous monastic schedule included six daily offices and one nighttime office (an "office" is a prayer service). Such a regime, while expected of those who had chosen to live a life of religious devotion, was unrealistic for the laity. A gain of the Protestant Reformation was to make regular prayer accessible to the laity. Creative new expressions ranged from Cranmer's *Book of Common Prayer* to household worship in the Puritan tradition.[15]

The rich and varied traditions of prayer in the story of the church lead us to consider how prayer can be central to our identity today, as we improvise

[14]James F. White draws this inference in *A Brief History of Christian Worship* (Nashville: Abingdon, 1993), 23.

[15]James White, *A Brief History of Christian Worship*, 55, 106-19.

fresh tunes in our neighborhood. The wind of the Spirit is blowing, birthing and renewing prayer practices in many churches. For example, a church in Vancouver has discerned that God is calling them to be a community of prayer in the city, as their core identity. When Pastor Monica arrived at the church, the community was already practicing intercessory prayer on Wednesdays at noon. Pastor Monica added centering prayer to the Wednesday noon prayer time.[16] Things grew organically from there. Noon prayer eventually spread from Wednesdays to every day of the week, with rotating leadership. Morning and evening practices have followed, blending in-person and online gatherings. Every year during Lent the church shares in a half-day prayer retreat where they learn new prayer practices together. Around twenty-five people join in. A praying community has developed in the church, and they have responded to God's invitation to prayer, one step at a time. This church is an example of a community that is improvising fresh expressions of the traditional daily office.

Other Strategies for Becoming a Community of Prayer

Fostering a *charisma* of prayer in your community can benefit from exploring the vast riches of the Christian prayer tradition, in its cultural, historical, and denominational diversity. Engaging a variety of prayer practices will help connect those with various prayer personality styles and build bridges into prayer. You might consider learning about, for example, contemplative prayer (Christian meditation),[17] centering prayer, praying with Scripture (*lectio divina*), Ignatian Examen (reviewing the day in prayer),[18] praying out loud all together (common in African cultures), listening prayer, praying in tongues, a liturgy of confession, and praying the Psalms.[19]

The converted prayer space that the chapter began with is one practical example of how communities can be characterized by prayer. We desire that

[16]On centering prayer, see Adele Calhoun, *Spiritual Disciplines Handbook: Practices that Transform Us*, rev. ed. (Downers Grove, IL: InterVarsity Press, 2015), 235-38.

[17]On the contemplative tradition, see James Finley, *Christian Meditation: Experience the Presence of God* (London: SPCK, 2004).

[18]A powerful introduction to the Examen prayer is Timothy M. Gallagher, *The Examen Prayer: Ignatian Wisdom for Our Lives Today* (New York: Crossroad, 2006).

[19]On praying the Psalms, see Cynthia Bourgeault, *Chanting the Psalms* (Boston, MA: New Seeds Books, 2016).

several prayer spaces would open in our communities, at a grassroots level. This isn't so much something that key leaders can plan for, but something that we pray for and encourage.

Another strategy is to circulate liturgies and prayer rituals for special occasions. These might include blessings over a house, a liturgy for work transitions, a liturgy for life transitions, a liturgy for the anniversary of a death of a loved one, and so on.[20] We desire that our people will gather with others to bring significant life events before the Lord.

Also, we can train teams who are equipped for healing prayer. The book of James instructs those who are sick to request the elders to pray over them and to anoint them with oil (e.g., Jas 5:13-18). A gathering for healing prayer can include a gospel reading, listening prayer, confession of sins, and anointing with oil.[21]

And via a rule (or rhythm) of life we can commit to a set of spiritual disciplines designed for growth in Christ. A rule of life can be agreed on by the whole community, or it can be a pathway for an individual as they are held within the community. Spiritual health and emotional health are intimately related, so a holistic rule of life will attend not only to the spiritual dimension of our life but also to the social, emotional, and physical dimensions.

Conclusion

One of the most delightful moments in my pastoral ministry was when a twenty-five-year-old woman sat down with me and reflected that she had discerned that God had called her to a life of prayer. She shared with me the desire to commit her life to prayer, praying for our church, for our city, and for our world. And she decided to live this life not in a monastery (she was very tempted in this direction) but within our community. When my friend shared God's calling her to a life of prayer, I was deeply grateful. Do we not

[20]For liturgies for special occasions, see Shane Claiborne, Jonathan Wilson-Hartgrove, and Enuma Okoro, *Common Prayer: A Liturgy for Ordinary Radicals* (Grand Rapids, MI: Zondervan, 2010). *Every Moment Holy* is another book series with prayers for the seasons of our lives (Douglas McKelvey, *Every Moment Holy, Volume II: Death, Grief, and Hope* [Nashville: Rabbit Room, 2021]). *Every Moment Holy* also provides a resource for daily prayer: www.everymoment holy.com.

[21]On healing prayer, see Charles R. Ringma and Mary Dickau, *The Art of Healing Prayer: Bringing Christ's Wholeness to Broken People* (London: SPCK, 2015).

want to be a part of communities in which such a desire for prayer is sparked and then set ablaze? Of course not everyone is called to this intensity of prayer, but we seek to nourish communities in which everyone prays and in which some are especially gifted for and called to prayer.

Conclusion

THERE IS A CURIOUS STORY from the life of Lesslie Newbigin that helps us orient to post-Christian society with realistic expectations.[1] Having served as a crosscultural missionary in India for thirty-eight years, Newbigin finally returned to the UK at the age of seventy. He unexpectedly took on a new pastorate in a poor neighborhood in Birmingham, England, a role that he held from 1980 to 1988. This surprising turn of events took place as Newbigin was presiding at a meeting of the district council of his denomination. The council was about to close a church in a poor, urban neighborhood. Convicted that he couldn't preside over such a closure, Newbigin stepped in as pastor in a part-time capacity. In his new pastoral role, Newbigin was energetic, thoughtful, and active in engaging his community in witness to Christ. The outcome of his ministry is striking in terms of sheer numbers, but not in the way you might expect. When he began his ministry, the church had just twenty members. And when he concluded his pastoral role, the church had just twenty-seven members. I find that very curious.

Newbigin was a singularly gifted communicator, preacher, and leader, exceptional in his generation. And yet his church in Birmingham grew by only a little. What do we make of that? To be sure, it says something about Western culture. His experience in Birmingham led Newbigin to reflect that the West is "the most difficult missionary frontier in the contemporary world . . . one of which the Churches have been—on the whole—so little conscious."[2]

[1]This story is taken from Lesslie Newbigin, *Unfinished Agenda: An Updated Autobiography* (London: SPCK, 1993), 234-36; also see Michael W. Goheen, *"As the Father Has Sent Me, I Am Sending You": J. E. Lesslie Newbigin's Missionary Ecclesiology* (Zoetermeer, Netherlands: Boekencentrum Publishing House, 2000), 103-4.

[2]Newbigin, *Unfinished Agenda*, 235.

Yet there are also spiritual reasons why we shouldn't be so surprised that this gifted leader didn't see significant numerical increase. Newbigin's experience reminds us of Jesus' experience of being abandoned. John writes, "Many of his disciples turned back and no longer went about with him" (Jn 6:66). (The Scripture reference—666—sounds comically ominous for such a dark moment in Jesus' ministry!) I assume that John observes this painful moment in Jesus' ministry to encourage leaders: a faithful ministry, a gifted ministry, doesn't necessarily lead to big numbers. So, in light of Jesus' ministry, for you, *I don't pray for a large church, I pray for a faithful church*. I pray for a tender and creative church that displays the love and truth of Jesus. While much of the messaging of Christian culture idealizes big gatherings, big bands, big stages, and big budgets, we need to find another path. In truth, the biblical pathway outlined in this book—of solidarity with the marginalized; of slow conversations; of earnest prayer; of attending to the mending arc of the biblical story; of thick, shared life; of leader-full communities—may not be a recipe for fast growth. But it is, I pray, a recipe for faithfulness that God will bless with fruit.

> *In light of Jesus' ministry, for you,* I don't pray for a large church, I pray for a faithful church.

Twelve Notes for Improvising Church

The post-Christendom turn demands that we reexamine our practices as the church. We can't simply assume that all we do as churches is demanded by Scripture, for so much of what we do is cultural. We must read the Bible freshly, with a renewed imagination for communities of witness. In the journey of this book we have done just that: we have sought to read the Bible with fresh eyes to discern key characteristics for the witnessing church in post-Christian neighborhoods. We have referred to such churches as "incarnational communities." These are churches that receive and extend the healing of Christ in a local neighborhood.

Jazz, by its nature, as a traditioned, improvised, nuanced, intelligent, conversational art form, is an evocative metaphor for the church in post-Christendom. In our journey we have become familiar with twelve notes for improvising community, devoting a chapter to each. These twelve notes

represent key characteristics of incarnational communities, and together they become a nonprescriptive pathway for nourishing communities of tenderness and witness. And we have grouped these twelve characteristics into three book sections: Part I: Harmony; Part II: Rhythm; Part III: Soul. It is helpful to list these twelve notes here, so we can look back over where we have come.

Part I: Harmony

1. The Text Grants

Scripture is the story of God recovering the divine purposes for all of the creation and the whole of human life, and of God's calling a people to bear witness to God's redeeming love in Christ. Four questions are crucial for biblical interpretation that shapes witnessing communities: 1. What is the biblical story? We saw that creation is a unifying element in the biblical story: the world matters to God. 2. What is biblical ethics? We saw a biblical ethic of kinship that runs through Scripture. 3. What is the gospel? We saw that the gospel announces Jesus' redeeming lordship over all of the creation, as the "mender of all things." 4. What is witness? We saw that witness (in life, word, and deed) isn't merely one task among many but the very identity of the church.

2. Leader-Full

Incarnational communities are leader-full in the sense that they are full of members who are empowered to use their gifts and creativity within the community and neighborhood. In post-Christendom contexts, key leaders need to nurture such leader-full communities, placing a high value on relationships and mutuality. The conversation around church leadership has rightly moved from leader-centered approaches toward collaborative leadership. The challenge before us is to lean deeply into collaborative approaches, while also taking a step further toward nourishing leader-full communities.

3. Local

Place matters. We can summarize the arc of the biblical story as a movement from placed, to displaced, to re-placed. In New Testament times, the *ekklēsia* (church) in Ephesus, Philippi, Corinth, and so on was a visible testimony to the grace and truth of Christ in a particular place. In cultures of dislocation, disassociation, and loneliness, incarnational communities can teach one

another to rest in the rhythms and seasons of our place. We can be oriented toward a local community from within that community, with a deep investment of time and love in its people, ecosystems, and institutions, in the name of Jesus.

4. Beauty

Beauty and creativity are vital for the church's witness and worship today. Churches need to excel at creating art and in living artistically, so that our faith in Jesus can shine out in a way that is evocative, beyond words. And churches need to create in a way that is rooted and located, in the sense that our art expresses the life of our neighborhood. So we need to make space for artists, bringing their inspiration and heightened perception into the flow of our shared life. Also, taking our cue from artists, we need to be creative in just about every aspect of church life, from housing arrangements to worship liturgies.

Part II: Rhythm

5. Worship in Polyrhythms

We can learn to worship in polyrhythms with the goal of nourishing incarnational communities. Four rhythmic layers can be superimposed to create rich worship: 1. The rhythm of the biblical story; 2. The rhythm of our community; 3. The rhythm of our neighborhood; 4. The rhythm of the wider church (global and historical). These polyrhythms are evident in the festival calendar of Deuteronomy 16:1-17, where we see a four-part movement that lies at the heart of Christian worship: 1. lament, 2. gift, 3. thanksgiving, and 4. creative kinship.

6. Shared Life

Witnessing communities seek to be makeshift family together, sharing in meals, dwellings, rest, play, prayer, creation care, advocacy, celebration, grief, and so on. They partner in the work of the gospel, loving their neighborhood to life. They bring the weakest among them into the center of the community, prioritizing kinship with vulnerable people. Leaders learn to nourish intercultural communities by, among other means, having diverse upper leadership and worshiping in a way that honors the practices and symbols of the cultures represented in their church.

7. Healing, Kinship, and Maternal Nurture

Healing, kinship, and maternal nurture are biblical motifs that can give us fresh vision for compassion in an atmosphere in which calls for justice have become distorted in the noise of ideological debate. First, witness as healing is the church's posture as it loves the neighborhood toward life. Second, the creative kinship of the kingdom of God re-forms us as family as we live in solidarity with vulnerable people. Third, maternal nurture is a biblical motif for witness that centers tenderness, evoking a fierce protection and advocacy for vulnerable people and vulnerable places.

8. Creation

In post-Christian societies, our growing consciousness of our interconnectedness with creation and our responsibility toward it will be a key and integrating characteristic of flourishing churches. Following the example of God, who has made a covenant with the creation (Genesis 9), we recognize our kinship with the creation, living with loyalty and solidarity with the non-human world. We can nurture our awareness of our mutual interdependence with our fellow sixth-day creatures by seeking to live, garden, work, and eat thoughtfully in relation to the creation.

Part III: Soul

9. Voice

The concept of "coherence" (taken from therapeutic practice), which refers to an alignment of mind, heart, face, and speech, can be evocative for reimagining dialogue about Jesus with those who don't know him. "Authentic utterance" or "genuine voice" refers to speaking about Jesus with coherence. We can be inspired by the early church: outsiders were attracted by their beautiful lives and spiritual vitality, prompting questions. And we can search for fresh and authentic phrases with which to speak about Jesus, offering truth about Jesus in the context of authentic dialogue.

10. Conversations

Incarnational communities seek to dialogue regularly on pressing issues facing the community. While respecting leadership, they also seek to make decisions together, discerning together what God is calling them to in the neighborhood. Incarnational communities grow and mature in their ability to have conversations, over the years. These communities value emerging practices such as listening skills, facilitation, restorative practices, conflict

skills, and collaborative leadership processes. In their shared life and conversations, they seek to hold together things that are often found apart within the church.

11. Sins of Our Kin

Incarnational communities receive Christ's healing by humbly learning about the ongoing story of colonialism and reordering our lives in response to the stories of peoples and lands. We should discern the ways in which interconnected issues of historical colonialism, racism, immigration, creation care, economics, and patriarchy have misshaped and disfigured our faith. The divine covenant with every people group (Gen 9–10) demonstrates the value and dignity of every cultural group, prompting us to learn the histories of our culture and to walk in a good way on the land.

12. Prayer

Witnessing communities are sustained by regular and extraordinary practices of prayer, often drawing from a range of traditions. Acts 1 shows us that prayer should be our first response upon learning that witness is the church's very identity; the Spirit comes in power in response to our prayer. A desire for contemplative practices is prevalent in Western cultures, both inside and outside of the church. Thus, prayer practices themselves, entered into in the name of Jesus, can be an act of Christian witness. Relatedly, prayer practices are also a key conduit for faith in times of doubt. There are many strategies for nourishing communities of prayer, ranging from Quaker clearness committees to fresh expressions of the daily office.

Looking back over this list, I am convinced that if there is one adjustment that is crucial for the Western church today, it is realigning our allegiances, our kinship connections, in light of Scripture. We need to recognize and creatively respond to Christ's call to solidarity with marginalized people in our neighborhoods and toward the wider creation. As we follow the example of Jesus in this way, we will also encounter him.

"What Do I Do Now?"

After you close this book, what can you do? Likely, you are a leader with plenty of dreams and hopes for your church, and perhaps you are poised on the edge of your seat, ready to launch! But before you spill out into your

unsuspecting pastor's office (or, if you are a pastor, into your unsuspecting church board meeting) and launch into an impassioned speech for church renewal, it is important to take a breath and to seek God's timing.

Can you pause and seek God's timing? Can you leave your important ideas at the foot of the cross, waiting for Jesus to invite you to pick up a few of them? Your vision delights God, and yet your patience will also delight God. How can you slow down and listen well? Can you notice what God is already stirring and birthing in your community?[3] And what would it feel like to initiate with wisdom, from a place of personal health?

First, take some time to listen to God in prayer and to journal. It usually takes more than one person to bring a new idea into reality. Who could you invite as a partner, or even a small group, into this journey? At my best, when God has something new for a ministry I am leading, I try to form a rich *process for communal discernment*. Sharing in a process of communal discernment is a slower but richer way of being leader-full as you go.

I have been writing this book with the prayer that the Lord would use it to *birth* ten new tender, creative, and Jesus-loving churches that I hear about and to *renew* ten others that I hear about. And I also have been praying for another ten new worshiping communities that I *don't* hear about and ten renewed worshiping communities that I *don't* hear about. So, if God births something within your community after reading this book, whether big or small, please reach out and let me know!

As for myself, I must stop writing now, as I have a jazz gig coming up and I need to practice. I have learned the hard way that there is no point merely cramming in a practice time the night before. The only way to maintain my playing at a high level is to be practicing every day, month after month, year after year. So, at ten o'clock every night (it's nearly ten now), once the kids are down and Erin has settled into her own creative practices, I sit down at the piano and immerse in the rhythms and sounds of the music (we keep musicians' hours).

[3]Linda Bergquist and Allan Karr use the phrase "congruence" to refer to an approach to church renewal that respects what the church has been, what the church is now, and what the church will become (*Church Turned Inside Out: A Guide for Designers, Refiners, and Re-aligners* [San Francisco: Jossey-Bass, 2010], 145-46).

This regular, sustained practice over years is how thoughtful incarnational churches are nurtured too. You can't achieve it in a night, or even in a year. In fact, you can't *achieve* a thoughtful church at all.

> *The only way to maintain my playing at a high level is to be practicing every day, month after month, year after year. . . . This regular, sustained practice over years is how thoughtful incarnational churches are nurtured too.*

Incarnational churches are built on thousands of small acts of faithfulness of many people, nourished by the Spirit. It takes slow conversations, bighearted kin-keeping, and learning from mistakes, with the Bible in our hands. "It takes tons of worship and prayer," as Dawn Humphreys said. If you are in, then you are in for the long haul. And if you are in, then you may find yourself on the leading edge of what God is up to in Western neighborhoods, as you cooperate with the Spirit who is improvising new melodies on the tradition.

Appendix

Preaching that Nourishes Incarnational Communities

HERE IS A PATHWAY, in brief, for preaching and teaching that nourishes incarnational communities.

In offering a vision for preaching at the end of this book, I don't want to give the impression that a church's vision is only held by preachers. Nor do I want to reduce pastoral ministry to preaching, for the book has demonstrated that church leadership requires our whole self and imagination. And yet without a fresh biblical vision for preaching, our preaching may undo our best efforts at nourishing incarnational community. So here is a brief explanation, just the bones. I hope that the way in which we have explored biblical texts throughout the book adds flesh to the bones.

Before we launch, it is important to state that there is no one correct method for biblical preaching or one correct form for biblical sermons. Anyone with the slightest acquaintance with diverse cultural expressions of biblical preaching will share this insight. So acknowledging a diversity of approaches to biblical preaching, here are six qualities that can nourish incarnational communities within post-Christian neighborhoods.

> *Without a fresh biblical vision for preaching, our preaching may undo our best efforts at nourishing incarnational community.*

1. Preach Christ and Christ's Way

Preaching should be centered on Christ and attuned to the way of Christ. We have already seen that Christ stands at the center of the story of

redemption. Never forget that it is all about Jesus. Lesslie Newbigin reflects, "The business of the sermon is to bring the hearers face to face with Jesus Christ as he really is."[1]

And preaching that is attuned to Christ must also be attuned to Jesus' way, which may be expressed as a biblical ethic of kinship. Scripture is nourishing Christ's people as communities of tenderness, as a people who receive and extend the healing of Christ. When we say, "Jesus' way," we are thinking of the ethics within all of Scripture, for all of Scripture finds its fulfillment in him (Lk 24:25-27; Jn 5:37-47). So, all of the kinship, justice, feasting, place-making, shared life, forgiveness, and more, that we encounter in the Old Testament is visible and tangible in Jesus' life and ministry.

2. A Missional Hermeneutic

Biblical hermeneutics is the art of biblical interpretation. We need to press into four key questions all our lives, as those who nourish others in Christ: What is the biblical story? What is Christ's way? What is the gospel? What is witness?

The phrase "missional hermeneutic" refers to reading the Bible missionally. We have come to see Scripture as the story of God redeeming the creation and calling a people to live as a sign to God's restoring reign. Scripture is not only the narrative of the story of redemption, as wonderful as that is; Scripture is also a tool to bring that redemption about! Michael Goheen puts it well, "To rightly understand the nature and authority of Scripture, then, is to understand its formative role, how it powerfully works to shape a faithful people and through them to bring healing to the world."[2]

3. Communal Frame

The books of the Bible were not written as abstract theological instruction; rather, each was written to shape the faithful life and witness of the ancient community it was written for. Echoing this dynamic of Scripture, we preach

[1]Lesslie Newbigin, *The Good Shepherd: Meditations on Christian Ministry in Today's World* (Grand Rapids, MI: Eerdmans, 1977), 24.

[2]Michael W. Goheen, "A History and Introduction to Missional Reading of the Bible," in *Reading the Bible Missionally* (Grand Rapids, MI: Eerdmans, 2016), 3-28, at 25.

to nourish our congregations as contrastive communities, shaped by the tenderness and truth of Jesus.

Preaching emerges from within the life of the community. We preach from within the community, at a particular moment on our life journey together. The preacher has a particular role in naming what the Spirit of Christ is doing among us and calling us toward. Together we theologize and read the Bible afresh as a people called to a particular life of witness.[3]

The communal frame for preaching should alert us to the reality that while preaching is vital, it is not everything. There is much more to Christian community and to pastoral leadership than preaching.

> *Preaching emerges from within the life of the community.*

4. Expository Preaching

Shortly before Paul's death, the great apostle to the Gentiles exhorted his trusted partner, Timothy, "Preach the word" (2 Tim 4:2 ESV). I would suggest that expository preaching directly and demonstrably explains and applies Scripture. By directly I mean that the homily instructs and encourages from the text. By demonstrably I mean that everyone can see that this is exactly what the preacher is doing. To be sure, preaching can be dialogical; to be sure, preaching can and should be creative (I often preach from the piano); and yet, we are always directly and demonstrably explaining the Word of God in Scripture, nourishing our community to faithfully play its part in the story of redemption. Preaching that is not directly opening Scripture may have short-term appeal, but in post-Christian societies, if we are not meeting Christ in the text on the Lord's Day, then people will eventually drop church in preference for brunch. Don't get me wrong, I *love* brunch, it's just that's what we are up against!

5. We Preach Christ to Nourish Faith in a Culture of Doubt

How can we display the wisdom of Christ and the beauty of Scripture in contexts where this is by no means assumed? (I am still speaking of homilies in corporate worship here.) We preachers can grow an intuitive awareness of the diversity of relationships that our people have with Scripture. And we

[3]On theologizing, see Harvey Conn, *Eternal Word, Changing World: Theology, Anthropology, and Mission in Trialogue* (Phillipsburg, NJ: P&R, 1992), 211-60.

can learn to hold out the word of life responsive to these complex relationships. We desire to preach *from* Scripture *into* life and culture, do we not? And when I started out as a preacher, it worked well simply to do just that. Until recently, people walked into church literally with the Bible in their hands. Yet in post-Christian, post-secular cultures, many of our people no longer assume that the Bible is God's authoritative word. They walk into church with culture and life on their minds. They are asking cultural questions, often good cultural questions, like: What about racism? They are asking life questions, often good life questions, about loneliness, about anxiety. So preachers need to find an aesthetic and empathic starting place. We consider something in our lives or in our culture that Christ aches for, or perhaps something that Christ celebrates. And in the context of this pressing theme (whatever it may be), we display the beauty of Christ and of Christ's way from Scripture. With the Bible in our hands, we can show how Scripture, and Christ as he is revealed in Scripture, outshines our best solutions and our grandest imaginings! In a sense, we are arguing for Scripture's authority without saying as much. Or better, we are making space for Scripture to argue for itself. The key point is that we are displaying the wisdom of Christ and the beauty of Scripture in contexts where this is by no means assumed.

AN EXAMPLE OF PREACHING THAT DISPLAYS THE BEAUTY OF SCRIPTURE

Here is an example of how I respond intuitively in preaching to a congregation's diverse relationships with Scripture. In chapters five and six of this book, I unpacked Deuteronomy 16:1-17, which is an ancient festival calendar. Themes of divine gift and gratitude grow from the soil of this text. Urban gardeners and foodies alike can delight in the annual rhythms of planting, harvest, and feasting in Deuteronomy 16:1-17. In preaching this text, I journey through the harvest seasons of Deuteronomy 16:1-17 in lots of detail. To unpack the theme of gratitude, I share the story of Mary Jo Leddy, a Catholic sister, who was brought into a posture of gratitude through an encounter with a young girl with refugee experience. And I reflect that when we take time to give thanks, the stress that we may be holding through the day begins to melt away. Through the homily I hope

my people can, 1) connect with Scripture as an outdoors book that can take us to the "peace of wild things";[a] 2) connect with God the giver; 3) experience gratitude as a spiritual practice; 4) wonder about the diversity of the people (of lack thereof) who sit at their table.

[a]The title of a poem by Wendell Berry.

At a more basic level, simply displaying in our preaching the justice and tenderness of God—strident themes in Scripture all too often neglected in evangelical preaching—and calling the church toward our biblical responsibilities for economic equality, biblical kinship, and kinship with creation, will do much to restore confidence in Scripture for many people.

6. Aesthetics and Posture

The next generation of preachers has both the opportunity and the responsibility to find fresh, creative, aesthetic, and dialogical approaches to biblical preaching. We need to consider what motivates people, and how people learn most effectively. People more often experience transformation when they engage as a whole person, as God has created them. This includes the cognitive, affective, and psycho-motor dimensions—head, heart, and hands. You might consider working creatively with some of these strategies. Engage your people by:

- preaching from a posture of commonality. A mutual posture is more likely to nourish dynamic and empowered communities;
- offering an invitation, rather than an authoritative command: "I wonder, is there an invitation here for you . . . ?";
- grieving what Christ grieves in our lives and in our societies;
- using art, music, fiction, philosophy, psychology. Can you play music? Integrate music with the spoken word. Do you write poetry? Dance? Paint? Use these gifts to communicate and apply Scripture to the heart;
- leaving room either for prayer, for quiet, for journaling, for dialogue, for reflective listening, or for further exploration;[4]

[4]Pastor Matt McCoy of Spring Church Bellingham once commented to me, "I don't speak for more than ten minutes before I ask a question that I don't know the answer to."

- exploring historical background that opens up the text. Most of us like learning in general, so don't dumb it down;
- directly addressing the difficult passages in Scripture that seem to display violence, misogyny, and so on;
- hearing from others via interviews and stories, having a variety of preachers, and so on.

Perhaps the key clarification that is needed as we reframe preaching is that we are not looking to develop brilliant and famous preachers; rather, we are seeking to nourish beautiful Christ-centered communities that display Christ's beauty.

General Index

Scripture Index

Also by Mark R. Glanville

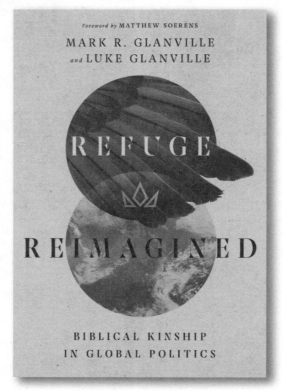

Refuge Reimagined
978-0-8308-5381-6